KU-740-941

Art Forms in Nature

WITHDRAWN

SWINDON COLLEGE

LEARNING RESOURCE CENTRE

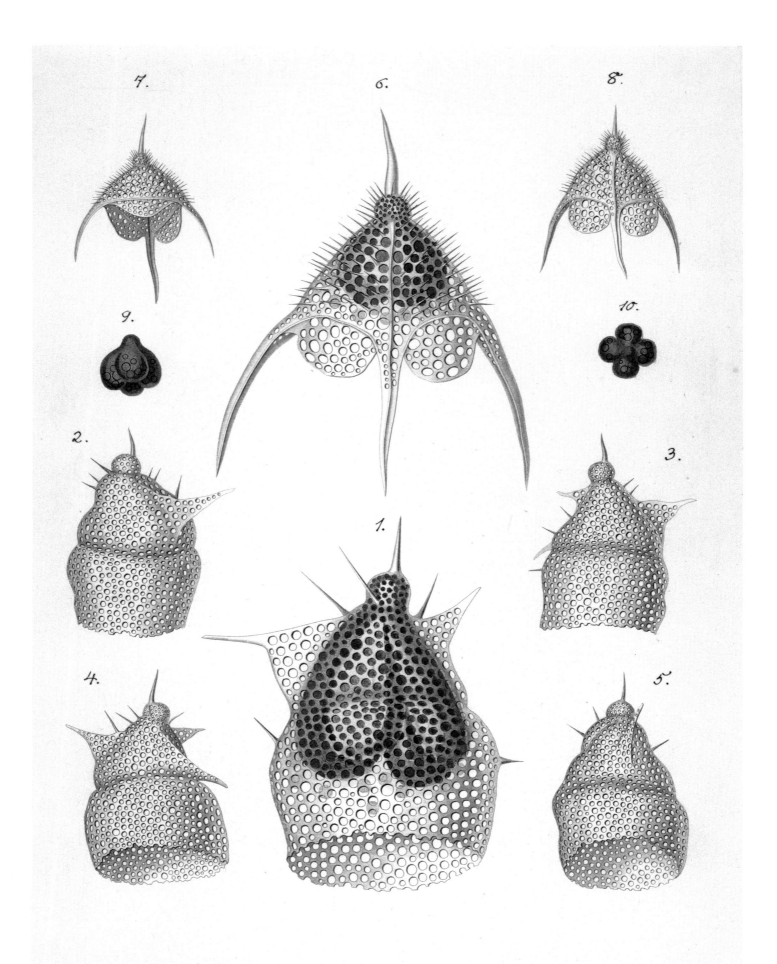

1—5. *Dictyoceras Virchowii*, Hkl. 6—10. *Dictyopodium trilobum*, Hkl.

Art Forms in Nature

The Prints of
Ernst Haeckel

One Hundred Color Plates
With Contributions by
Olaf Breidbach and Irenäus Eibl-Eibesfeldt
and a Preface by Richard Hartmann

Prestel
Munich · London · New York

Color plates reproduced from the first edition
Kunstformen der Natur, Leipzig and Vienna, Bibliographisches Institut 1904.

The Publisher would like to thank Richard P. Hartmann
for his work on this edition.

On the cover: Plates 8 and 80
Frontispiece: Plate from Ernst Haeckel's
Die Radiolarien, Berlin 1862.

Comparative illustrations were kindly provided by the authors.

© Prestel-Verlag, Munich · London · New York 2010
15th edition 2014

The Library of Congress Control Number is available; British Library
Cataloguing-in-Publication Data: a catalogue record for this book is
available from the British Library; Deutsche Bibliothek holds a record
of this publication in the Deutsche Nationalbibliographie: http://dnb.dnb.de

Translated from the German by Michele Schons
Edited by Michael Ashdown

SWINDON COLLEGE
5405000415521
LEARNING RESOURCE CENTRE

Prestel Verlag, Munich
Member of Verlagsgruppe
Random House GmbH

Prestel Verlag, Neumarkter Strasse 28, 81673 Munich
Tel. +49 (89) 4138-0; fax: +49 (89) 4136-2335

www.prestel.de

Prestel Publishing Ltd., 14–17 Wells Street, London W1T 3PD
Tel. +44 (020) 7323-5004; fax +44 (020) 7323-0271

Prestel Publishing, 900 Broadway, Suite 603, New York, NY 10003
Tel. +1 (212) 995-2720; fax +1 (212) 995-2733

www.prestel.com

Design and Typesetting: WIGEL Munich
Reproduction: ReproLine, Munich
Printing and binding: Passavia Druckservice, Passau

MIX
Paper from
responsible sources
FSC® C022274

Verlagsgruppe Random House FSC® N001967
The FSC®-certified paper *Hello Fat Matt 1,1* produced
by mill Lecta has been supplied by PaperlinX.

ISBN 978-3-7913-1990-2

Preface

By Richard P. Hartmann

The book *Art Forms in Nature* is an epoch-making work. It was the showpiece of a respectable household and fulfilled a very particular purpose; its contents were, like nature, beautiful, for nature—according to the author—has a "sense of the beautiful." Despite its pretentious cover and its manifest sense of deeper significance, it had no alibi function; it was more than just physical evidence of the educational level of the household. On the contrary—it was brought out at every possible opportunity, presented, examined, even admired not only by the youngest of the household, but also by the grandfather. An *opus magicum*, it strikes the mysterious chords of the *Riddle of the Universe*[1] and *Miracles of Nature* in the form of a "miracle of life," and displays their interconnections to us over one hundred pages.

This book of images was fascinating then as now, for our curiosity grows with every page turned and is satisfied by an always completely new perspective on the fantastic, on the multifarious morphological forms and figures that seem to unfold as simply as if in a children's book—just like in Carl Larsson's *House in the Sun*. We are also reminded of the lucid clarity of Runge's drawings, of his life image *The Morning*.

The consistently maintained image structure produces a rhythmic sense of dynamics analogous to that of Maurice Ravel's didactic instrumental piece *Bolero*. The central composition—Haeckel's very own design principle, which he developed for this book—captivates the beholder. He used this principle to exemplify function in relation to form within the meaning of ecology (a term that he significantly influenced) in his illustrative plates.

From a vast quantity of biological preparations, which he examined and described largely on his own according to biological-scientific categories, he made a selection, depicting and describing each organism separately. Thereafter, he ordered the sketches symmetrically on every page—according to a centralistically orientated compositional principle—so that the central figure and the respective forms at the edge were distinguished from each other by a formally differentiated relationship to the environment. Neither the specific natural location nor the specific environmental situation were depicted. The ecological regularity between the depicted lifeforms is therefore represented neither according to "scientific principles" nor related to the respective environmental conditions; instead, Haeckel used an artistic compositional principle to make the significance of organic growth and differentiation apparent from the form. Justifiably, Haeckel thereby referred to Goethe, since for both of them form, as an aspect characterized by entelechy, was central to their consideration; the composition succinct and unpretentious—since it was, in fact, unintentional—so that every beholder could easily understand that which was important. The diversity of the species, with their many and varied appearances, is conceived in a well-ordered fashion and harmonically presented, emphasized in its plasticity of form with beautiful colors.

Symmetrical Form, Organic Growth

The fascination with worldly wisdom that these pages radiate historically became the stylistic notion of an epoch that celebrated life, recognizing its aspects of growth and flourishing both to scale and in exemplary fashion for the human way of life, and reproducing them symbolically. It was realized by a symmetrical form that was influenced by Haeckel, and since then designated as "organic form," and incorporated allegorically into art history as a "form of organic growth" and of the "organically grown." As a natural-historical document, it corroborates the stylistic notions of "Art Nouveau" and "Jugendstil" in an intellectually historical fashion.

Brief Instructions to Viewing Haeckel's Pictures

By Olaf Breidbach

Ernst Haeckel: The Biologist

Who was Ernst Haeckel? The first preliminary description reveals a contentious biologist, the first full professor of zoology in Jena, important and renowned for his emphatic advocacy of Darwin's theory of evolution. His often pointedly and polemically formulated writings led him, no less, to the center of sometimes vehemently disputed biological debates at the end of the nineteenth century. However, his fame was not merely a consequence of his many popular speeches and writings, but also of his numerous, carefully compiled monographs on individual animal groups. In 1862, he qualified as a lecturer with his study on a group of single-celled organisms, exquisite in their ornamental morphology—radiolarians. In these organisms, he discovered—guided by his instructor Johannes Müller—complex patterns of symmetry reminiscent of crystals, on which he based his classification of these forms. He went on to pursue this notion of the morphology of organic forms being analogous to crystals, discovered symmetries in other groups as well and, seven years after Darwin's epochal work on the origin of species was published, he took the decisive step of attempting to draw up a comprehensive classification of the form of living things. He developed a sort of organic crystallography—or, organic stereometry, as he called it.

His idea was that the classification of organic forms would exhibit a series of ever-increasing complexity. This would be apparent in the external forms only conditionally. Their tissue, nevertheless, would become increasingly differentiated in the course of evolution. The individual cells, already structured symmetrically, are integrated in this tissue; macroscopically, they can in part be described in simple stereometric terms, but they exhibit a great richness of complex patterns of form in their finer structures. He interpreted this series of forms, defined by means of such description, as being the result of a continuous history of life-forms. According to his interpretation, the basic structures of organic life—here meaning cells—arranged themselves in ever more complex configurations. In this way, they established a series of individual organismic forms. However, Haeckel maintained that organisms that originate in this way do not remain unchanged, but, instead, are and have been subject to further differentiation of their respectively attained structures by means of inheritance and adaptation. A picture of an ever-increasing structural diversity of life-forms, fanning out continuously, unfolded before his eyes. Any species in a branch in a phylogenetic tree is built according to rules acquired through and conserved in the development of this life-form. According to Haeckel it follows—and this notion became of central importance for him—that the individual forms in their developmental process establish this sequence of individually acquired rules, thus replicating (or as Haeckel put it—recapitulating) the respective development of the individual (ontogeny), the evolutionary development of its species (phylogeny). This is the thrust of his "Biogenetic Law."

A single life-form, a particular species, can conserve itself, however, not only in its status, but it can "allow" for further modifications in development, and therefore further levels of morphological complexity. It is even possible—with this sort of form type—that two or more alternative paths of further development are open to a given

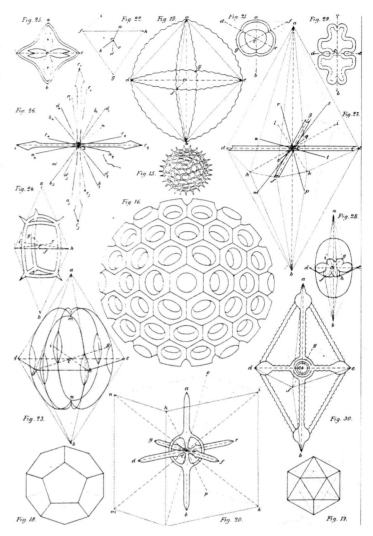

Fig. 1 Basic polyaxon and homopolar forms. Plate II in Haeckel's *Generelle Morphologie der Organismen*, vol. 1, 1866

species. Accordingly, the reconstructed kinship of forms does not depict a mere series of similarities in which we, as observers, order relatively similar looking forms. Rather, these series of similarities represent actual continuous lines of descent in evolution. An adequate depiction of the diversity of these forms does not only constitute a catalogue, in which similar-looking organisms are ordered with respect to one another, but rather a genealogical tree that displays the existing succession of forms.

Haeckel drew up these kinds of genealogical trees in his *Generelle Morphologie der Organismen* (*General Morphology of Organisms*), published in 1866, which comprises unicellular organisms, plants and animals—including human beings. Haeckel claimed that all species represent stages in the developmental process of an ultimately unified genealogy of living organisms. The diversity of living things is ordered along a line of descent that can be traced back to a simple, basic "primordial" form.

With this thesis—put forth by Haeckel in great detail—he not only became a proponent of Darwin's theory of evolution during the critical phase of the debate over the acceptance of Darwinism but,

simultaneously, offered the first concise outline of a biology that could incorporate the principles of evolution. This outline was revolutionary in its implications. It radicalized Darwinism in a way that Darwin himself had not been prepared to present with such rigor. Eventually, however, Darwin took up this—as he wrote to Haeckel—exceptionally courageous and groundbreaking outline.

Haeckel's Reasoning

For Haeckel, this depiction of a genealogical tree of life-forms, i.e., the possibility to use Darwin's theory consistently and free of contradictions as an ordering principle for the diversity of organic forms was, at the same time, proof of the validity of Darwinism. However, when Haeckel employed this line of argumentation in biological debates, he encountered difficulties, not least because of his own contradictory approaches: in drawing up his genealogies he was very extensive, while he continued to work with a rather minute and comparatively narrow methodology when it came to his individual studies. He was still unable to provide comprehensive proof of the evolutionary process; he did not offer an explanation of the mechanisms of evolution. His detailed studies instead focused on the description of similarities in form, which failed to *explain* the processes of evolution.

Haeckel worked as a zoologist, employing the classical methods of morphological comparison that were already in use in the biological sciences before the theory of evolution had been posited. However, contradictions arose in his work as a result of these methods, which are important for the intellectual history of evolutionary biology and for the understanding of the subsequent development of biology—particularly in its exclusion of physiologists in exchange for morphologically oriented scientists—but which do not pertain here (see Bowler 1989; Breidbach 1997a).

In contrast, what remains important for the present discussion is to remember that, for Haeckel, structural perfection and differentiation in the course of the succession of an ever more complicated architecture of forms not only represented a means of classification for the individual type, but became the basis of establishing lineages themselves.

Art Forms in Nature as a Zoological Work

If we leaf through the pages of the present volume with this in mind, the multifarious, often playfully structured forms no longer resemble merely a collection of exotica to us. Haeckel demonstrates their stereometry with respect to a wide variety of forms. They all seem to be subject to the principles of symmetry, and are consequently not to be regarded solely as the result of a "game" of nature. Instead, all of nature seems symmetrical. Haeckel claimed that the constituent characteristics of living organisms could be concealed in these symmetries. This notion, directly related to "romantic" natural science and, in Haeckel's eyes, particularly to Goethe, points to a very old tradition of describing nature, and was practiced by French physiologists in the eighteenth century. In this profusion of symmetrical series, which seem to stem from the workshop of a brilliant designer, a fundamental formula for living things shines through for Haeckel. The many forms brought together in his work appeared to him to be a series of variations of simple constellations of symmetry. His depictions of them embrace a succession of complexities in which he saw the mechanics of evolution at work. His *Art Forms in Nature* seeks to reproduce such constructions. Every plate in this work is an example of Haeckel's notion of a principal unity of all living things. Each one of these illustrations—which for the uninitiated observer are at first only highly ornamental—was, for Haeckel, proof of his thesis. For him, the individual form, its inherent symmetry, documented Darwin's notion of the evolutionary development of all living things.

Haeckel invested a corresponding amount of care in his depictions. His plates do not simply illustrate the text; they stand for themselves, they reveal nature in all its peculiarities. The quality of these works

Fig. 2 Coral reefs near El Tûr on the Sinai Peninsula. Fig. III in *Arabische Korallen*, 1876

corresponds to their significance. The individual forms are executed with the utmost delicacy, and employ stylistic elements—as will later be described in greater detail—that reflect ways of seeing prevalent at the time, the aim of which was to reproduce natural forms as accurately as possible. A comparison made between Haeckel's drawings of radiolarians, for example, and those still extant, original preparations stored at the Ernst-Haeckel-Haus in Jena shows that he fulfilled this aim. The reproaches concerning Haeckel's alienation of nature, with which individual colleagues confronted him, are irrelevant. He shows the nature of forms; he reveals them in a singular way, which explains the fascination of these plates.

Biology of the Strange

Haeckel did not conceive of a specialist book. Even the original format of his publication speaks against this: Haeckel published *Art Forms in Nature* in a series of ten installments, each containing ten illustrations. These, as well as the short, readily intelligible commentaries on the individual plates show that he addressed a wide public in this work. Analogous to—though much more systematic than—Alfred E. Brehm's *Tierleben* (Animal Life), it is a popular introduction to, above all, microscopic organisms. This volume contains a colorful selection of plates, in which—especially laymen will notice—strange forms have found expression.

Curiously enough, it is precisely this strange aspect that is so appealing. The net-like forms of radiolarians look somehow familiar; it is, in fact, surprising to discover that they are forms taken from nature. In examining the plates it almost seems as though, in particular, radiolarians, medusae (jellyfish) and echinoderms (a group which includes sea urchins and star fish) represent the forms of all living things. Conversely, insects, which—as we learn in school—make up more than three-fourths of all species, are hardly represented—the beetle, for example, does not appear at all.

What sort of collection of illustrations is this then, which Haeckel presents to us? The last of the plates in *Art Forms in Nature*, plate 100, depicts mammals, various forms of antelope, though the horns are the focus here, the contours of which remind us of those of the snails and the ammonites illustrated earlier. Plate 92 is a depiction of a diorama of ferns. Plate 74 shows orchids, almost conventionally executed. On plate 67, we find mammals again—here, bats. Here, the artist restricts himself to the representation of these creatures' curious looking ear and nose structures. The faces of these animals are reduced to their ornamental elements. In these plates, the reader is reminded very much of the symmetries in the organization of the most various of invertebrates shown in many plates. In these images we are confronted with highly refined ornamentation. The aspect of the animal's relationship to its particular environment does not appear to have been of interest. In nearly all the portrayals of radiolarians, only the skeletons of these creatures are portrayed. When alive, they are enclosed in a gelatinous cell body. But, these fragile cell bodies are mostly destroyed in the process of preservation. The majority of Haeckel's depictions of radiolarians are not sketches of these creatures, which are difficult to delineate accurately, but of individual structural peculiarities of these animals. The symmetries of these constituent parts are what Haeckel brings to the fore. These peculiarities of form—which he accentuated in his selection of colors, the type and form of the picture and, not least, by his arrangement of the individual creatures—

not the physiology or ecology of life-forms, seemed to him to encapsulate the very essence of these organisms that he studied with such care.

Argumentation in the Image

Let us examine plate 65—a depiction of red algae. We see three vertical layers of individual portrayals, which become concentrated towards the bottom. In the center of the plate—in a semi-schematized rendering—part of a lateral branch of red alga emerges, around which the other sectional illustrations cluster (owing to the particular accentuation of these details). On the side, depiction 4 takes up the motif depicted in the central drawing of the "pinnation" of the red algal branch in a very loose form. On the other side, organism 6 shows a fractally appearing leaf edge zone, which in this context no longer looks like a finely dissected leaf, but a condensed feathery structure.

Both basal sectional views (depictions 10 and 11) also fit in to this pattern of a purely visual demonstration of variations of form. Placed next to depiction 9, these details drawn from the microscopic specimen look merely like simplified forms of the basic form of a red alga (a thallus). What does Haeckel accomplish with this? His picture is convincing because it plays with visual signals. Without having to trouble with language, he generates a general impression of a form type in his plates, which is heightened by the unified coloration of the individual leaves.

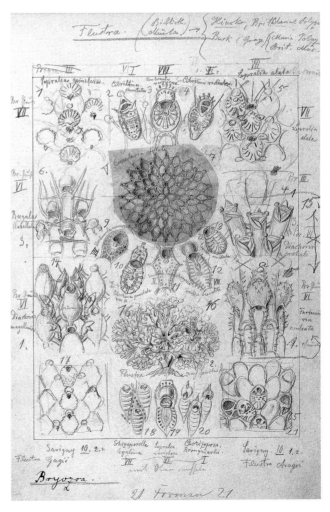

Fig. 3 Bryozoans. Design for plate 33 in *Kunstformen der Natur*

Fig. 4 Adolf Giltsch (1852–1911), a lithographer active in Jena who received commissions from Haeckel for plates in *Kunstformen der Natur*

He is concerned with depicting variations of symmetry and—in so doing—revealing his conception of a form type.

With this in mind, it becomes clear why Haeckel undertook a series of plates that did not correspond to any overriding order. Each plate is an argument in favor of the basic notion expressed in his introduction. Every plate is an example, a sample and collection piece which, in its mere existence, explicates the concept of organic symmetry. This also explains why the commentaries on the individual illustrations remain comparatively superficial. Haeckel briefly introduces each form type depicted and either gives short statements on which he elaborates or refrains from giving a more detailed commentary on the works that he compiled.

Organic Symmetries

It goes without saying that Haeckel reduced the organisms he beheld to the basic pattern of symmetry that interested him. This is perhaps most evident in both his plates depicting fish. One of these portrays so-called trunk fish, which are readily integrated into the scheme of a symmetrical organization of organisms (plate 42). The other plate (plate 87) concentrates on a few peculiar-looking forms of fish in the center of the page and surrounds these almost arabesque-like form types with a margin of fish scales, in which Haeckel wishes to demonstrate the inherent ornamentation of this group of higher organisms. His message is clear: the fish are reduced to plain references of symmetry shown in this plate. The reference to the ornamental forms in the center suggest continuity in the organization of this type of organism, which in its fragmentary structure—ranging from scales to the basic forms depicted as ornamentation in the center of the picture—seems to become comprehensible as an organic stereometry.

This plate is not a special instance, but illustrates Haeckel's whole notion, indeed conception, found throughout this book.

There are only few depictions, such as plate 49, that convey an essentially lifelike portrait of forms. These depictions, compared to the plates illustrating symmetrical constellations, are rather conventionally executed, and their descriptive quality may not be compared to that of the plates revealing form types.

Summa Naturae?

What, then, is *Art Forms in Nature*? Is it a work that is intended to make biology—particularly marine life—appealing to a wide public or does something else lie behind this apparent potpourri of forms?

Perhaps it would be interesting to examine the texts more closely, with which Haeckel introduced his illustrations. A closer look reveals that the organisms that Haeckel depicted in the individual plates come from vastly different regions of the globe; they come from Heligoland and Australia, from Thuringia as well as from the steppes of Africa. These organisms—i.e., the majority of the invertebrates and individual plants illustrated here—were given names, for the first time by Haeckel. The names which come after the two-part Latin names (the scientific names of the species), are those of the first scientist to describe the species. A closer examination reveals that Haeckel published a wealth of initial descriptions in this work, which at first glance appears to be a publication of popular science. This applies to the plants (for example, plate 63, figure 1) as well as to the unicellular and higher organisms (for example, plate 88). The quality of these original descriptions is —with regard to their literary form—in part, sketchy; in his descriptions, Haeckel mainly emphasizes the visually conveyed signals of these organisms. This observation is interesting in forming an opinion on the character of this publication. It shows how seriously Haeckel took this collection of illustrations.

This conclusion is supported by a second observation: Haeckel uses *Art Forms in Nature* to evaluate and to reward his contemporaries. It is not uncommon in the process of naming new organisms to leave a sort of memorial to colleagues and friends, whose names subsequently become associated with the scientific nomenclature of a given species. According to the accepted rules of taxonomy, the first description of a hitherto unnamed species is binding. Thus the taxonomist—the individual who systematically classifies species and who may also need to name newly discovered species—has a tool in hand, albeit not a hammer or chisel, with which to construct a relatively permanent "monument" for the honored person. Haeckel memorialized his first wife (Anna Sethe), whose name was used twice (see plate 6)—not, however, Agnes Haeckel—Baroness Frida von Uslar Gleichen, once (see plate 10), his lithographer Adolf Giltsch, twice (see plate 27), and Bismarck, a supporter and benefactor of zoology in Jena, to whom he—in plate 23— dedicates a "well-set" radiolarian.

What does this mean? The naming of a species is not a trivial matter. It is not a matter of chance that Haeckel scattered these new names throughout his work. Naming "new" species after persons whom he highly valued bears testimony to the significance he attributed to the corresponding nomenclature, and where it was published. This sequence of plates, which follows no overriding scheme, means a considerable amount of work for taxonomists, since, after all, it is by no means easy to ascertain which in a particular group are actually new descriptions. This in itself, however, reveals the significance Haeckel placed on *Art*

Forms in Nature, also from a scientific point of view. For him, this work represents a comprehensive treatise on his conception of nature.

The plates also illustrate his basic notion of organic stereometry. He gives a detailed account of the reasons for this in his epilogue to the ten installments of *Art Forms in Nature*. The idea of being able to discern the organization of forms by looking at them and thereby to gain insight into their schematic order, enabling the phylogeny of living things to be reconstructed, is expounded upon by him once again in further detail.

What becomes apparent is that each individual plate was not intended to be an illustration of a curio; rather, each plate serves an exemplary function. Each life-form shown in the plates provides Haeckel with proof of his thesis stated in the introduction, thereby exemplifying his concept of organic stereometry. The length to which Haeckel went in his use of exemplary specimens in individual plates is revealed in plate 95 in which he juxtaposes—without the necessity that derives from a purely comparative view—the larval forms of living (present-day) echinoderms (a group which includes starfish) with fossilized echinoderms from the Paleozoic era. In it, he creates an icon representing his conception of the meaning of his "Biogenetic Law."

Yet, this juxtaposition is difficult to justify: systematically comparing fossil forms with living echinoderms is problematic, but the phylogenetic status of fossil forms becomes comprehensible when they are viewed as primitive forms of species living today, the composition of the latter being considerably more differentiated. Haeckel treated these forms in his monograph. However, in their highly bilaterally symmetrical organization, they do not readily fit with the group of living echinoderms. This changes, however, when Haeckel compares them with the early

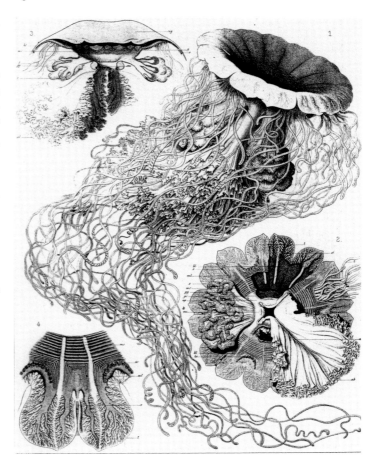

Fig. 6 *Desmonema annasethe* HAECKEL (a jellyfish). Pencil drawing by Haeckel. Plate XXX in Haeckel's *Monographie der Medusen*, 1879

larval forms of living specimens. Here, analogous principles of development are revealed. At first sight, it is not possible to make out whether living or fossilized forms are depicted in plate 98. If the fundamental biogenetic law is valid, it would be permissible to place the various forms of the echinoderms in a phylogenetic sequence: early forms in the development of an individual organism would reveal the structure of the form to be postulated as in the case of old, fossil forms.

At the same time, however, the coinciding of ontogenetic and fossil forms is intended to *exemplify* the validity of the "Biogenetic Law," which can nevertheless only be inferred by *means* of such observation. This means that this comparison of ontogenetic and fossilized forms reveals parallels, which invite interpretation, but provide no explanations in themselves.

Admittedly, Haeckel thinks differently here. The view, the possibility of being able to carry out a corresponding classification, is in itself already proof for him that a corresponding classification is valid. It is "simply" a matter of seeing the truth. The act of seeing, the depiction of forms, appeared to him to be the true means of acquiring knowledge of nature.

The Illustrations

For Haeckel, the illustration is not a depiction of existing knowledge, but is itself the acquisition of knowledge of nature. The truths of nature are seen. Accordingly, Haeckel's *Art Forms in Nature* is not merely a set of examples, which with each detail reveals part of the whole. It demonstrates naturalness itself. By revealing the form of nature, knowledge of nature may be ascertained, which, according to Haeckel, should not

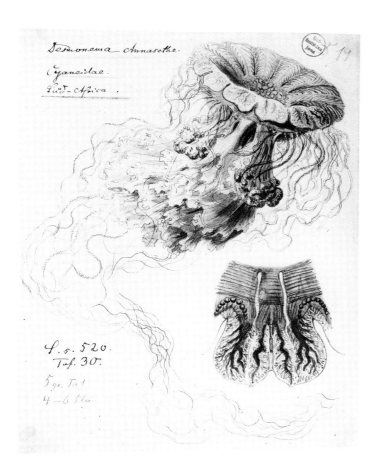

Fig. 5 *Desmonema annasethe* HAECKEL (a jellyfish). Pencil drawing by Haeckel. Plate XXX in his *Monographie der Medusen*, 1879

be restricted to branches of natural science following experimental agendas. Knowledge of nature is "natural aesthetics." Accordingly, aesthetics are nothing more than reflections of nature itself. Nature, which develops out of and into itself, is "beautiful."

How is this view of aesthetics to be substantiated? Is nature always present in itself in the act of acquiring knowledge? Is that which is beautiful merely the state of nature in this respect? Haeckel's reasoning is simple: humans are nature, they are a part of, and the result of, evolution. Our actions and thoughts are products of this evolution. Accordingly, when humans come to know something, ultimately it reveals their own nature. Our knowledge—which has developed in and is subject to the laws of nature—is in itself nature (and, according to Haeckel, nothing more). The draftsman, his sensory organs, his motor activity, are results of a development with which, in the end, nature merely represents itself. Haeckel's comprehensive conception of the world, his adherence to monism, which he expounded upon in *Die Welträthsel* (*Riddle of the Universe*), is based on this notion of knowledge of nature and natural beauty and the biologism derived from it, but which appears purified in monism itself. *Art Forms in Nature* is also to be interpreted as part of this *weltanschauung*.

Consequently, the pages of *Art Forms in Nature* took on a further dimension for Haeckel. The fact that the illustrations are "aesthetic," beautiful, and that this beauty is found in the smallest facets of nature —such as in unicellular organisms or in the medusae of the deep sea— demonstrated to Haeckel that one finds in the smallest living things what distinguishes, or what at least should distinguish, humans in their judgements: "spirit." The beauty of these miniscule creatures revealed to him the natural quality of one of the largest forms of life —human beings. Haeckel maintained that to be part of nature is to be an element in and the result of the evolutionary process. Accordingly, the phylogeny of forms is simultaneously the phylogeny of the spirit.

Art Forms

Does this help us to understand "art forms in nature" and the art forms explicit in them? What is it that Haeckel depicts here that is so beautiful? It is the beauty of ornament. The forms illustrated in these pages seem to fit seamlessly into the repertoire of Art Nouveau forms. Haeckel demonstrates the magic of organic symmetries. He teaches us to look at life-forms as elements of an organic crystallography. What does this amount to?

Let us examine this in an example: one of the most beautiful organisms in *Art Forms in Nature* is the medusa *Desmonema annasethe* HAECKEL (Fig. 6), which is reproduced time and again. This species of medusa, caught off the coast of South America (the Phyletic Museum of the University of Jena still possesses the specimen which Haeckel described), consists of one bell-shaped cap to which the hanging body is attached, and a tangled mass of long, fine tentacles. His first pencil sketch (not executed in color)—stored in the archives of the Haeckel-Haus—also gives an impression of the gelatinous structure of the animal's body out of which the wild mass of tentacles grows. Even in the monochrome lithograph by E. Giltsch, with which he illustrated the first scientific description of this species, this wild structure that congeals into a pleasant ensemble of tentacles—which is somewhat more voluminous than the original—almost conveys the impression of being a blueprint of this species. Haeckel entrusted the lithographer A. Giltsch —who produced the plates for *Art Forms in Nature* according to

Haeckel's instructions—with this previously published lithograph as a model and added to it a color sketch, which makes the actual gelatinous body resemble a gauzy, even flowery, form. What then has happened to the jellyfish *Desmonema annasethe* in *Art Forms in Nature*?

Plate 8 reveals a kind of "inflorescence," similar to an anemone only much finer. Below this, there is draped, finely folded silk, enveloped by two orange "cloths" resembling velvet-like curtains. The whole of this is wrapped in "Art Nouveau ornamented," yellow-orange arabesques, which gently play around the gauzy body of this flower-like creature and end in consummate ornamentation, which contrapuntally comes together in a comparable but far less exquisite form. This play of ornamental threads surrounds an almost round spout-shape that is largely folded in on itself: the perfect presentation of an image of an organism whose consistency, pattern of movement and functional organization could also be comprehended in a completely different way.

What is Haeckel doing here? Is he teaching us to see nature the way it really is? Does he see in nature what he depicts? Or, is he demonstrating that the Art Nouveau style represents an ideal medium to "transport" these relatively inaccessible organisms to us in their actual forms and in a visually appealing way? The extent of his affinity for Art Nouveau's way of seeing is evident in, if nothing else, the interior of his home, the "Villa Medusa," in which he used drawings from *Art Forms in Nature* as ornamental ceiling decorations. Haeckel's approach did not determine Art Nouveau, instead Art Nouveau's approach determined Haeckel's. What ensued was a symbiosis between decorative sketches and descriptive observations of nature, which proved to be extremely prolific.

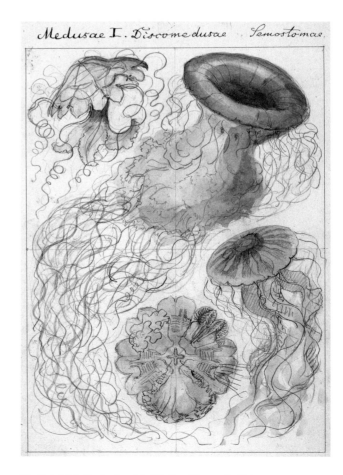

Fig. 7 Jellyfish. Design for plate 8 in *Kunstformen der Natur*

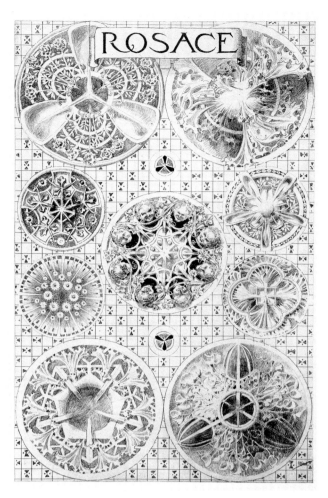

Fig. 8 ROSACE. Plate in René Binet's *Esquisses décoratives*, Paris, 1902

Nature-Inspired Decor

Siegfried Wichmann (1984) and Christoph Kockerbeck (1986) looked into the question of Haeckel's influence on Jugendstil, the German equivalent of Art Nouveau, and, with regard to Hermann Obrist (1862–1927), for example, were able to provide proof of it. In fact, his influences extended to the works of many other exponents of Art Nouveau, such as Louis Comfort Tiffany (1848–1933), Joseph Maria Olbrich (1867–1908) and the architect August Endell (1871–1918). However, one of the most monumental implementations of Haeckel's form types can be found in the entrance gate of the Paris World Exposition in 1900, conceived by René Binet (1866–1911), which—as proven by the curator at the Ernst-Haeckel-Haus, Erika Krauße—derives from Haeckel's depictions of radiolarians. On March 21, 1899, the architect wrote to Haeckel:

> About six years ago I began to study the numerous volumes written on the Challenger Expedition in the library of the Paris museum and, thanks to your work, I was able to amass a considerable amount of microscopic documentation: radiolarians, bryozoans, hydroids, etc...., which I examined with the utmost care from an artistic standpoint: in the interest of architecture and of ornamentation. At present, I am busy realizing the monumental entrance gate for the exhibition in the year 1900 and everything about it, from the general composition to the smallest details, has been inspired by your studies.
>
> (Cited from Krauße's essay in Engels 1995)

In 1902, the same architect published an extensive series of designs in the style of Art Nouveau entitled *Esquisses décoratives*, which he announced to Haeckel with the following remark:

> The book that I will be publishing will clearly demonstrate the high value of your works, and it will assist those, who do not know very much about the history of these infinitely small creatures, to understand the significance of "artistic forms."
>
> (Cited in Krauße's essay in Engels 1995)

When Haeckel writes in his introduction to plate 72 that "the fine cell network of the delicate leaves [of the moss produce] beautiful motifs for embroidery patterns, while the capsule with the delicate cover and the opening's serrated edge provide patterns for urns and bottles," it is hardly surprising that, for example, a vase embellished with such decor—made by Lucien Bonvallet in 1905—is in the possession of the Musée d'Orsay.

Aesthetics of Nature

The importance of this type of natural aesthetic for training the eye, and thus our conception and comprehension of the forms in nature, reaches far beyond the immediate effects of Haeckel's *Art Forms* on architecture and design, which in comparison have not been studied closely enough. Haeckel's illustrations were reproduced widely, finding their way into standard German encyclopedias—such as *Meyers Enzyklopädie* and *Brockhaus*—as well as into textbooks. They not only represent the artist's way of seeing, which furnished these tomes with a new repertoire of forms. Haeckel's influence goes beyond this. He comprehends nature in terms of such arabesques. Haeckel even goes so far—as we observed in his illustrations of the trunk fish, the bats and the red algae—to reduce nature to arabesques. In this way, his vision remains detailed; his "art forms" are natural forms. Haeckel sees nothing new, nothing foreign to nature. He reproduces and fixes a kind of vision, which particularly emphasizes aspects of the decorative, which his subjects possess. Haeckel chose a perspective, a detail, an enlargement in which precisely these characteristics come to the fore. The nature of things, which is revealed in this "nature," is reduced, while at the same time forms appearing foreign are made intelligible. Establishing their ornamental character relieves one of the necessity to ask about the "why and wherefore" of such forms. Haeckel depicts successions of ornaments, drawing analogies where "nature" seems to show itself, while the question as to the cause of effects and the effects of individual forms becomes secondary.

What interests him in the bats he depicts in his *Art Forms* are the patterns produced by the nose and ear orifices. The ornamentation leads an autonomous existence. It can—as in the case of the fish—become fragmented itself: the fish is no longer discernable, only its scales. Nature appears to be stratified in symmetries. These symmetries are manifest. In beholding animate nature, Haeckel, accordingly, seems to lay open its essence. Seeing—that is, seeing à la mode de l'art nouveau—becomes an act of acquiring knowledge. Haeckel's perception remains determined by a style, which guarantees a certain continuity. Because this modish way of seeing, with its narrow categories, finds confirmation even in the formal organizational peculiarities of such distant deep-sea organisms, it concludes that it is universally valid. It no longer reflects its preconditions, it simply illustrates them: nature appears à la mode.

In this way, the nature of living organisms becomes tangible, it appears as a whole. This is significant, because the view of "nature," which Haeckel is able to incorporate into his own view, became lost at the time in the analytical concepts of physiologists and in the mathematical formulas of physics.

Haeckel, thus, partakes in the tradition of his science. In the 1993 Paris exhibition "L'âme au corps," an entire section was devoted to the history of biological illustrations. Here, one could see that Haeckel was not the first to embody this strange "nature," in particular pictorial forms. The anatomist, who dissects an animal down to its skeleton, was faced with the difficulty of being presented with new structures that could not necessarily be abstracted from his daily surroundings. The depictions of Lamarck's preparations, who brought together a variety of hitherto unknown forms of life—invertebrates as well as vertebrates—are also examples, as well as the illustrations by George Cuvier, who—also in the first decades of the nineteenth century—continually had to invent new names for unknown fossil forms, which he had prepared from limestone rock at Montmartre. However, even these are exponents of a long tradition in which natural scientists created for themselves the methods by which they classified and, if need be, sketched the organisms that could not be described in everyday categories.

What distinguishes Haeckel in this tradition? For one thing, the exquisite quality of his depictions, for another, the subject matter —the diversity of new, hitherto unknown forms, which he presented to a public whom Jules Verne had already informed in his novels decades earlier that the "world" scarcely had any further organisms to conceal. In the final analysis, Haeckel not only captured the interest of his contemporaries with *Art Forms in Nature*, but did so in a way that corresponded to their tastes.

In Jugendstil, a first comprehensive way of seeing, which consciously marked an entire society, was formed. Art Nouveau was fashionable, which not only dictated tastes, but also—as demonstrated by Haeckel—ways of seeing. The possibility of superimposing the "face" of this style on to the natural world was—as described—productive for both sides, for biologists as well as for designers. Haeckel, however, could be sure that his message would be understood. The foreign forms that he demonstrated—filtered through decorative lenses—were no longer foreign to his contemporaries, who were able to assimilate them. People were able to see themselves in this foreignness, their way of seeing

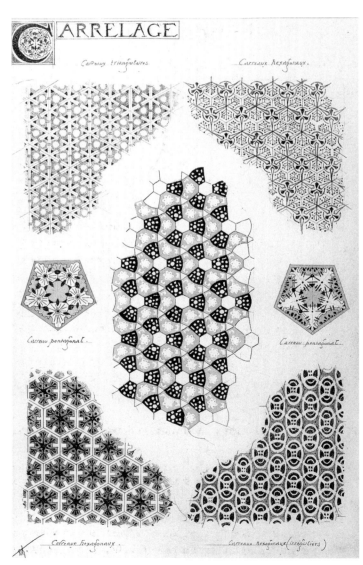

Fig. 9 CARRELAGE. Plate in René Binet's *Esquisses décoratives*, Paris, 1902

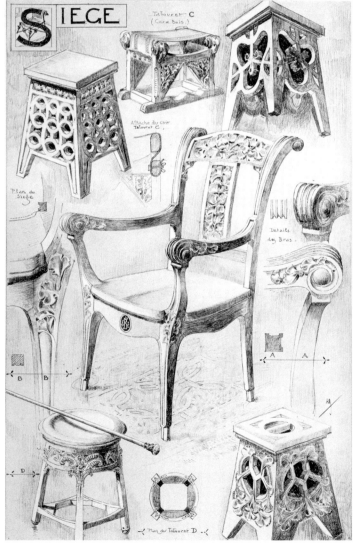

Fig. 10 SIEGE. Plate in René Binet's *Esquisses décoratives*, Paris, 1902

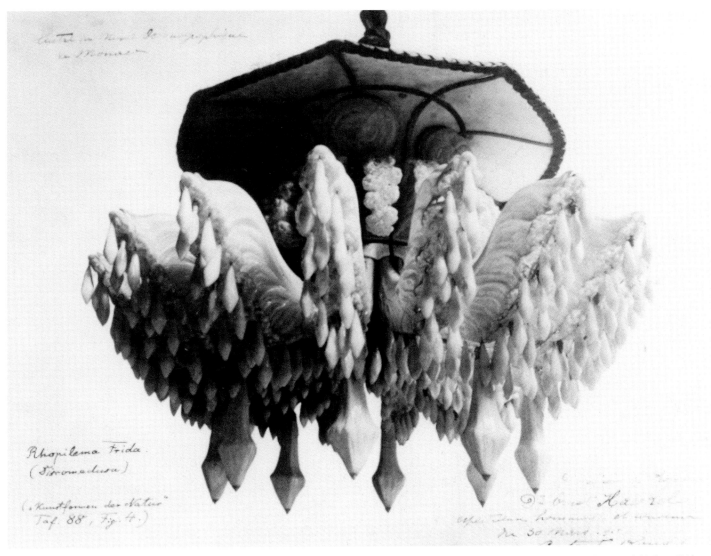

Fig. 11 Glass chandelier in the Oceanographic Museum, Monaco. Designed by Constant Roux, Paris, and modeled after plate 88 in *Kunstformen der Natur* (*Rhipilema frida*)

—and in the style of the avant-garde (Fig. 11). The solution was found in this style, which anathematized that which appeared strange by making it ornamental.

Every symmetry allowed itself to be captured in ornamentation, which was solely concerned with discovering the symmetry of natural forms. Haeckel's illustrations are an attempt to do just this. For this reason, he refrains—for example, with molluscs and with different types of coral—from illustrating the animal in its entirety. He disregards the soft body, in which the organism's blueprint is directly manifested, and examines only non-living growth products (e.g., a snail shell), which "leave" the "actual" animal body while still being attached to it. This is justifiable taxonomically, because, in so doing, he is registering specific characteristics of the animal. These characteristics, these traces are, however, not the animal itself. His vision appears to have been led by the fashionable, and the observer is lured into mistaking his details for the whole of nature.

Viewing Nature

Nature seen as such is approachable. Haeckel brings the utterly foreign into the living room, so to speak. Haeckel was not only influential through his publications, such as *Art Forms in Nature* or *Die Natur*

als Künstlerin (Nature as Artist) of 1913. Of particular importance are Haeckel's writings on and activities in the area of monism as well as popular authors of the time, such as W. Bölsche, who directly and explicitly allied themselves to Haeckel in their literary works. The works presented are comprehensive and in their explicit reference to the scientific foundations as Haeckel had understood them, offer an enormously effective picture of nature. To this extent, the way of viewing nature that followed this concept soon became well established. It seemed to be upheld by wide acceptance. Haeckel's methodical approach ensured understanding amongst laymen. To see nature was, for him, already knowledge.

By these means, Haeckel provided a picture of nature's entirety, which contemporary physics seemed to lose sight of in its formal operations. Contemporary physicists of the time did not strive to gain an overall picture of the world; quite the opposite, they increasingly lost such a view. They were dependent upon recording their findings in formulas and on abstraction, which led them to lose sight of the whole of "nature." A formula is substantiated in and by its mathematical and logical soundness. From it, conclusions are drawn, which lead to conclusive experiments. This enables tests to be devised, allowing statements to be made on the value of a formula. If their validity is proven, further physical postulates can be constructed by means of logical

derivation. However, a physics that functions on this basis has lost its direct link to nature.

With his conception, Haeckel opposes the stringency of formulas. The effect that Haeckel's attempts have had on the development of the modern understanding of nature, in specialized as well as in the overall conception of nature, has not yet been studied. At the end of the development beginning with Haeckel are the animal films by Sielmann and Grzimek's productions, which also show in as detailed a way as possible how it "actually" is in nature. In these examples, the medium used to foster an understanding of nature produces the brightest possible images. Is it then "nature" that is captured here? Does this constitute —rather than in the consequences, much discussed by philosophers of modern physics, for our view of nature—a second strand in the tradition of a scientific conception of the world that has governed twentieth-century attitudes? An important part of this strand is played by the notion that seems to have been relinquished by natural scientists operating in an analytically formal manner: the notion of nature.

Haeckel, it must be noted, did not stand alone. The accounts of his travels, and his *Art Forms in Nature,* represent one of the most popular contributions of his time to this "aestheticization" of nature by a natural scientist. A history of the illustration in textbooks on biology after 1900, which would probably offer more, and more detailed, material on this subject, has, however, not yet been written.

How are we to assess Haeckel's natural aesthetics? Unconsciously, he sought to look beyond his culture, but could only do so from the perspective of that culture. This reveals something further. Haeckel's conception of nature is a conception of culture. His illustrations, even his perception of natural forms, are marked by Art Nouveau. Thus, his vision is not "objective" as he maintained. His vision, but also the way in which he visually conveys notions, are subject to the demands, expectations and dispositions of his time. Accordingly, his *Art Forms in Nature* are such for two main reasons: firstly, because they discover beauty in nature and, secondly, because they structure nature as an artistic form, i.e., according to what is fashionable.

Art Forms in Nature presents "*art-i-facts.*" The illustrations of nature presented here reflect the perceptual culture of Haeckel's day, i.e., the way of seeing of an entire era. The distant world, the foreign, becomes part of the decor in this culture; it seems "controllable." Interestingly enough, it is at precisely this point that the developments in physics and this type of biology converge. Both seem—from completely different perspectives—to control nature.

Moreover, the attempt to aestheticize nature does not confine itself to the biologist. Physicists such as Ernst Mach and Franz Exner began to concern themselves with aesthetic matters around 1900. Around the turn of the century, a temporary cooperation between the arts and sciences seems to have taken place (Breidbach 1997b). A more detailed analysis has not yet been made.

Lambroso's criminal pathology, Eadweard Muybridge's studies of motion, the clinician Jean-Martin Charcot's depictions of his practices as well as Benedetto Croce's and Gustav Theodor Fechner's aesthetic concepts would be discussed in a more comprehensive survey. Only a few of the names can be mentioned here, which stand at the beginning of further avenues of research that were to be explored later.

Art Forms in Nature contains, first and foremost, sumptuous illustrations, which are counted amongst the best pictures of nature ever created by a scientist. What do we find in it? Plates. These plates speak their own language—what Haeckel saw in them is one thing, what we make of them is perhaps another; René Binet and his colleagues, also Max Ernst later, have shown us what they could do with them: form art!

Ernst Haeckel—The Artist in the Scientist

By Irenäus Eibl-Eibesfeldt

Art is the fare of the complete human being; it is a basis for existence, a medium of life and, since art knows no exhaustion, an eternal life without exhaustion. For in art, creativity knows no bounds.

Ernst Fuchs, 1977

When I visited the ocean for the first time twenty-five years ago and, in August 1854, was introduced to the inexhaustible, wonderful world of marine life by my unforgettable master Johannes Müller on Heligoland, nothing exerted such a powerful force of attraction on me amongst the myriad animal forms, of which I had not seen living specimens until then, as the medusae. Never will I forget the delight with which I, as a twenty-year-old student, first observed Tiara and Irene, Chrysaora and Cyanea, and attempted to render with my paintbrush their splendid forms and colors …

With these all but effusive words, Ernst Haeckel (1879) began the introduction of his monograph on the medusae (jellyfish), a work comprising 672 pages, supplemented with a magnificent atlas including 40 plates. However, with the exception of this introduction in which Haeckel expresses his enthusiasm, the lengthy text is essentially dry. Two sides of his nature find expression in this work: the artistically endowed observer impassioned by his subjects' beauty and the objective intermediary of knowledge, level-headed and matter-of-fact. The plates speak for themselves.

Science and art, the highest cultural achievements of humankind, are often mentioned in the same context, as they represent different ways of viewing the world: on the one hand, reason and objective understanding, which, through unbiased observation and experimentation, are employed to investigate the laws of nature that underlie the innumerable manifestations of animate and inanimate nature; on the other hand, the artist, who employs skill and imagination to create works that awaken aesthetic sensibilities in himself and in others. The scientist who, striving for objectivity, seeks to avoid above all else instinctive subjectivity and who, as a discoverer, grapples with the actualities of this world; the artist, who follows his fancy and his feelings, strives to create something entirely new.

In reality, however, scientists and artists rarely embody fundamentally different personality types. Both scientist and artist feel compelled to examine more closely the beauty and the unsolved problems of this world. Moreover, artists are just as curious as scientists. They enjoy experimenting, which enables them to learn astonishing things, for example, about their clientele—to whom they can sell empty picture frames, for instance—the emperor's new suit of clothes, so to speak. They would like to know how their work is effective, what role they should play in society and what, for instance, the worth is of monuments or the splendid facades of buildings that they so skillfully design. Furthermore, both are marked by a strong need to express themselves, though the scientist is primarily concerned with relating knowledge, while the artist appeals to the emotions of his fellow human beings. The artist is not nearly as interested in the number of stamens of a flower as in its beauty, a person's charisma or the atmosphere of a storm-tossed sea. He would like to express his feelings, his vision of the beautiful, the noble, the honorable, the sublime or the horrific. Abstractly and pointedly, he searches for the key to the soul by means of alienation such as exaggeration.

However, as I have stated, the scientist's interests also lie in beauty. He can discover it in the solution to a problem, which strikes him as "elegant." The more insight the natural scientist—or, in this case, the biologist—gains into the workings of organic life, the more the miracle of life fascinates him, beauty being manifest in the smallest living things. Contrary to some claims, knowledge does not disenchant, but, instead, unfolds ever-new miracles before our eyes.

In the final analysis, artists resemble scientists in their endeavor to seek out a better world. They feel beholden to all that is good, truthful and beautiful. And, on their quest for the "final" truth, it is not uncommon for both to lose sight of reality.

Ernst Haeckel was scientist and artist in one. At the beginning of his career he even considered becoming a landscape painter. However, the beauty of organisms led him to science (figures 1–3).

For more than twelve years of his life he dedicated himself to the study of unicellular organisms, or protozoans. In his monograph on radiolarians from Messina he laid the foundations of his studies on protozoans. Twenty-five years later, he published another monograph

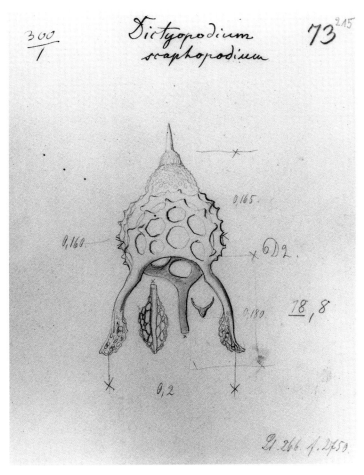

Fig. 1 Haeckel's drawing of the radiolarian *Dictypodium scaphopodium*

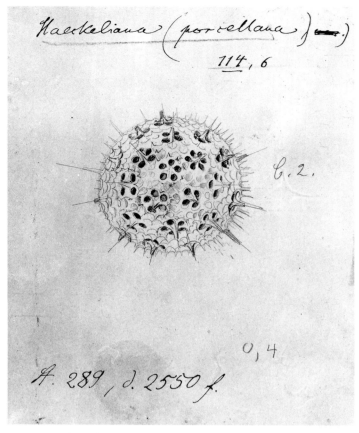

Haeckeliana (porzellana)

114, 6

6, 2.

0, 4

A. 289, d. 2550 f.

Fig. 2 Haeckel's drawing of the radiolarian *Haeckeliana porzellana*

the front, which they decorate with moss, fruits, snail shells, flowers and brightly colored beetles. They insert the flowers into a moss structure created just for this purpose. Heinz Sielmann, who observed and filmed this activity, saw how a male stepped back, after inserting a flower, to scrutinize his work. Apparently he was not particularly satisfied with it because afterwards he pulled the flower out and stuck it back in somewhat differently. When we arrange flowers according to our personal taste, our behavior resembles that of the crestless gardeners. Both are examples of manipulating objects in the environment for aesthetic ends.

However, the extraordinary radiolarians that Haeckel describes turn neither to their own kind nor to us with their appearance, which thanks to our microscopes we are able to see in all its plastic splendor. The exquisite skeletal forms are not works of art, but instead serve as protection, while the long, ray-like projections act as flotation devices, increasing the body surface area, and thus the buoyancy of these tiny creatures. Groups of contractile molecules, which attach themselves to the spicules, allow the surface area of the internal soft body to be varied, enabling the buoyancy to be actively regulated.

As observers, we find the radiolarians beautiful. However, there are reasons for this, which have nothing to do with these organisms, but, instead, are based solely on the manner in which our perceptual mechanism functions.

Our sensory organs and central nervous system are, as the result of evolutionary development, genetically programmed to recognize

on the radiolarians collected on the deep-sea English Challenger expedition. He described over 4,000 different species, extolling the "fantastic treasures of radiolarians" that were unearthed from the depths of the ocean on this expedition. A selection of these treasures is presented in this volume—a new edition of Haeckel's *Art Forms in Nature*. And what we see is indeed astonishing. The delicately perforated enclosing shell made of silica, and often protected by spicules, occurs in an inconceivable diversity of forms.

In the face of such impressive diversity we might ask: What laws of nature are being expressed here? What led to this great diversity of form? What function does it fulfill? And what is it that makes these organisms so exhilaratingly beautiful? Haeckel maintained that nature works here much like an artist, and even postulated that protoplasm has an inherent "artistic drive" (E. Haeckel 1913).

Naturally, we see this differently today. Works of art made by human hands are devoted to the service of communication. The artist turns to his fellow human beings with his works, be it for their moral improvement or instruction.

There are things in the animal kingdom that we find aesthetically appealing, such as the ornamental feathers of the humming bird or the bright colors of coral fish. These features serve as signals in intra-specific communication. However, these signaling features are innate in these creatures, without the latter having to create them. An interesting exception are the bowerbirds of Australia and New Guinea, in which the males, for mating purposes, build bowers with twigs, which each species decorates characteristically. Satin bowerbirds, for example, color their arbors with chewed berries, which they apply by combining with saliva. The males of the crestless gardeners (another species of bower-bird) build around a shoot a tent-like construction with an opening at

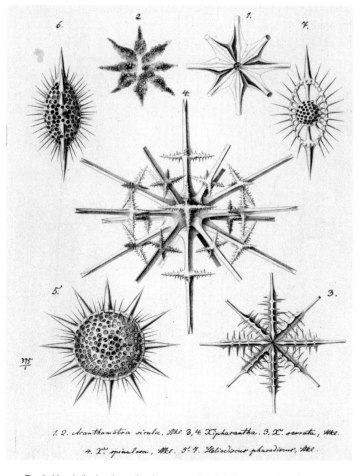

Fig. 3 Haeckel's drawings of various types of radiolarians: 1–2: *Acanthometra sicula*, 3: *Xipharantha serrata*, 4: *Xipharantha spinulosa*, 5–7: *Heliodiscus phacodiscus*

regularity, and hence order. The world must be predictable for an organism or else it is not capable of living in it. In our environment there are recurring, hence recognizable, objects and creatures that must be perceived as obstacles; it is a matter of survival to be able to recognize useful plants or the intentions of, say, predators, game and, ultimately, those of our fellow human beings.

That such regularities exist and can be detected is a primary hypothesis on which our existence is based. In fact, we are constructed in such a way that we expect them. When an expectation is fulfilled, we derive pleasure from its discovery. This, among other things, is what the aesthetic stimulus of the "searching image," and the delight in discovering it in the hidden figure, are based upon. Our sensory perception is actively on the lookout for things that can be formally registered. Gestalt psychologists discovered this quite early on. If we have perceived and recognized something, our perception often asks whether there is anything else to discover, disengaging from what has just been perceived. This occurs particularly with images that allow for various possible interpretations.

All edges of the Necker cube are delineated in such a way that both sides appearing as squares, which one can perceive as being either at the back or the front, are the same size and both laterally and vertically offset from each other. If one fixes one's eyes upon the image of the cube, at first one of these surfaces seems to represent the front of the cube; however, after about three seconds, the image reverses and what we had interpreted as being the front side of the cube now becomes the back. With patterned surfaces, which allow for many interpretive possibilities, we perceive numerous fluctuations, or reversals, of the interpreted pattern at three-second intervals. Owing to this autonomous process of interpretation, the surface appears to alternate between the various interpretative possibilities (figures 4 and 5).

We seek order. The gestalt psychologist Wolfgang Metzger (1936) spoke in this connection of a love of order of the senses. Corresponding to a love of order of the sense of sight are figures that stand out against a background and that are distinguished as forms by clearly recognizable levels and axes of symmetry. This is one reason why we find crystals,

or certain types of organisms, so beautiful, whether they are bilaterally or radially symmetrical. This is also why coarse, brightly colored pieces of glass are construed as being beautiful when reflected as six-pointed stars in the angled mirrors of a kaleidoscope. Haeckel discusses these "ideal basic forms" in his *Generelle Morphologie der Organismen* (E. Haeckel 1866).

Fig. 5 When looking at this image, we perceive a change in pattern at approximately three-second intervals. In its search for order, our perception structures what it perceives and interprets the perceived image in various ways (reproduced from D. Marr 1982).

Our perceptual mechanism operates in such a way that incoming sensory information from the sensory organ is processed in several stages in the central nervous system. Owing to the particular "circuitry" of the nerve cells of the retina, for instance, and of the subsequent processing of the sensory information in the central nervous system, it is initially effected that it is only the relative differences in brightness, not the absolute intensity of light, that determine what we see. A piece of coal appears black to us, regardless of whether we see it in bright sunlight or in a darkened room; correspondingly, a piece of paper will be perceived as white under the same lighting conditions. The eye does not allow itself to be fooled, regardless of whether the coal reflects more light in the sun than does the piece of paper under poor lighting conditions.

The "circuitry" of our retinal cells also effects a physiological interaction of receptive fields, which are activated either solely by light (so-called "on systems") or by darkness ("off systems"). This causes a mutual inhibition effect which intensifies the contrast of the light-dark borders and of the light-dark contrasts of an object's surfaces. We therefore see light shapes against a dark background as being lighter, and dark shapes against a light background as being darker, than if we were to observe these same shapes without the backgrounds. This helps us to distinguish the figure from the background.

The recognition of an object seen against a background is also prompted by certain "assumptions" that are built into our perceptual mechanism. It is for this reason that our perception automatically assumes that objects defined as being smaller move against a motionless background. This hypothesis enables us to identify and react quickly to game as well as to predators without long deliberation. This ability, however, can also lead to misinterpretations. If, for instance, we look at the moon on a cloudy moonlit night, we appear to see the moon moving across the clouds. Even though we know that this cannot be the case, since it is the clouds that are being blown along by the wind, it still does not prevent us from being temporarily deceived by this

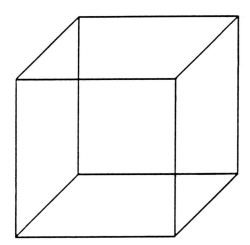

Fig. 4 Our reaction to the Necker cube —an image that can be visually interpreted in two ways—bears testimony to the actively searching nature of our perception. When we first look at the cube, we perceive one of the sides appearing as squares to be the front of the cube. However, after three seconds (the so-called Pöppel constant), the image appears to reverse, so that what we had taken to be the front side of the cube becomes the back and vice versa. This phenomenon is the result of our perception's automatic reaction to disengage from the initial impression and to question in a sense anew whether there is anything else to be seen.

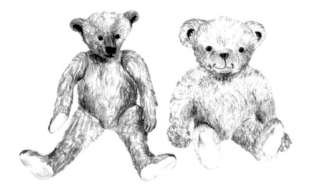

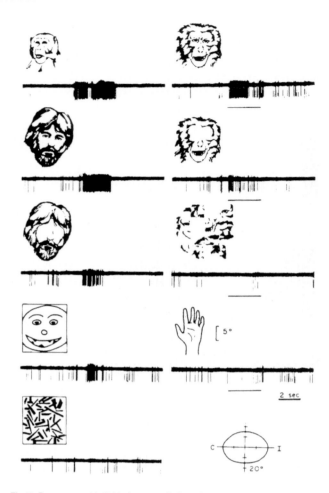

Fig. 6 Examples of the first teddy bears ever produced: on the left (made by the Steiff company in 1905–06) the original, on the right, the more "evolved" version, in which the legs and arms have been shortened, the head and body are rounder and the face more closely resembles that of a baby (reproduced from C. Sütterlin 1993).

illusion. And who has not had the impression, while on a train that has stopped at a railway station, that it is moving when, in reality, it is the train on the next track that is in motion. But our perceptual mechanism does not believe that the scene filling our entire field of vision is moving away from us. Instead, it concludes that we ourselves are moving.

Perceptual experiences of this kind presuppose the existence of specific neural networks that serve the central nervous system as reference patterns. Knowledge on the meaning of certain perceptions is neurally encoded in these; thus expectations are preprogrammed. The incoming information from the sensory organ is compared with these reference patterns, and, if it corresponds to certain expectations, then certain patterns of behavior tend to be triggered. However, an investigative behavior may be discontinued when an expected condition is attained. Konrad Lorenz spoke of innate schemata; the word 'templates' has become a commonly used term for these in English.

Knowledge of characteristics of an animal's own species or, specifically, of potential rivals or mates as well as of the significance of certain trigger stimuli (or "releasers") triggering an offer of assistance, courtship behavior, a contest or an escape can be contained in these reference patterns. Their existence has also been proven in humans and they underlie many of our judgements. That we classify something as beautiful, ugly, frightening, disgusting, exciting or otherwise interesting is based, among other things, on biases incorporated into these innate schemata. The neuronal structures that underlie these patterns grow during embryonic development and childhood until functional maturity has been reached. Others develop through learning processes, on the basis of individual experiences as well as those passed on culturally. It is not uncommon for these reference patterns to be subject to further specification and differentiation through individual learning processes. Perhaps the best-known example for this is the "baby schema" described by Konrad Lorenz. Infants and small children are distinguished by a comparatively large head and short extremities in relation to the rest of the body, as well as by rounded bodily contours. In addition, the cranium dominates over the facial bones, so that the forehead, bulging slightly forwards, protrudes over the face. The toy industry presents these features in an exaggerated form. In a "trial-and-error" learning process, teddy bears became ever cuter, in that the extremities became shorter and the head, with a pronounced forehead, became larger (figure 6).

The human face is a crucial reference surface in human communication. When we hold a conversation with another person, we observe

Fig. 7 Responses of individual nerve cells from the temporal cortex of a rhesus monkey. This diagram shows the visual patterns of stimuli shown to a rhesus monkey and, below them, the corresponding neuronal responses. Every dash represents a nerve impulse. The monkey's response to facial stimuli is particularly striking. Faces of monkeys with eyes triggered the strongest responses. Faces with eyes missing resulted in considerably fewer nerve impulses, though more than a scrambled face of a monkey, a hand or an irregular configuration of lines. In contrary, the highly schematized face resulted in strong responses (see G. G. Gross, et al 1981).

their face and read from its changing expressions whether the person is favorably or unfavorably disposed towards us. Our facial expressions, with the help of which we often entirely unconsciously signal a particular mood, are essentially innate. Around the world people smile, laugh and cry in a way that we can readily understand—as do those born deaf and dumb, even though they could not have learned such behavior just by watching others.

If we consider the important role the face plays in human communication, it is not surprising that, in both apes and humans, there is a special region of the brain that serves facial recognition (figure 7). Even new-born infants attentively study schematized pictures of faces, which consist merely of two squares for the eyes and a square for the mouth, centrally located below the eyes within an oval for the face, which is delineated by a single line. In contrast, the infants pay considerably less attention to another version, placed next to the first, which is like the first, only turned upside-down so that the "mouth" is above the eyes (figure 8) (E. Valenza et al 1996). In order to resemble a facial schema, the eyes and mouth must stand in a certain relation to one another. Our ability to recognize a face appears to be determined by innate neuronal reference patterns. Humans possess yet another region of the brain, which is specialized for the recognition of individual faces. If the function of this region is terminated due to illness or accident,

the afflicted person is no longer able to recognize people he used to know by their face. He is, however, able to recognize faces as such, but can only recognize a person when the latter speaks. This phenomenon is called prosopagnosia.

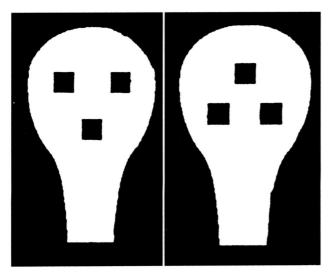

Fig. 8 The new-born infants to whom these highly schematized "faces" were shown spent considerably less time studying the image on the right, in which the squares representing eyes and a mouth have been turned upside-down so that the mouth appears above the eyes (reproduced from E. Valenza, et al, 1996).

In Europe, certain generally accepted ideals of beauty exist with regard to faces of adults. A high forehead, somewhat receding facial bones below the cranium with only slight prognathism, a not too large mouth and a fine bridge of the nose are all considered to be marks of beauty. These are so-called paedomorphic features, which are more pronounced in women than in men. We find the associated tendency to attribute qualities of gracefulness to these features in other geographic ecotypes as well, although the general ideal of beauty is overlaid by the ecotypical ideal. In experiments, test subjects found computer-generated composite (averaged) images of faces more attractive than the many individual faces, from which the composite images were generated.

Judith Langlois and L. A. Rogman (1990), who conducted this experiment, postulate the existence of "beauty detectors." They found that three one-month-old babies looked longer at pictures that were judged as beautiful by adult test subjects, than at those considered "unattractive." They concluded, therefore, that there is an innate reference pattern, which underlies the different degrees of attention.

V. S. Johnston and M. Franklin (1993) asked students to generate an ideal face of a beautiful woman with the aid of a computer program in several stages. They developed a face which strongly resembled the average face of the population in which they lived, but which was characterized by more child-like features (figures 9 and 10).

The adult human body is also characterized by sex-specific features, which we find attractive or noble. Moreover, our anthropomorphizing aesthetic sense of judgement evaluates animals according to the same predetermined standards that we apply to our fellow human beings. The muscular but slender gazelle strikes us as noble and graceful —however, this is not the case with the plump hippopotamus.

An aesthetic prejudice of a particular kind is exemplified in our positive valuation of plants—otherwise known as phytophilia (I. Eibl-Eibesfeldt and H. Hass 1985). Vegetation is generally pleasing to the

human eye, and this predilection is not confined to trees and herbs in flower. Where there is a dearth of greenery, such as in an urban neighborhood, we decorate our homes with "substitute" nature. Ferns, rubber plants, philodendrons and poinsettias fill our rooms, and we take delight in their growth. However, we bring plants not only into our homes, but also decorate them with curtains and wallpaper bearing plant decor. How did this preference come about? It most likely reflects an archaic, aesthetic imprinting. Our Paleolithic ancestors found everything they needed to live in areas where plants grew. Plants thus became indicators of habitats that sustain human survival. Natural selection bred on aesthetic preference for plants, which contributes to the determination of our choice of biotope. Carl Gustav Jung spoke of an "archetypal model."

In a similar way, an aesthetic preference for a certain type of landscape is also predetermined in us. Around the world, parks have a relatively similar design: trees stand alone or in small groups, between which one can enjoy unobstructed views across open greens. Rocks and individual bushes are decoratively interspersed while streams and ponds, inhabited by water-fowl, enliven this "ideal landscape" that reminds one of the savannah in which human beings evolved. Life in this landscape must have impressed features of this "primordial home" to humankind on our ancestors (G.H. Orians 1980). By means of natural selection, this preprogrammed aesthetic preference has persisted until today en-

Fig. 9 Differences in proportions and facial features (in particular, the mouth and lips) of the composite "ideal" beauty and the average image of the Caucasian female student populations in New Mexico, with whom Johnston and Franklin carried out their experiment.

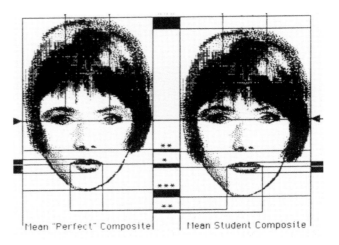

Fig. 10 The composite on the left was rated as being the most beautiful; the one on the right bears the same characteristics but with the proportions of an "average" face of the population (reproduced from V.S. Johnston and M. Franklin 1993).

coded neurally in innate reference patterns. In this context, a remarkable study was recently carried out by E. Synek (1998) in which pre-pubescent children clearly demonstrated a preference for the savannah. Later—as a result of being raised in a particular environment—a secondarily developed preference for a landscape type characteristic of their home overlaid the first. This preference is emotion-based, bonding a person to his native place, and is lasting. This may be an imprint-like fixation similar to that of imprinting (figures 11 and 12).

In 1935 Konrad Lorenz discovered that imprinting is a learning process for which, in the development of an animal, a time window is kept open. In this impressionable period, that which is learned is never forgotten. It is an innate reaction of young chicks to run after any object that emits alluring rhythmic sounds, regardless of what kind. They will also run after balls that produce whistling noises. If they do this

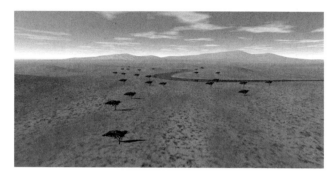

Fig. 11 The landscape type preferred by prepubescent test subjects is characterized by very few trees and hills. It represents the archetype of the savannah landscape in which human beings evolved.

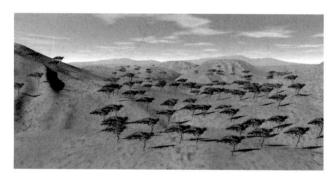

Fig. 12 Of the six photographs from which the test subjects could choose, this picture, which illustrates the most trees and hills, was selected by the post-pubescent group. It may be presumed that such a preference is a reflection of the landscape in which these test subjects grew up, in this case Austria's mountainous and wooded countryside. The six pictures shown in the test showed a transition of landscape types between that shown in figure 11 and that shown here. The prepubescent group preferred the first picture in this series (figure 11), whereas the post-pubescent group preferred the last (reproduced from Synek 1998).

shortly after hatching, they will continue to do so in the future without altering their object preference. In the meantime, we know the neuronal process responsible for this irreversible imprinting. With inexperienced chicks, the dendrites, or branches, which conduct messages from the periphery to the neurons that process audible stimuli are characterized by numerous synaptic connections with other nerve cells, which resemble thorn-like projections that can be counted. After an imprinting of a pure tone, most of the "ears" of the neurons become eliminated. The nerve cells have now been "tuned" to a very particular quality of stimulus (E. Wallhäuser and H. Scheich 1987). The reference

pattern that determines our aesthetic preferences can depend upon the development of the individual, although fixations similar to imprinting and alterable tastes induced by fashion may also be observed.

But, does all this help us understand why we find radiolarians and jellyfish beautiful—organisms with which we as land-bound beings normally have nothing to do? In which of the schemata developed by us as adaptations do they fit and which reference patterns are addressed?

In a letter dated January 27, 1867, written from Lanzarote, Italy, to his parents, Haeckel describes a siphonophore:

> Imagine a delicate, slender flowering whose leaves and brightly colored flowers are transparent like glass, and which meanders through the water with the most graceful and sprightly movements, and you have an idea of these delightful, beautiful and delicate examples of animal finery.

Similarly, zoologist W. Breitenbach commented in a book about these creatures, published together with Haeckel (1913):

> When a jellyfish such as this ... floats on the surface of the calm ocean of warmer climes, it resembles a swimming flowering plant whose leaves, tendrils, flowers and fruits look as though they were made of vivid, brightly colored, transparent crystal. The forms of the individual parts are extraordinarily delicate and often so fragile and transparent that, in the seawater they can scarcely be made out, much like a breath or a fog ... Nature has scarcely produced anything so fragile and splendid in color as these wonderful creatures.... To laymen and inlanders, these daughters of the ocean seem mysterious and fantastic, and they do not really know what to make of them.
>
> (W. Breitenbach in E. Haeckel 1913, p. 62)

Both statements indicate that it is our phytophilous "organ" that is at work here—that central reference pattern into which our aesthetic predilection for plants is incorporated. However, something else is expressed in Breitenbach's description: delicacy and complexity as well as the mystery of the fantastic. The organic degree of differentiation of an organism plays an important role not only in our assessment of how beautiful or interesting we find it, but also in our classification of it on a scale of values ranging from "high" to "low." We cannot help but rate a bird as being aesthetically superior to a sea cucumber, the complex makeup of which, even beauty, we discover only upon closer examination. As an oblong, sausage-like shape, at home on the sandy ocean floor, it looks downright unsightly. Our general impression of the siphonophore, about which Breitenbach enthuses, is that it is much more differentiated, and hence more beautiful, despite the fact that its entire structure is actually more primitively organized than that of the sea cucumber. We discern order in the rows of tentacles, in the series of polyps specialized for various tasks, in their symmetry; and at the same time, it looks unbelievably complex—being a "higher" organism. And because it is also new and foreign, it piques our interest, our curiosity.

Our higher valuation of differentiation compared to that of a lack of differentiation also leads to our negative valuation of a secondary loss of differentiation (i.e., involution). There is a type of crustacean (*Sacculina*) that grows through the body of its host, a crab, as a parasitic, root-like network of suction tubes. As a larva, it swims equipped with legs and sensory organs, thus qualifying it as a higher organism. However, once it attaches itself to the host, it discards all these signs of differentiation. What remains is a finely branched, tube-like creature

that grows through the host's body and that essentially consists of genital glands. A similar loss of differentiation in body and behavior occurs, albeit somewhat less dramatically, in some races of household pets—in contrast to their wild counterparts—which we also value negatively.

On a cultural level, we treasure the diversity of human cultures. This cultural legacy is presently endangered by the worldwide tendency towards homogenization in all spheres of life. This smoothing out of all differences is detrimental. Time will tell to what extent our positive valuation of diversity can protect us from such developments. As a species we consciously reflect nature in more facets than any other species has done before us. Through human beings, nature, in a sense, become conscious of itself for the first time. Space, with its billions of stars and planets, is surely indifferent to this, but opportunities consciously to deepen our understanding open up to us, which we should foster. We should therefore promote our positive valuation of differentiation and diversity through education, as it can protect us from involutive developments.

At length, Breitenbach's eulogy on the beauty of the jellyfish addresses the mystery of the fantastic, and touches upon human curiosity, which is also the fundamental motivation underlying all research. Whenever we discover something new, be it a hitherto unknown animal, a new species of plant or even a new causal relationship, it is accompanied by well-nigh euphoric sentiments. For a scientist, the discovery of regularities, through which the impenetrable becomes transparent, is an aesthetic experience of a particular kind—an intellectual victory. It enables us to better understand the world. The curiosity that also inspires us to seek out beauty in all its variations is reflected in the markets that also live from this urge: radio, television, the media and tourism. They drive us to active investigation. Higher mammals are particularly curious and playful in their youth. Humans remain this way until old age, thus staying at least mentally young.

If we immerse ourselves in the plates of Haeckel's *Art Forms*, we are first captivated by the wealth of creatures that we have never seen

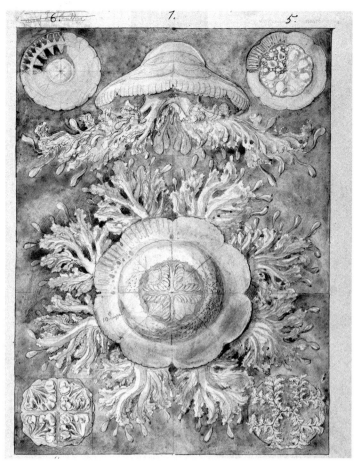

Fig. 13 This depiction of a jellyfish, with the scientific name of *Toreuma bellagemma*, is the original work that was reproduced as plate 28 in *Kunstformen der Natur*.

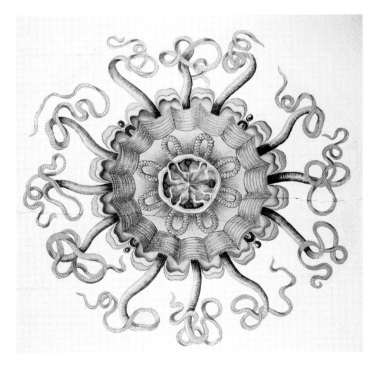
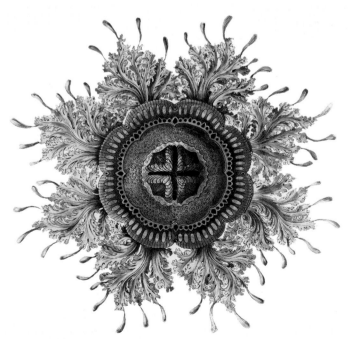

Figs. 14 and 15 Jellyfish as ceiling decor in Haeckel's former home, the "Villa Medusa"

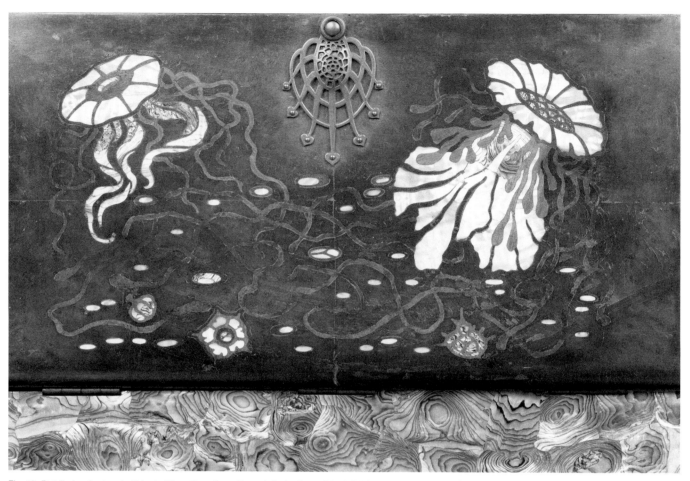

Fig. 16 Detail of a chest embellished with mother-of-pearl intarsia in the form of the jellyfish *Desmonema annasethe* HAECKEL. In her memory, Haeckel dedicated this particularly beautiful jellyfish to his first wife Anna Sethe.

before. Our searching gaze wanders and discovers ever-new details and patterns of order, both on the level of the entire organism as well as in its constituent parts. The organisms are beautiful in their reflection, in their various levels of symmetry and their spatial orientation on various axes. Thanks to Haeckel, we are able to behold the filigree forms of radiolarians, diatoms, desmids, foraminifers and dinoflagellates.

The diversity and degree of differentiation of the skeletal forms of radiolarians are particularly astonishing. Is this an expression of different adaptations to different ecological niches? I have already expressed my doubt since all coexist as free-floating plankton in the same oceans, many of these diverse species even at the same depths. With respect to their skeletons, all of them seem equally capable of survival. Their diversity would then seem to be an expression of these organisms' high capability of mutation. And that which does no damage remains. Not everything fulfills a function. Bernd Lötsch (1991) aptly pointed out: "Nature does not create like an engineer, but, instead, like a playful artist."

In all their colorfulness, some of the striking marine organisms look the way they do in order to signalize to others that they are unpalatable, that it is not worth catching them. This applies to certain snails of the taxonomic order *Nudobranchia*, which feed on stinging polyps that they ingest without breaking open their stinging capsules. Unharmed, they transport these stolen stinging capsules (kleptocnides) as brightly colored projections on their backs, where they grow and serve the new owner as weapons of defense. Should an inquisitive fish dare to catch such a snail, it will quickly spit it out and, it can be certain, will never attempt to eat another one of these colorful creatures again.

Ultimately, however, other snails and perhaps even worms resembling the *Nudobranchia* snails in color and form, but which are not equipped with stolen stinging capsules, may profit from this.

It is certainly worth reading about the various organisms illustrated as art forms in nature in this volume, such as the frogs caring for their brood, by carrying the tadpoles on their backs to another pond when their own has dried up, or alligator snapping turtles, which lie well-camouflaged under water with open mouths, the narrow, worm-like tips of their tongues making dancing movements in the water. This serves to attract fish that mistake the tongue for a worm and end up landing in the mouths of these tortoises.

Ernst Haeckel was both artist and scientist. Together with the lithographer Adolf Giltsch, he artistically rendered what he beheld — in individual depictions of organisms and their placement in relation to one other in the plates. Critics reproached Haeckel for artistically enhancing his subjects in these aesthetically appealing works. Of this, there can be no doubt. This nonetheless does not detract from the scientific value of the depictions, since this remains unaltered in this respect. The artistic embellishment enriches the depictions, as it invites the eye to linger, holds our attention, puts us in a reflective mood and delights the eye. When observing them, we are struck with awe — something that we should not forget. There is nothing wrong with conveying all of this—one simply must possess the skills to do so.

Ernst Haeckel was without doubt a master in this respect. The first three illustrations of this work are ample evidence of his artistic and creative talents, which are reflected both in the sketches as well as in

the plates prepared for printing. In addition, we may consider here the plate of the jellyfish *Toreuma bellagemma* (figure 13). The illustration of the jellyfish is artistic-ornamental, while being morphologically flawless. It served as a basis for plate 28 of *Art Forms in Nature* and so invites comparison with the lithographic execution by Adolf Giltsch.

Haeckel also used this illustration as the basis for a ceiling ornament in the dining room of his former home. Further examples of the use of the jellyfish motif as ceiling decor are shown in figures 14 and 15. On the occasion of his eightieth birthday, Haeckel received a wooden chest form the German Association of Monists, which was embellished with mother-of-pearl intarsia of the jellyfish *Desmonema annasethe*, the same jellyfish that Haeckel had dedicated to his first wife (figure 16). Haeckel's illustrations inspired many artists of the time. The Paris architect René Binet used a radiolarian as the basis for the monumental entrance gate for the Paris World Exposition in 1900 (figure 17), while in his work *Esquisses décoratives* we find many features that were inspired by Haeckel. As an example, a plate of his rings from this work are shown in figure 18; Olaf Breidbach gives further examples in his contribution to this new edition of Haeckel's *Art Forms*. In this context, the reader is referred to the publication by Erika Krauße (1995), in which Haeckel's aesthetic theory and its consequences are discussed in detail.

As a scientist and a professor, Haeckel was a pioneer of many things. He was a catalyst in the breakthrough of Darwin's theory of natural selection, hence the theory of evolution, on the Continent, and had an edifying effect on popular thought through his writings. His evaluation of Immanuel Kant's theses is of great importance. Kant claimed that only part of our knowledge is based on empirical experience and is therefore acquired *a posteriori*—after experience. He held, nonetheless, that a considerable part is based on the final faculty of pure *a priori*

reason—before all experience—and is therefore independent thereof. Haeckel countered Kant's dualistic theory of cognition in his "Biological Theory of Cognition." What Kant classified as *a priori* knowledge, Haeckel explained in terms of *a posteriori* phylogenetically developed cognitive capacity. It is the phylogenically developed brain, thus the inherited cerebral structures, that enables us to make *a priori* judgements prior to the acquisition of individual experience. Thus, Haeckel is actually the founder of the so-called "Biological Theory of Cognition," which was further developed by Konrad Lorenz and Karl Popper and which later fell into obscurity.

I would like to cite Haeckel here. He writes:

Purely speculative metaphysics, which were further developed from theories of apriorism established by Kant and which found its most radical advocate in Hegel, ultimately led to the utter rejection of empiricism and claimed that all knowledge is in fact acquired through pure reason, independent of all experience. Kant's great mistake, which had such serious consequences for all of philosophy that followed, largely lies in the fact that his critical "Theory of Cognition" did not take into account physiological and phylogenetic principles which were only acquired sixty years after his death through Darwin's reform of the theory of evolution and through the discoveries of the physiology of the brain. He regarded the human soul with its inborn characteristics of reason as a ready-made being and did not inquire into its historical origins ... he did not consider that this soul could have developed phylogenetically from the most closely related mammals. However, the wonderful ability to make *a priori* judgements has arisen through the inheritance of cerebral structures, which the vertebrate ancestors of humans acquired slowly and in stages (through adaptation and synthetic association of *a posteriori* experiences and perceptions). Moreover,

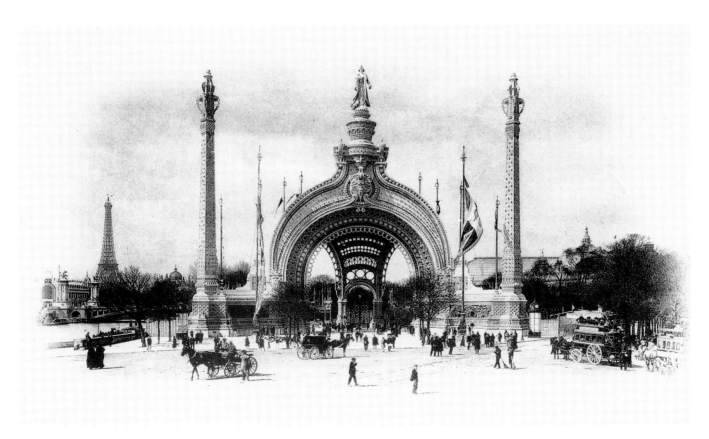

Fig. 17 René Binet modeled his monumental entrance gate to the Paris World Exposition in 1900 on one of Haeckel's drawings of radiolarians.

the firmly established perceptions of mathematics and physics, which Kant explained as synthetic *a priori* judgements, originated by means of the phyletic development of the faculty of judgement and may be traced back to continually recurring *a posteriori* experiences and conclusions based thereupon. The "necessity," which Kant ascribed to a particular characteristic of these *a priori* judgements, would be applicable to all other judgements were these phenomena and their conditions fully known.

(E. Haeckel 1904, p. 5)

Near the end of his book entitled *The Miracle of Life* (*Die Lebenswunder*) Haeckel again discusses these points.

Our human knowledge is undoubtedly limited: certain limits are inherent in our knowledge of truth owing to the innate (inherited from a series of primate ancestors!) organization of our brain and to our sensory organs. Kant was indeed correct in his critical theory of cognition in that we are only ever able to perceive the appearance of things, not their innermost, unknown nature, which he describes as the "object in itself." He is nonetheless mistaken and misleads our conception of nature when he thus questions the reality of the outside world and maintains that it only exists in our imaginations! —in other words, that "life is but a dream."

(E. Haeckel 1904, p. 182)

Fig. 18 ANNEAU. Plate with rings, as reproduced in René Binet's *Esquisses décoratives*, Paris, 1902

Many years ago, the American zoologist Gaylord Simpson countered those who doubted the reality, of an "outside world" by saying that the ape that did not recognize the correct representation of the branch it intended to jump to, was not one of our ancestors.

Our perception as well as other adaptations reflect suitably relevant facets of a reality so well, in fact, that today we can send probes into space, which even land where we want them to. It has once again become fashionable to doubt the degree to which reality can be investigated, indeed to doubt reality itself. Repressive wishes underlie this trend. Some would like to block out reality where it inconveniently stands in the way of ideologically based utopias: this particularly applies to the field of human behavioral biology. Empirically derived knowledge is construed as a construction, thus as one detached view amongst many possible ways of seeing the world. Hubert Markl (1986) aptly remarked that he who does not wish to perceive reality has already failed to do so. Moreover, the qualifying of Beuys' rather provocative statement "everything is art and everyone is an artist" can be seen in this context. In the foreword to Walter Schurian's book *Austrian Painting after 1945*, Hubert Christian Ehalt wrote: "In former times it was handicraft skills that were learned and practiced with such perseverance; now a constant flow of new ideas and discourses is what constitutes the work of art. In this way, the arts are detaching themselves ever further from traditions and solid criteria, on which there is a consensus; they have become more closely bound to context and time. One might ask pointedly whether—when the idea of these context-related works is outmoded—a storeroom of materials and an intellectual history of discourse is all that will remain." (in W. Schurian 1997, p. 10)

I wonder whether there is not more behind this development. Despite the fact that all times have witnessed frauds that find their market, and in our uncertain times, when one sometimes only needs to be clever or shameless to find an art market, I wonder whether the changes in the visual environment in which many people grow up today also play a role in the development of contemporary tastes.

Few children today experience the wonder of how caterpillars pupate and turn into butterflies. They can no longer watch how dragonfly larvae come out of the water and climb up reeds and how the adult dragonfly emerges from its back. Seldom can they lie on their backs in a fragrant meadow on a sunny, early summer day, when the marguerites and sage are in bloom, to dream about the swallows that describe a course high up in the blue sky, to watch beetles crawl along the blades of grass, the swarm of insects on the white spread of blossoms and the bumblebees and other bees in eager search for honey. Is it not possible that the aesthetic sensibilities of people who have grown up in what many would find ugly, artificial environments of the industrial fringes of modern metropolises, have also been altered as a result of such new environments? If this were so, would it not explain, at least in part, the acceptance of assemblages made from found objects and other ignoble materials? It cannot be denied that as a consequence of this development, the feeling for the beauty of nature diminishes and is accompanied by a breakdown of values, which threatens our relationship to nature and thus the preservation of the community of life so vital for our survival.

It is not so that art should only present us with the beautiful. With his depictions of the atrocities of war, Goya holds a mirror before us that awakens horror. And that artists experiment and seek the key to all our inspirations of the soul, that they want to discover what it is that we find ugly, that they want to provoke—all these are legitimate

fields of experimentation. But the important educational and pacifying value of beauty should not, as a result, sink into oblivion.

We are a tremendously successful species, which, just in this century, has pressed forward from the mechanical to the electronic age, and which has made its first trips into space; today, with some 6 billion people, we populate the last inhabitable corners of the earth. With our great numbers, equipped with modern technical means, we are in the process of destroying our environment, thus our basis for existence. We must adopt a survival ethos that not only takes into account our future, but also that of our grandchildren. The need to develop such a survival ethos—to think ahead for future generations and to evaluate the consequences of our present actions—is obvious to us on a rational level; however, the practical implementation of this knowledge will be inevitably impeded by our fatal drive to take part in the rat race of the here and now (I. Eibl-Eibesfeldt 1996). Those who have not experienced nature in all its beauty, and therefore have not developed feelings of respect for it, will be more likely to pursue their own shortsighted interests according to the principle "after us the deluge," without regard for nature or grandchildren. This can be counteracted by information and explanation, on the one hand, and by creating an aesthetically informed consciousness of the beauties of organic nature, on the other. The new edition of *Art Forms in Nature* makes an important contribution to this. It is a sign of awareness in times of such uncertain values —a prelude to the coming millennium that inspires confidence.

Bibliography

Binet, R. *Esquisses décoratives*. Paris, 1902.

Brauer, A. *Das Runde fliegt: Texte, Lieder, Bilder*. Munich, 1983.

Bowler, P. J. *Evolution: The History of an Idea*. Berkeley, Los Angeles and London, 1989.

Breidbach, O. "Entphysiologisierte Morphologie — Vergleichende Entwicklungsbiologie in der Nachfolge Haeckels." *Theory in Biosciences* 116, (1997a), pp. 328–48.
ed. *Natur der Ästhetik – Ästhetik der Natur*. Vienna, 1997b.

Clair, J., ed. *L'Ame au corps: Arts et sciences, 1793–1993*. Paris, *1993*.

Ehalt, C. Foreword in W. Schurian. *Österreichische Malerei nach 1945*. Vienna, 1997.

Eibl-Eibesfeldt, I. "Die Falle des Kurzzeitdenkens: Das Thema Vergänglichkeit und Bestand in Wissenschaft und Kunst." In E. Pöppel and M. Kerner, eds. *Zeit und Mensch*. Aachen, Leipzig and Paris, 1996, pp. 89–97.
Die Biologie des menschlichen Verhaltens – Grundriß der Humanethologie. Munich, 1984 (2nd edn., 1986; 3rd edn., 1995; Weyarn, 4th edn., 1997).
H. Hass. "Sozialer Wohnungsbau und Umstrukturierung der Städte aus biologischer Sicht." In Irenäus Eibl-Eibesfeldt, et al, eds. *Stadt und Lebensqualität*. Stuttgart and Vienna, 1985.

Fuchs, E. *Fuchs über Ernst Fuchs*. Munich, 1977.

Gross, G. G., et al. "Cortical Visual Areas of the Temporal Lobe." In Clinton N. Woolsey. ed. *Cortical Sensory Organization* 2, 8. Totowa, N.J., 1981.

Haeckel, E. *Die Radiolarien (Rhizopoda radiaria): Eine Monographie*. 2 vols. Berlin, 1862.
"Generelle Morphologie der Organismen: Allgemeine Grundzüge der organischen Formenwissenschaft, mechanisch begründet durch die von Charles Darwin reformierte Descendenztheorie." Vol. 1: *Allgemeine Anatomie der Organsimen*. Berlin, 1866.
Studien zur Gastrea-Theorie. Jena, 1877.
"Das System der Medusen." In *Craspedoten*. Jena, 1879 (repr. 1986).
"Report on the Radiolaria, Collected by H.M.S. Challenger during the Years 1873–1876." Part I: *Porulosa* (*Spumellaria* and *Acantharia*); Part II: *Osculosa* (*Nesselaria* and *Phaeodaria*). London, 1887. (Report on the Scientific Results of the Voyage of H.M.S. Challenger … Zoology. Vol. 18, Parts 1–2).
Die Lebenswunder: Gemeinverständliche Studien über Biologische Philosophie. Stuttgart, 1904 (popular edn.,1906; 5th edn., 1925).
"Die Natur als Künstlerin." In F. Goerke, ed. *Die Natur als Künstlerin*. Berlin, 1913.

Hundertwasser, F. *Schöne Wege: Gedanken über Kunst und Leben*. Munich, 1983.

Johnston, V. S. and M. Franklin. "Is Beauty in the Eye of the Beholder?" *Ethology and Sociobiology* 14 (1993), pp. 183–99.

Kockerbeck, C. *Ernst Haeckels "Kunstformen der Natur" und ihr Einfluß auf die elementare Bildende Kunst der Jahrhundertwende*. Frankfurt am Main, 1986.

Krauße, E. "Haeckel: Promorphologie und 'evolutionistische' ästhetische Theorie." In Eve-Marie Engels, ed. *Die Rezeption von Evolutionstheorien im 19. Jahrhundert*. Frankfurt am Main, 1995, pp. 347–49.

Langlois, J. and L. A. Rogman. "Infants' Differential Social Response to Attractive and Unattractive Faces." *Developmental Psychology* 26, no. 1 (1990), pp. 153–59.

Lötsch, B. "Ästhetik zwischen Natur und Architektur: Der Streit um das Schöne." *Zeitspiegel* 5–6 (1991).

Lorenz, K. "Der Kumpan in der Umwelt des Vogels." *J. Ornithol* 83 (1935), pp. 137–413.

Markl, H. *Evolution, Genetik und menschliches Verhalten: Zur Frage wissenschaftlicher Verantwortung*. Munich, 1986.

Marr, D. *Vision*. New York, 1982.

Metzger, W. *Gesetze des Sehens*. Frankfurt am Main, 1936.

Orians, G. H. "Habitat Selection: General Theory and Applications to Human Behavior." In S. J. Lockard, ed. *The Evolution of Human Social Behavior*. New York, 1980, pp. 49–66.

Pöppel, E. "Musikerleben und Zeitstruktur." Kreuzer, F. ed. *Auge macht Bild, Ohr macht Klang, Hirn macht Welt: Salzburger Musikgespräch*. Vienna, 1983, pp. 76–87.
Grenzen des Bewußtseins: Über Wirklichkeit und Welterfahrung. Stuttgart, 1984.

Schurian, W. *Österreiche Malerei nach 1945*. Wiener Vorlesungen im Rathaus. Vol. 58, Vienna, 1997.

Sütterlin, C. "Kindsymbole: Von Puppen und Teddies." In W. Schiefenhövel, et al. *Eibl-Eibesfeldt: Sein Schlüssel zur Verhaltensforschung*. Munich, 1993, pp. 118–25.

Synek, E. *Evolutionäre Ästhetik: Vergleich von prä- und postpubertären Landschafts-präferenzen durch Einsatz von computergenerierten Bildern*. Diplomarbeit, University of Vienna, 1998.

Valenza, E., et al. "Face Preference at Birth." *Journal of Experimental Psychology: Human Perception and Performance* 22, no. 4 (1996), pp. 892–903.

Wallhäuser, E. and H. Scheich. "Auditory Imprinting Leads to Differential 2-Deoxyglucose Uptake and Dendritic Spine Loss in the Chick Rostral Forebrain." *Developmental Brain Research* 31 (1987), pp. 29–44.

Wichmann, S. *Jugendstil Floral Funktional*. Herrsching, 1984.

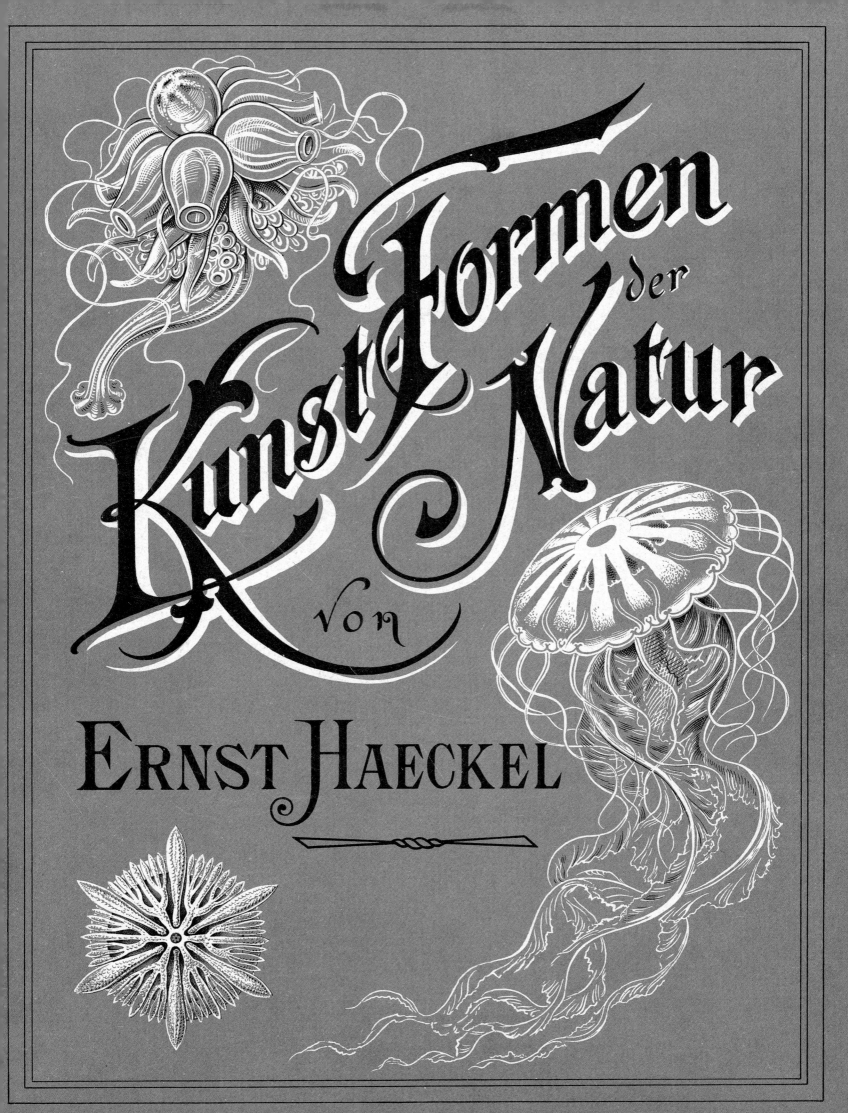

Kunst=Formen der Natur

von

ERNST HAECKEL

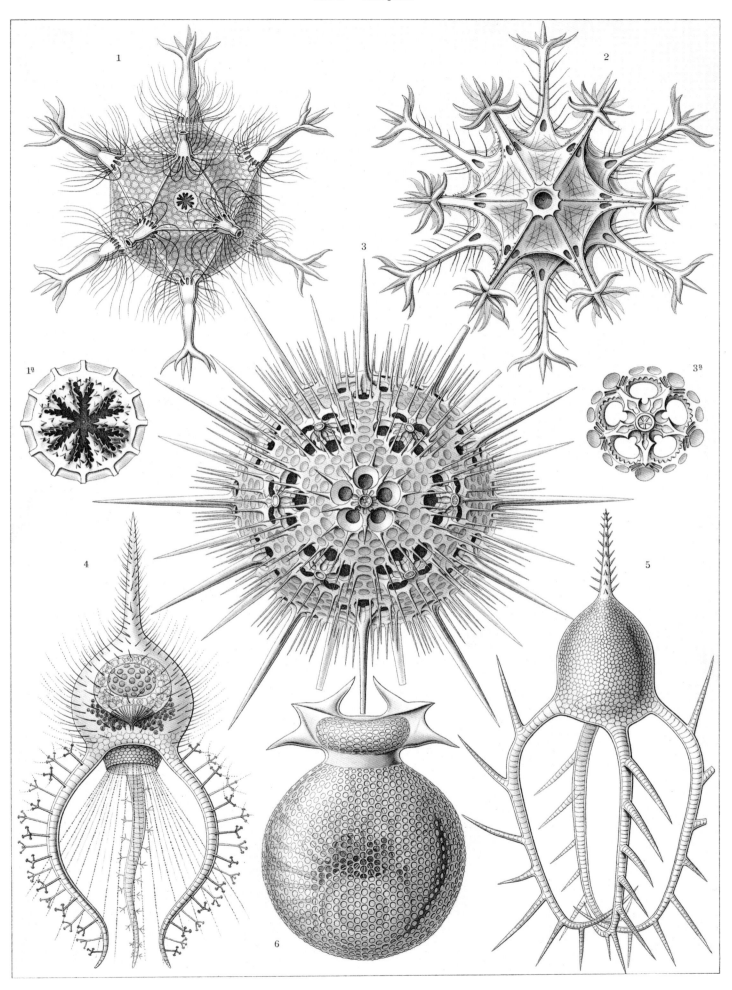

Phaeodaria. Rohrstrahlinge.

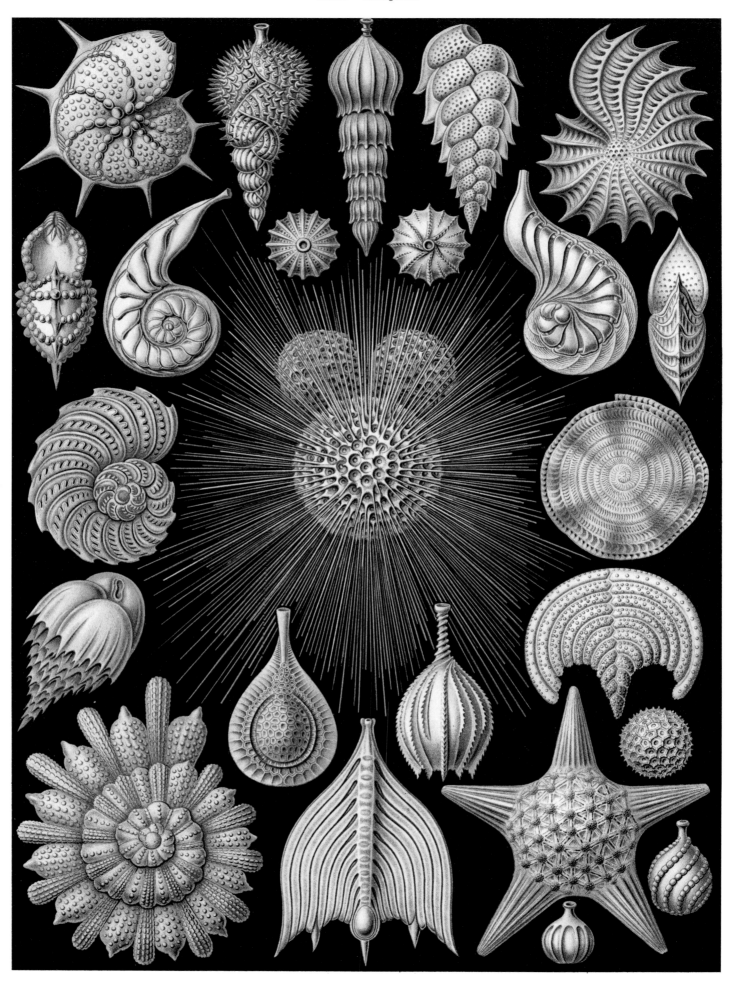

Thalamophora. Kammerlinge.

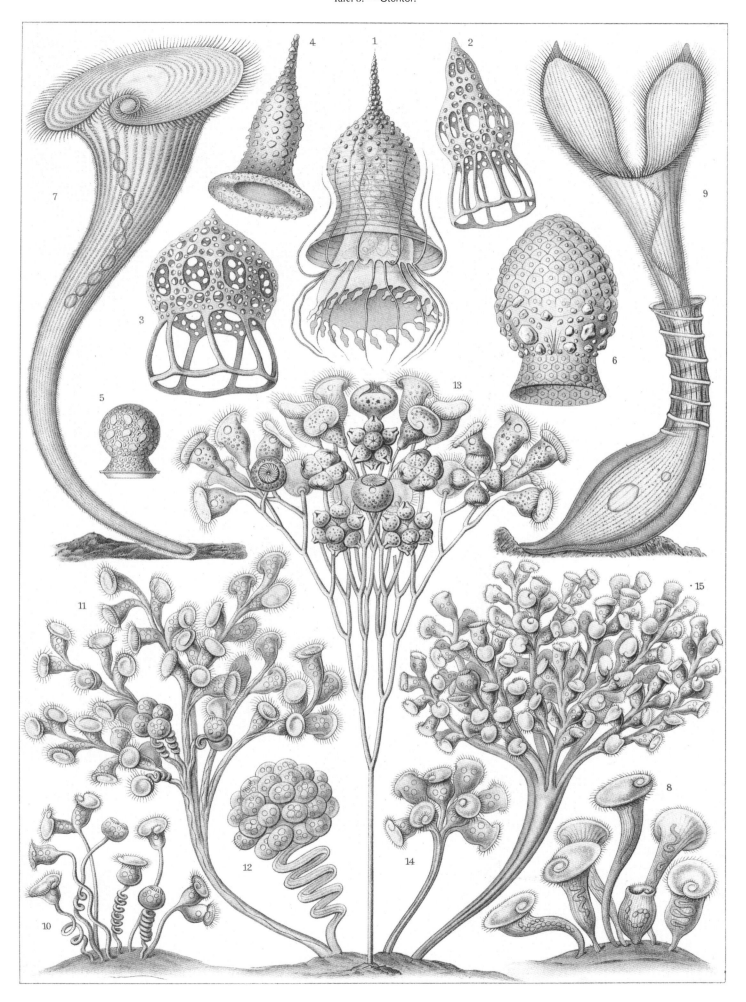

Ciliata. Wimperlinge.

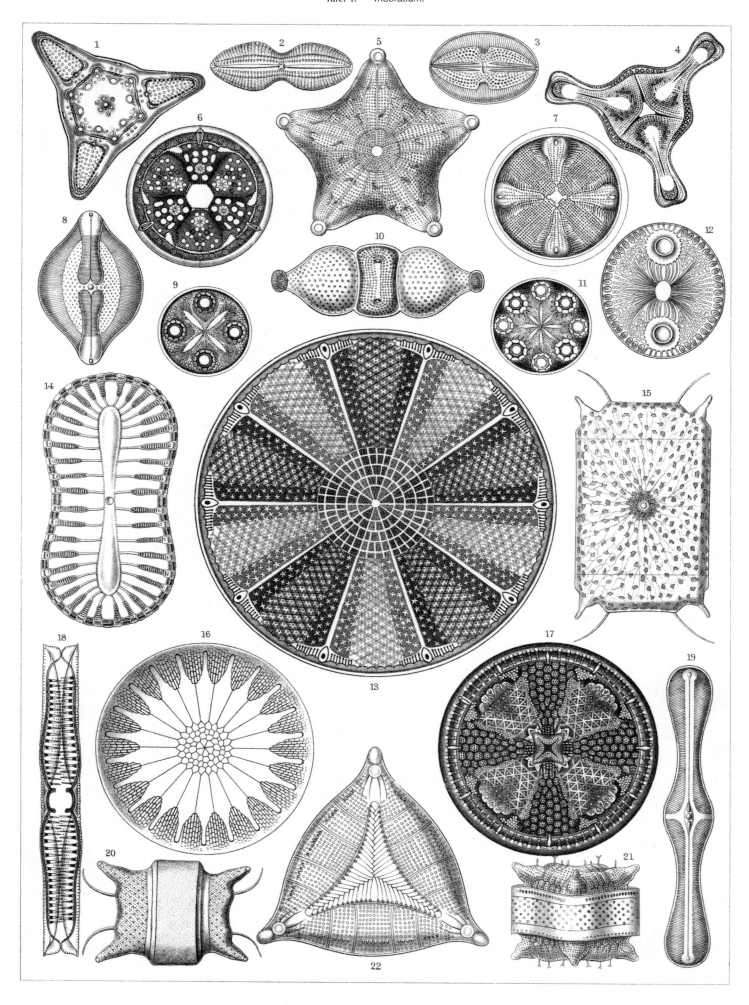

Diatomea. Schachtellinge.

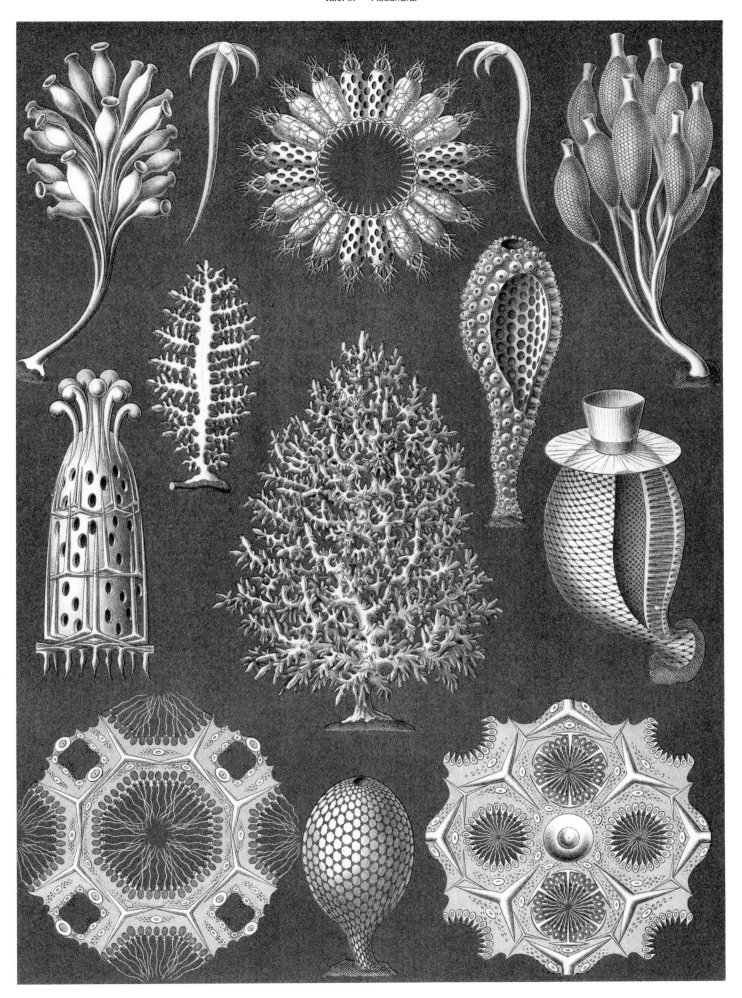

Calcispongiae. Kalkschwämme.

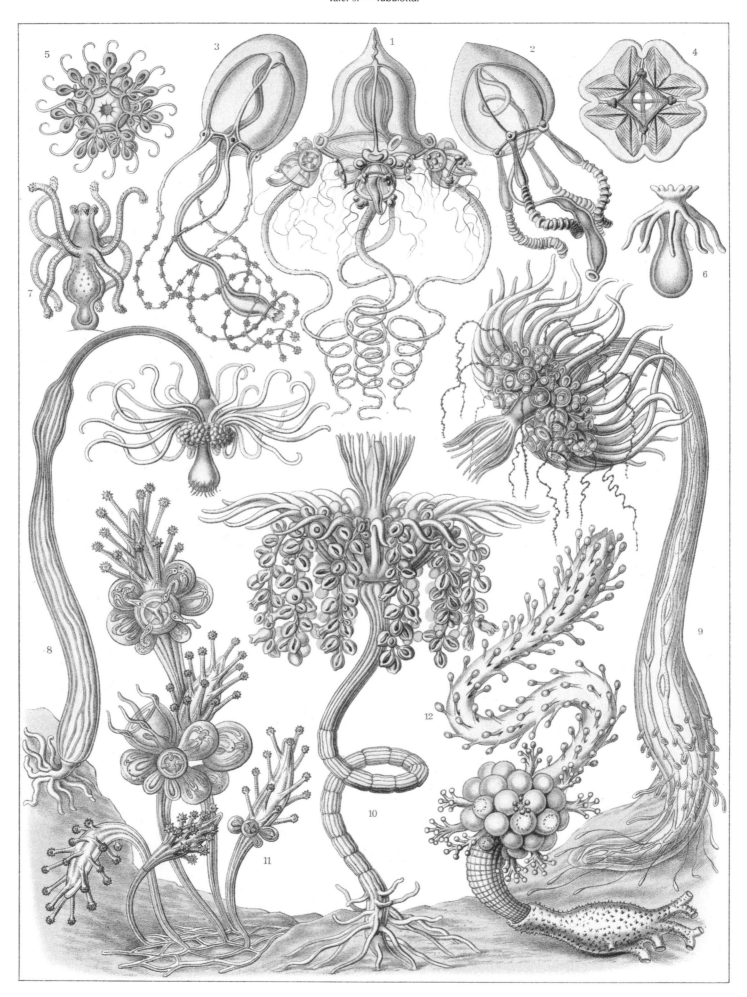

Tubulariae. Röhrenpolypen.

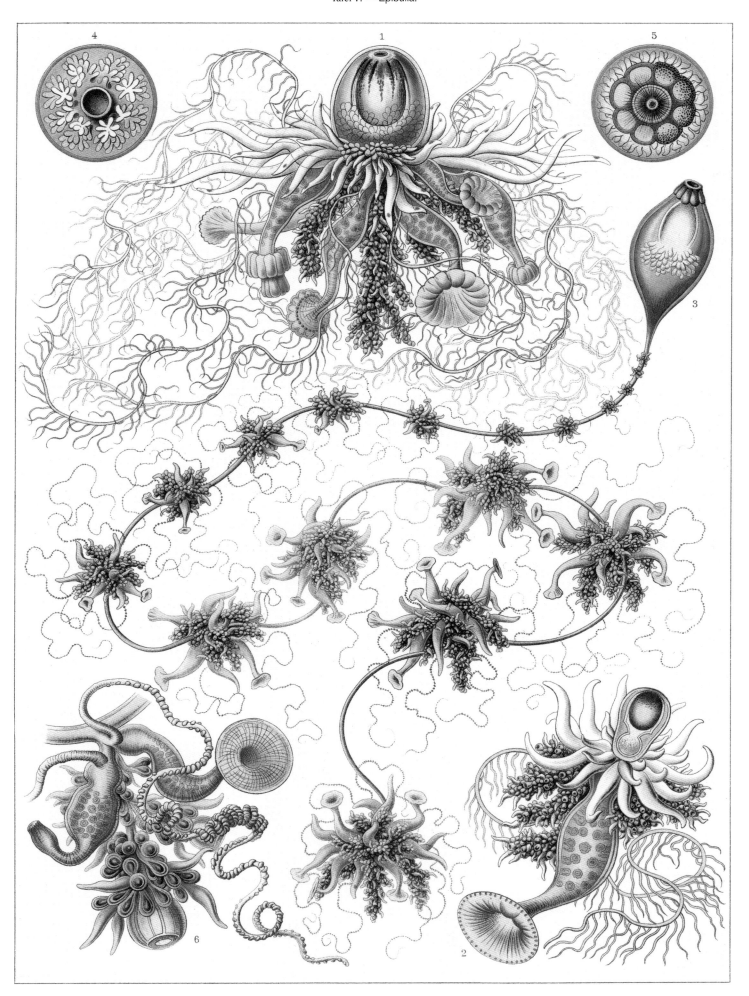

Siphonophorae. Staatsquallen.

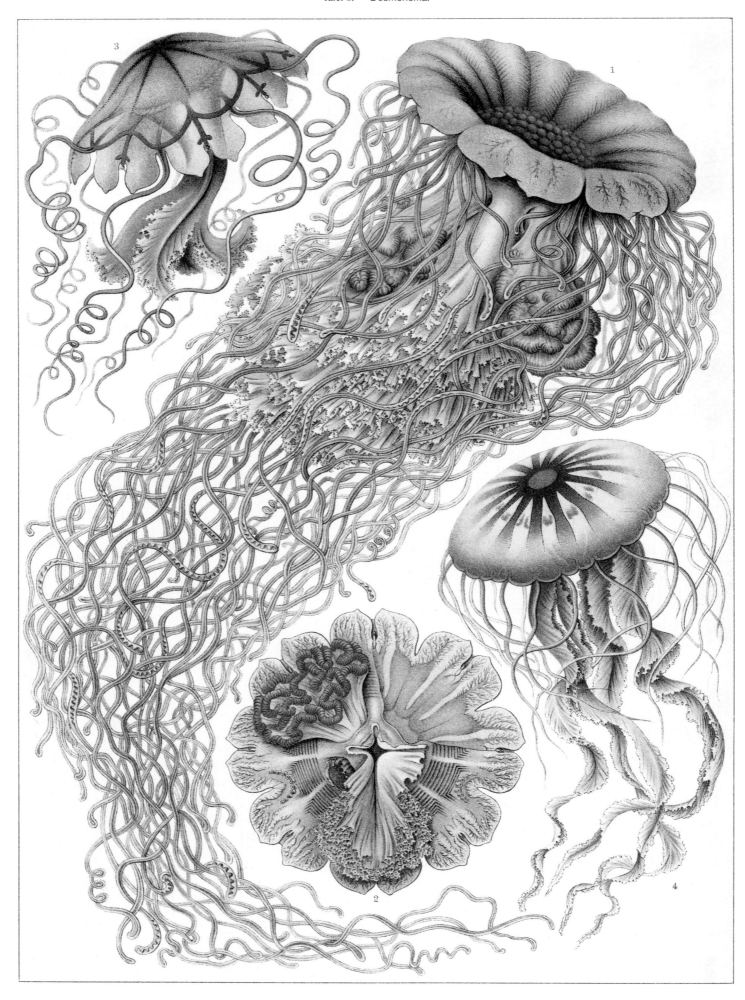

Discomedusae. Scheibenquallen.

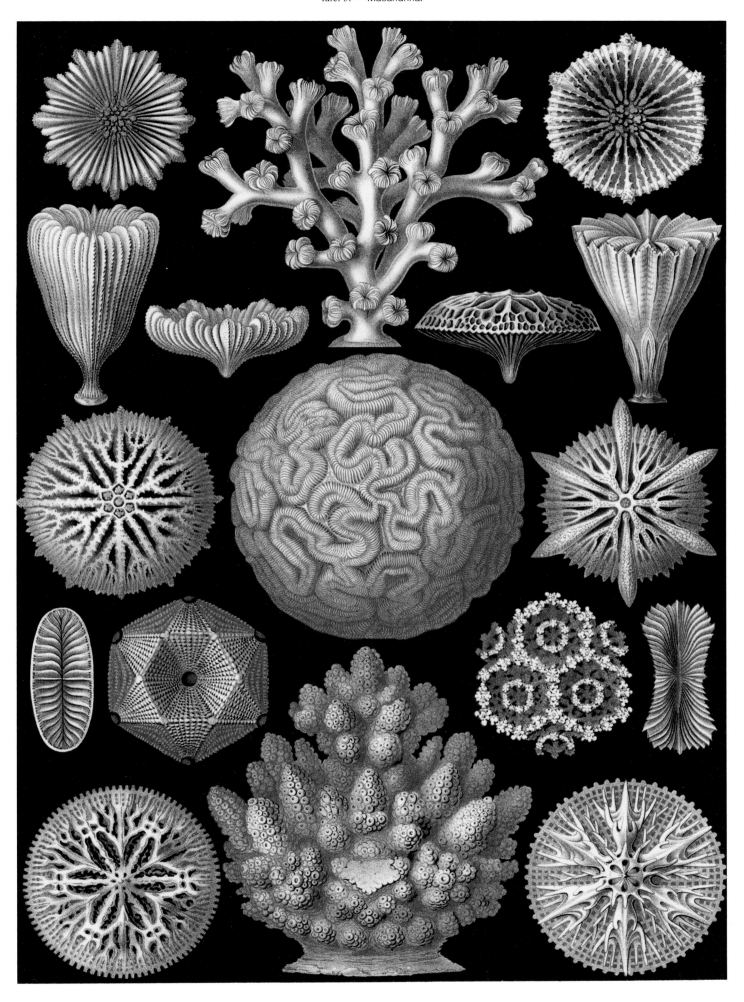

Hexacoralla. Sechsstrahlige Sternkorallen.

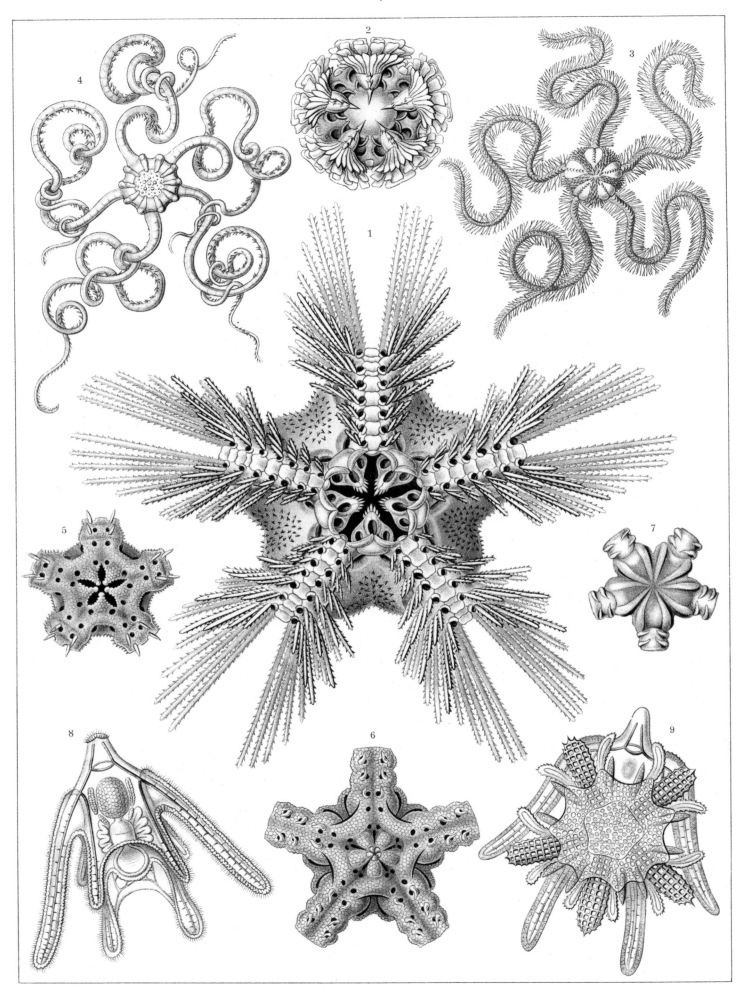

Ophiodea. Schlangensterne.

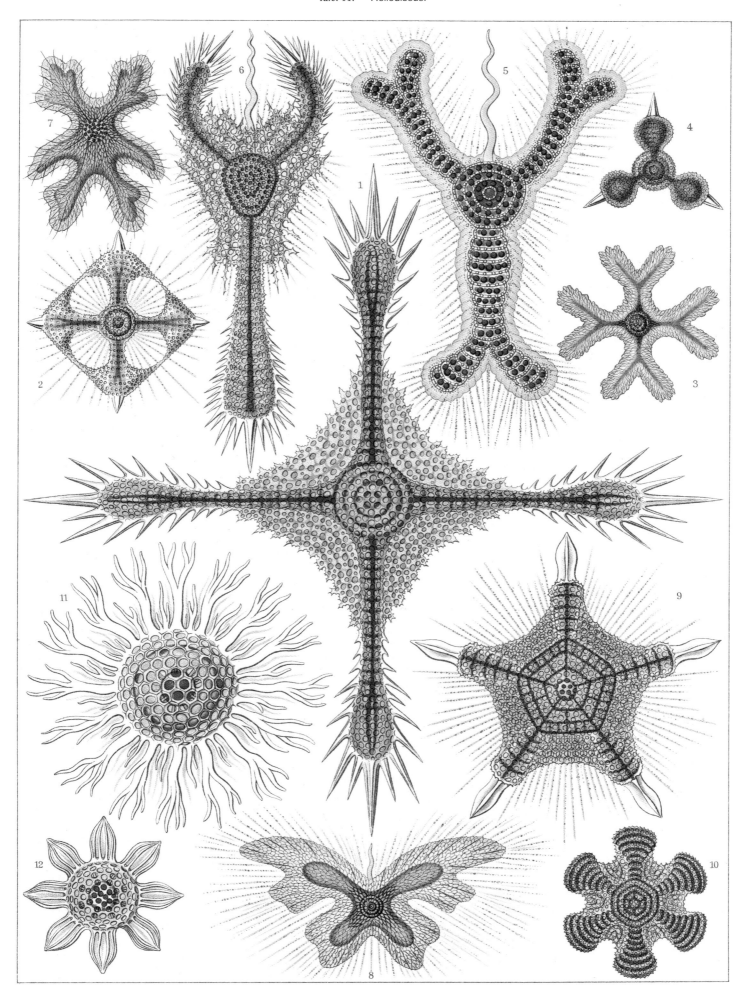

Discoidea. Scheiben-Strahlinge.

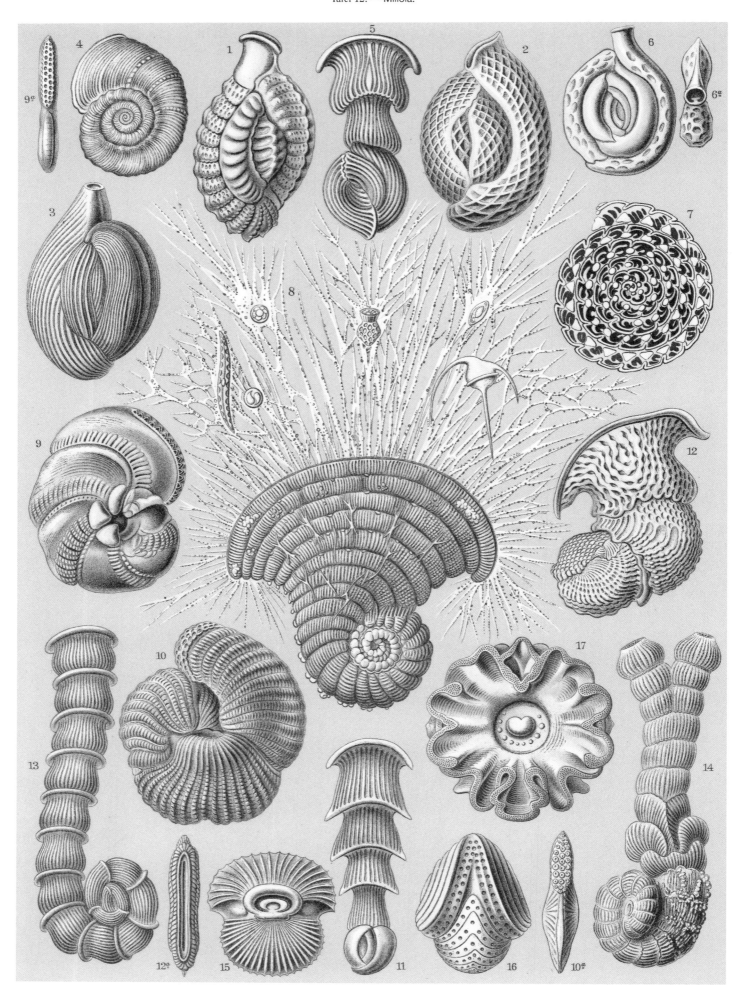

Thalamophora. Kammerlinge.

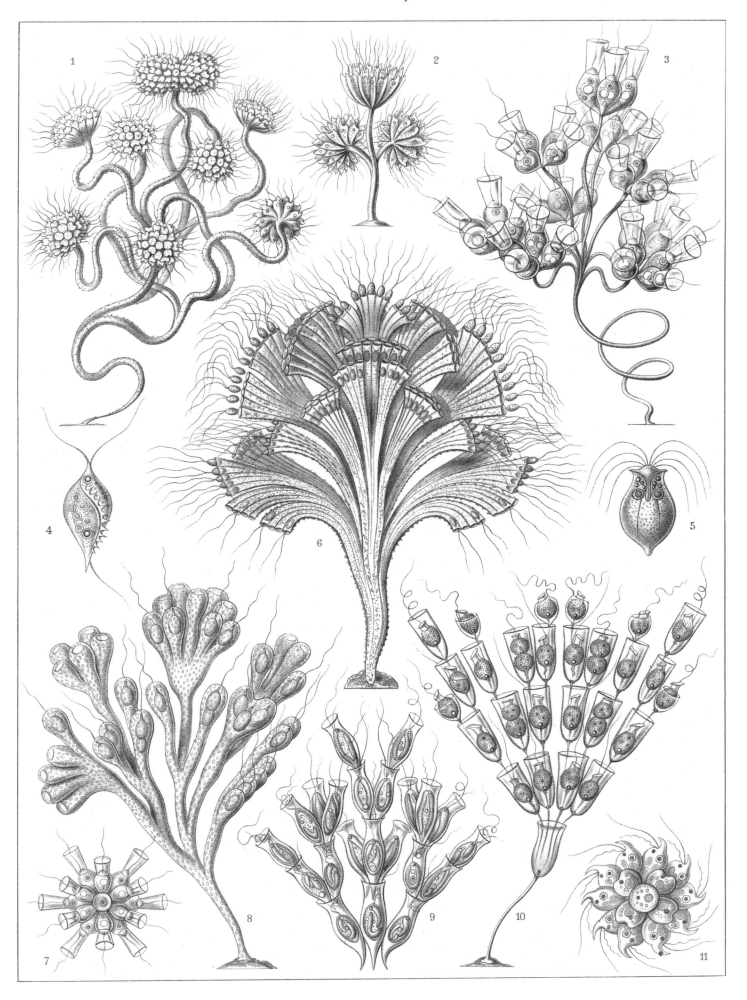

Flagellata. Geißlinge.

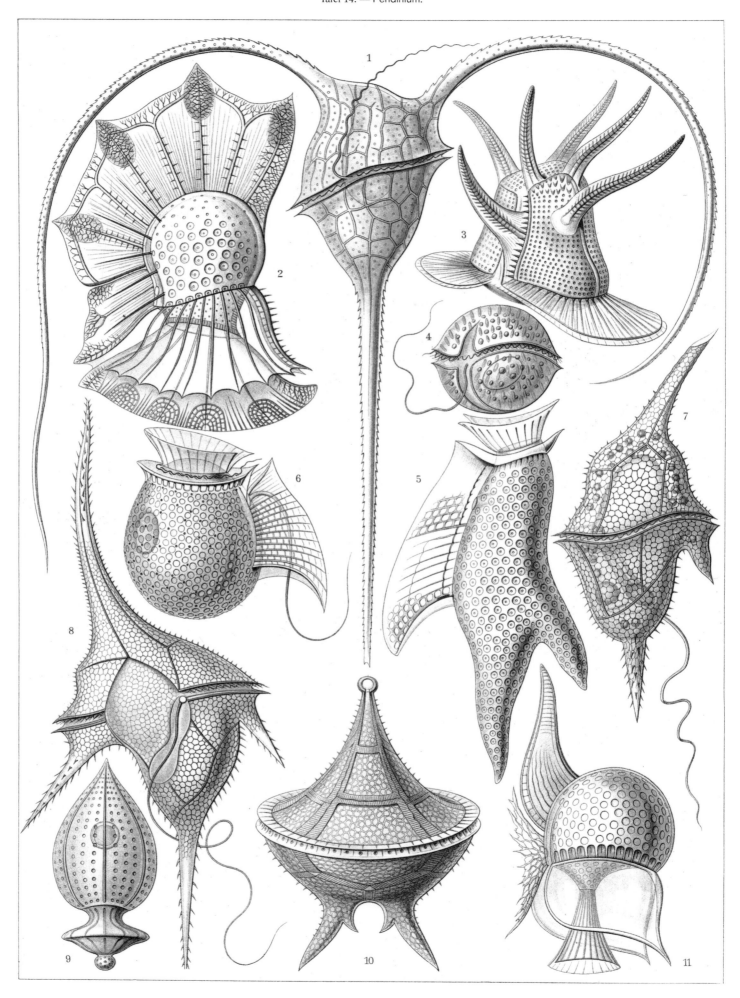

Peridinea. Geißelhütchen.

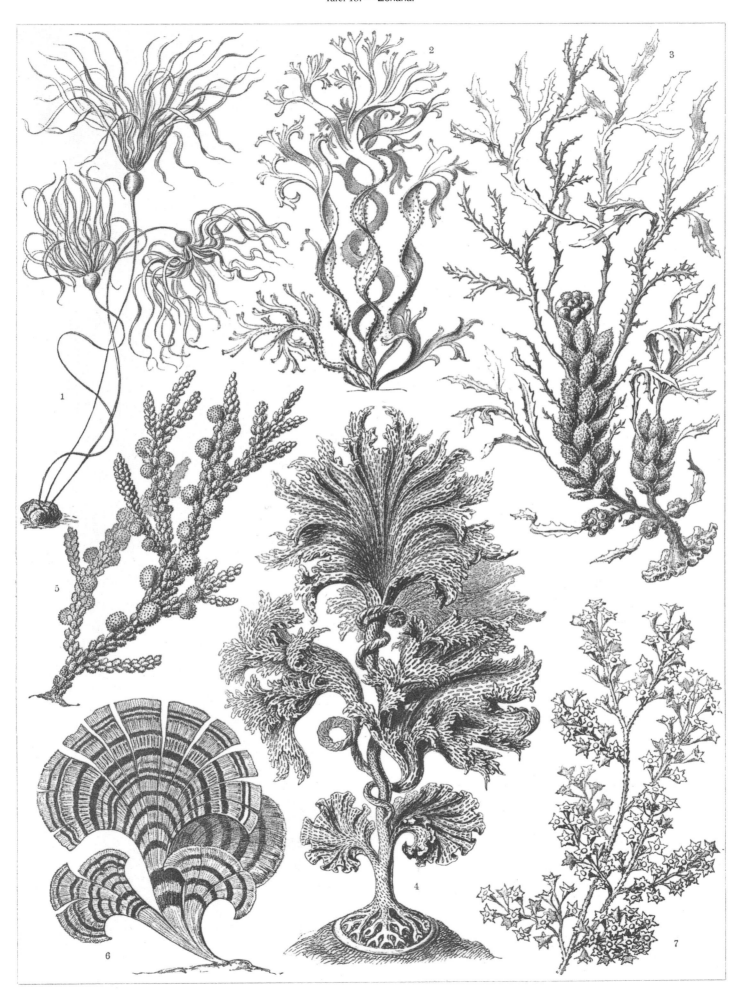

Fucoideae. Brauntange.

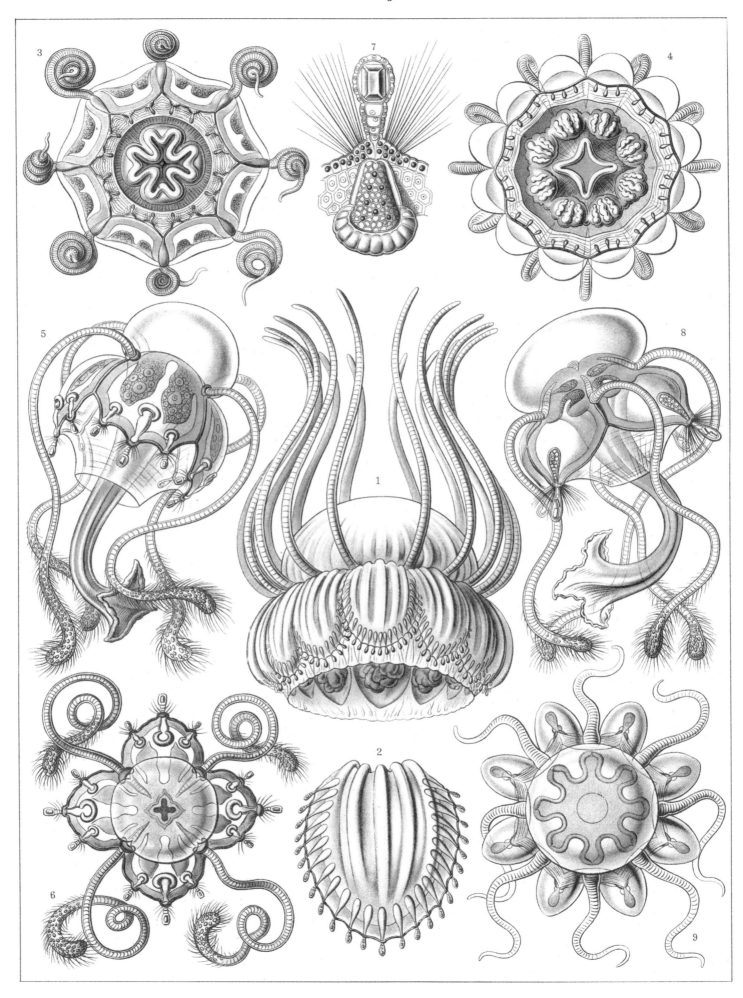

Narcomedusae. Spangenquallen.

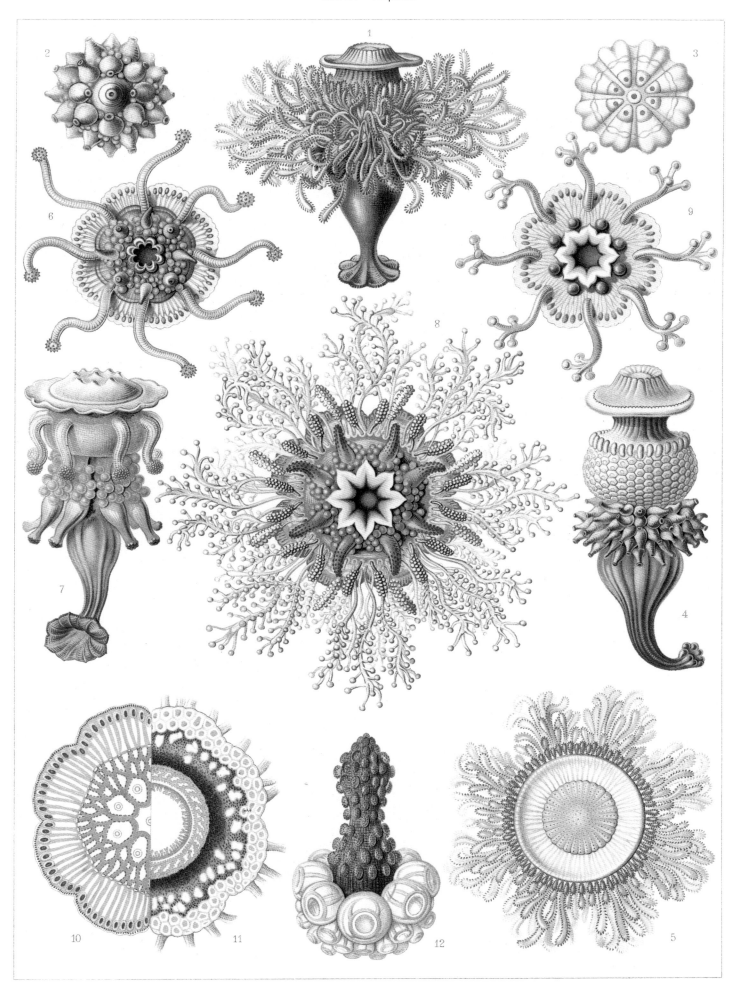

Siphonophorae. Staatsquallen.

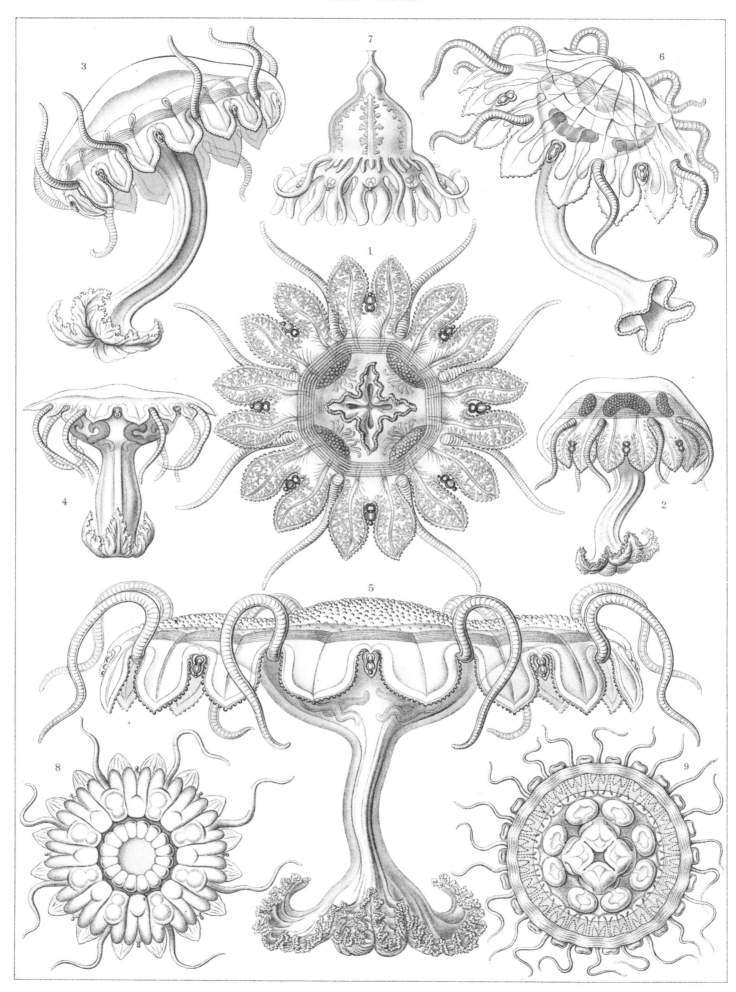

Discomedusae. Scheibenquallen.

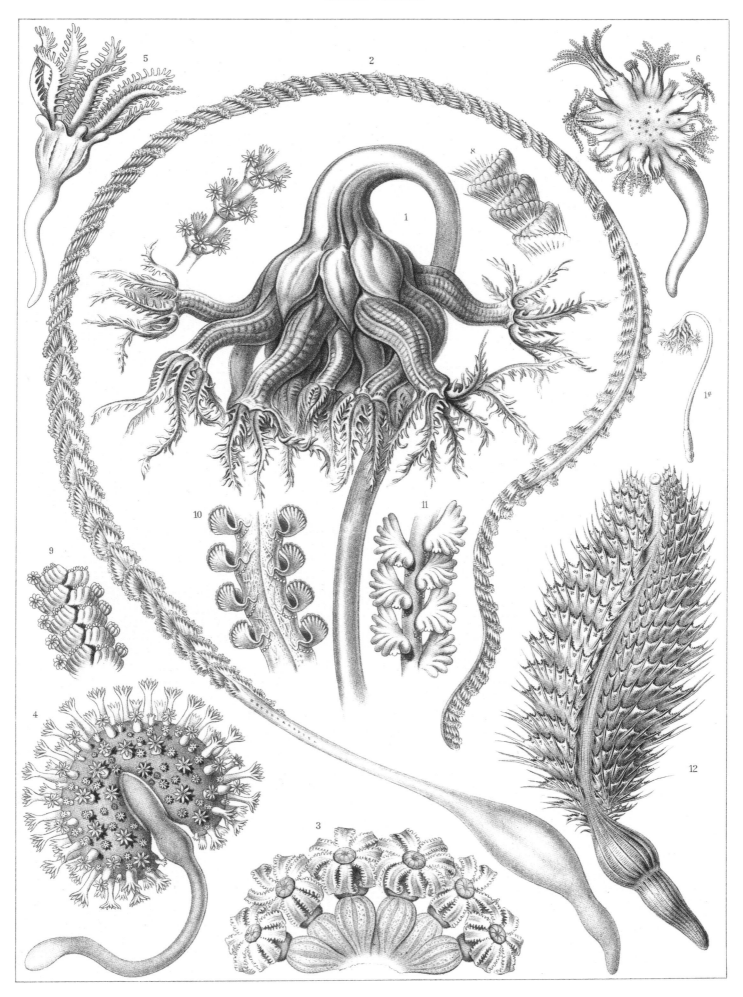

Pennatulida. Federkorallen.

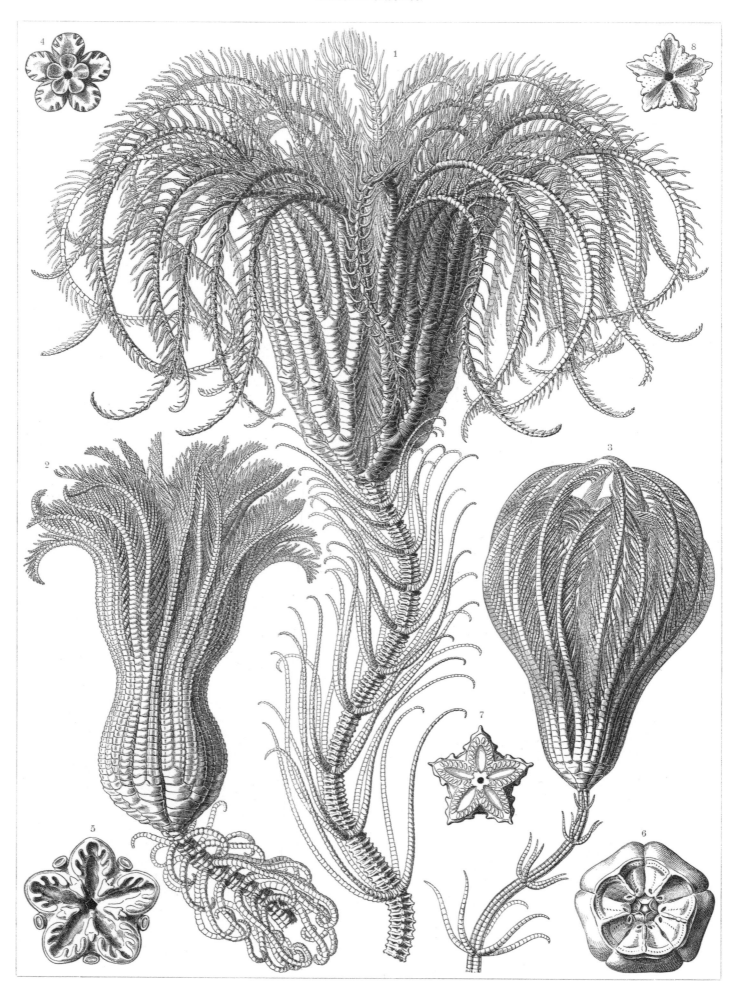

Crinoidea. Palmensterne.

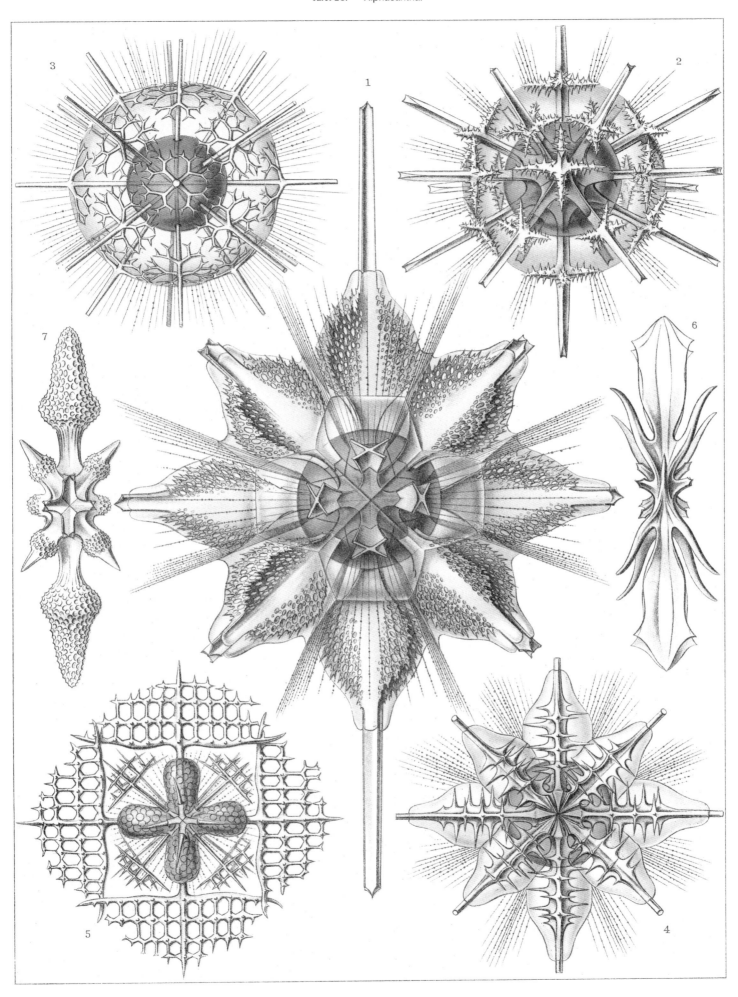

Acanthometra. Stachelstrahlinge.

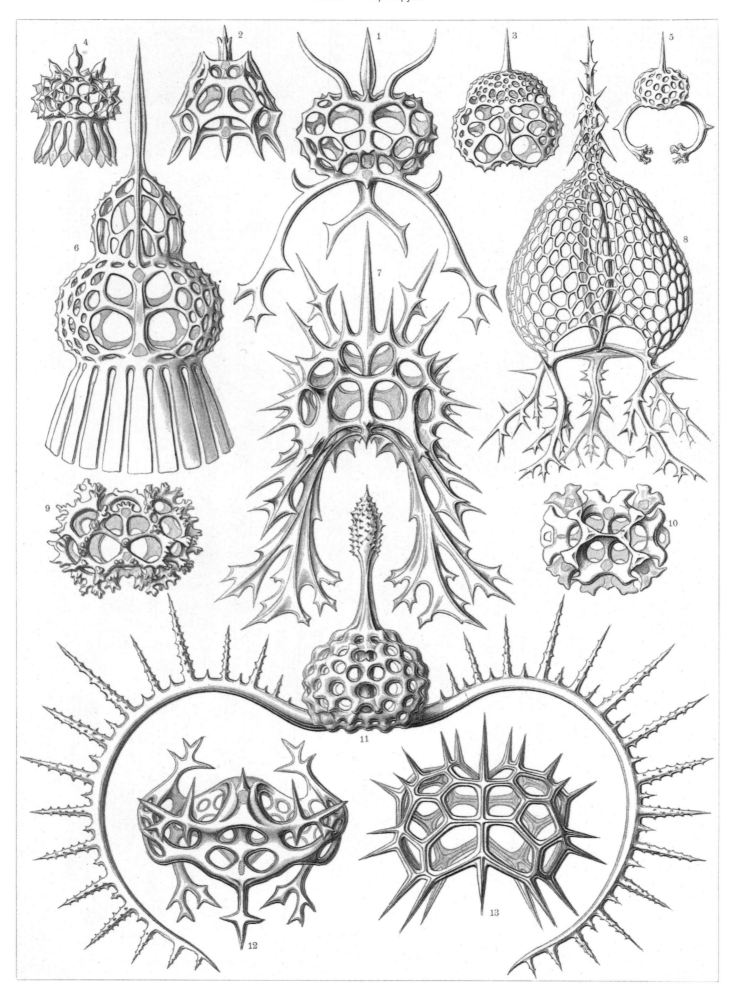

Spyroidea. Nüßchenstrahlinge.

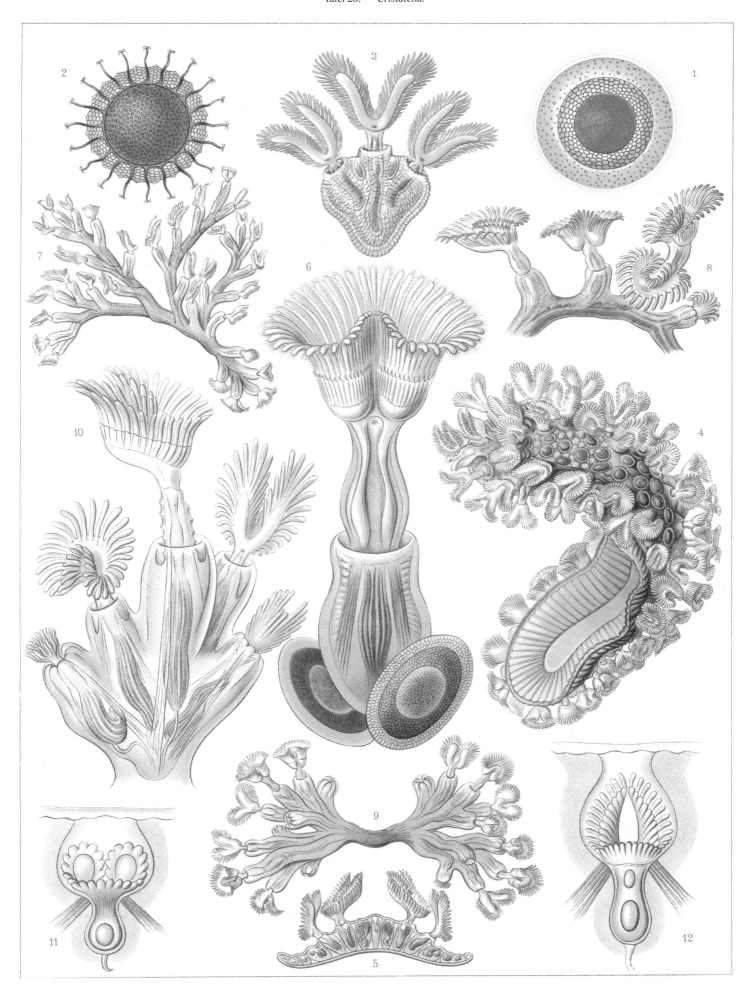

Bryozoa. Moostiere.

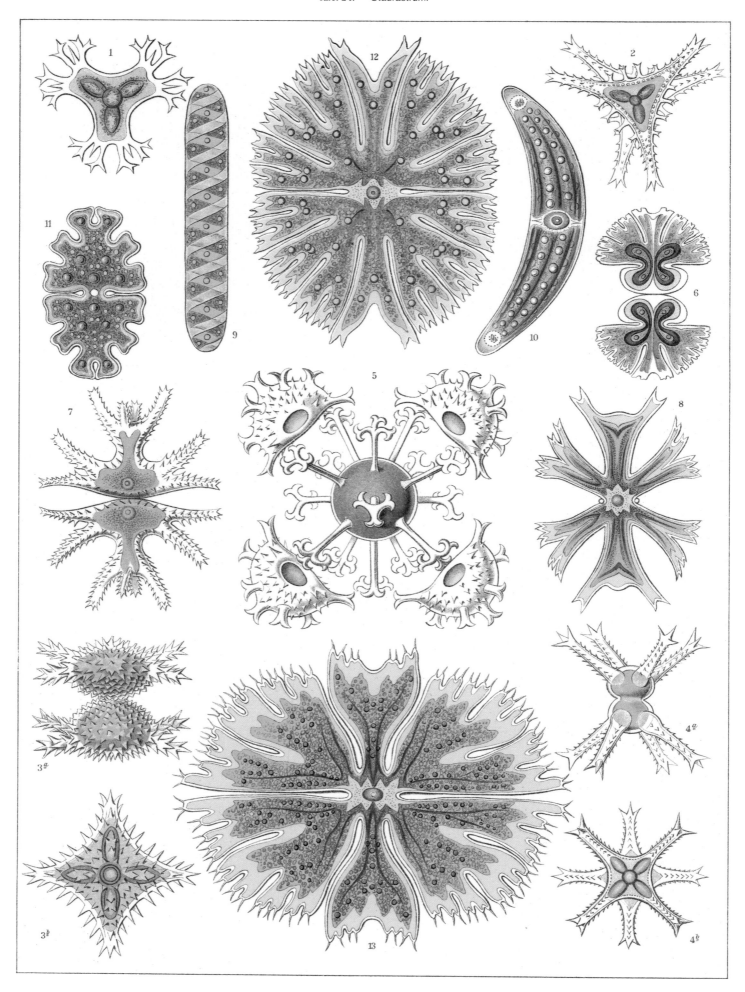

Desmidiea. Zierdinge.

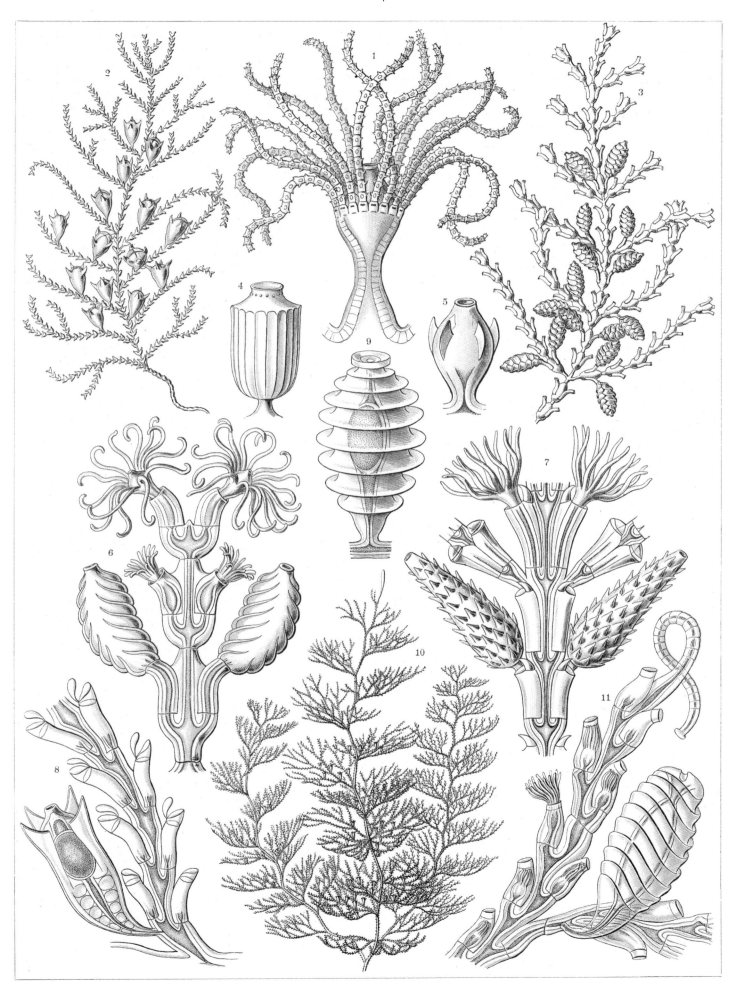

Sertulariae. Reihenpolypen.

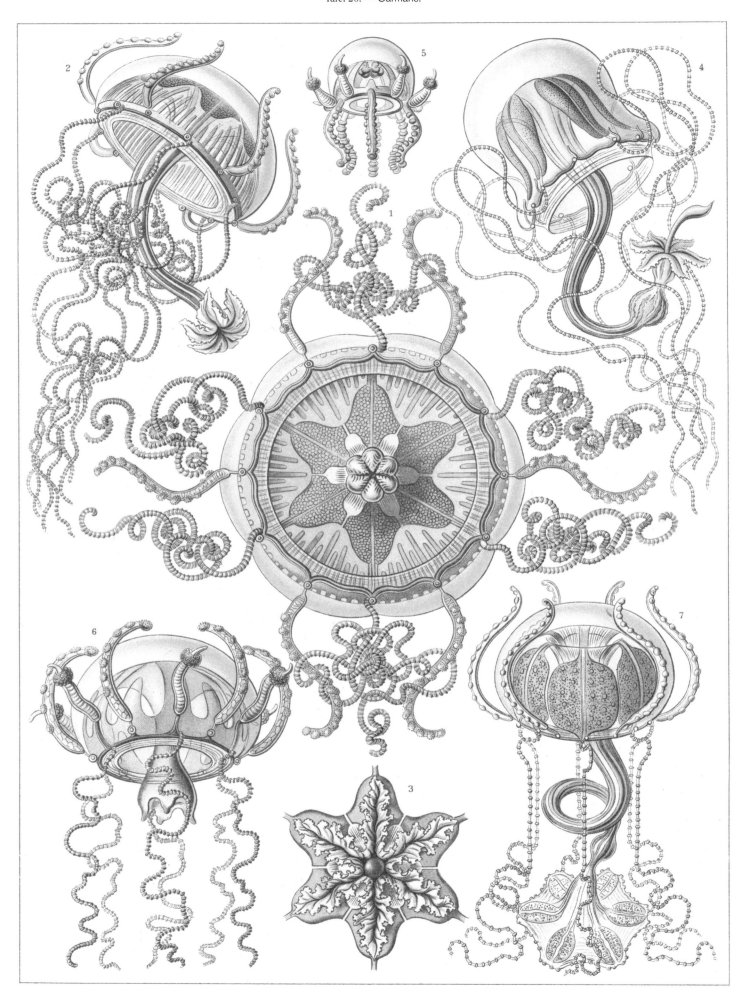

Trachomedusae. Kolbenquallen.

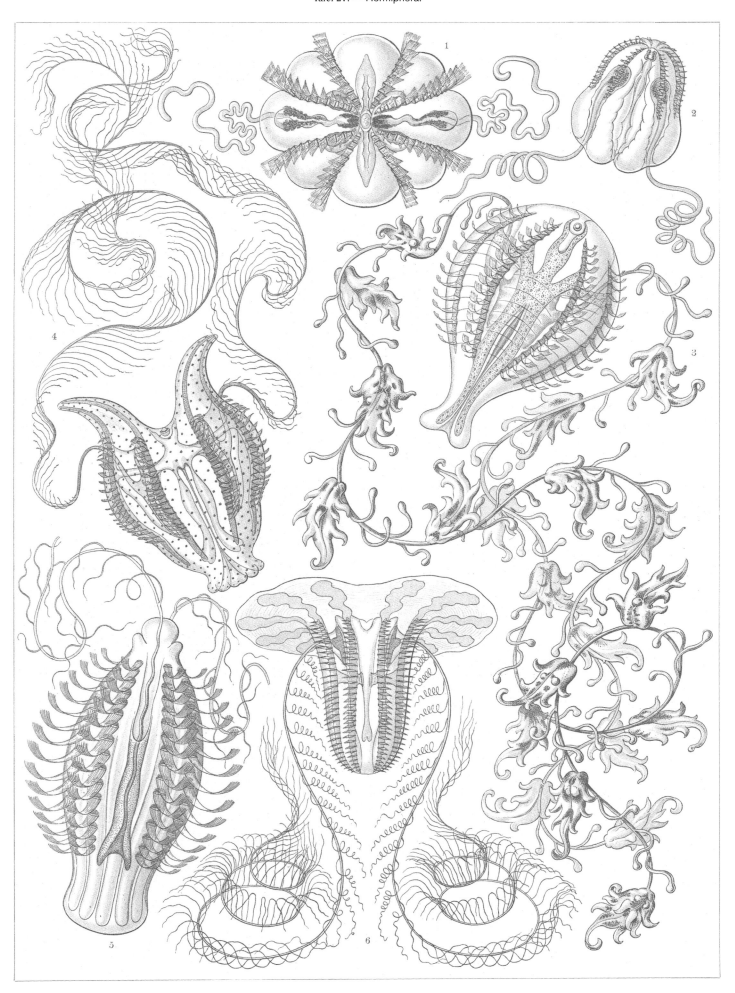

Ctenophorae. Kammquallen.

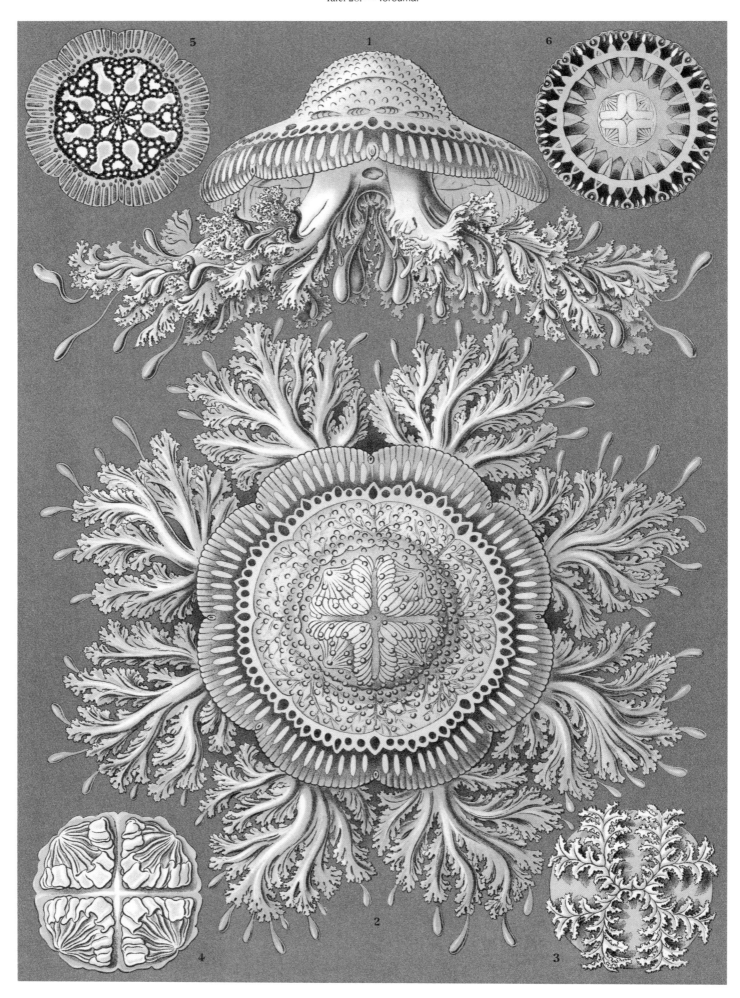

Discomedusae. Scheibenquallen.

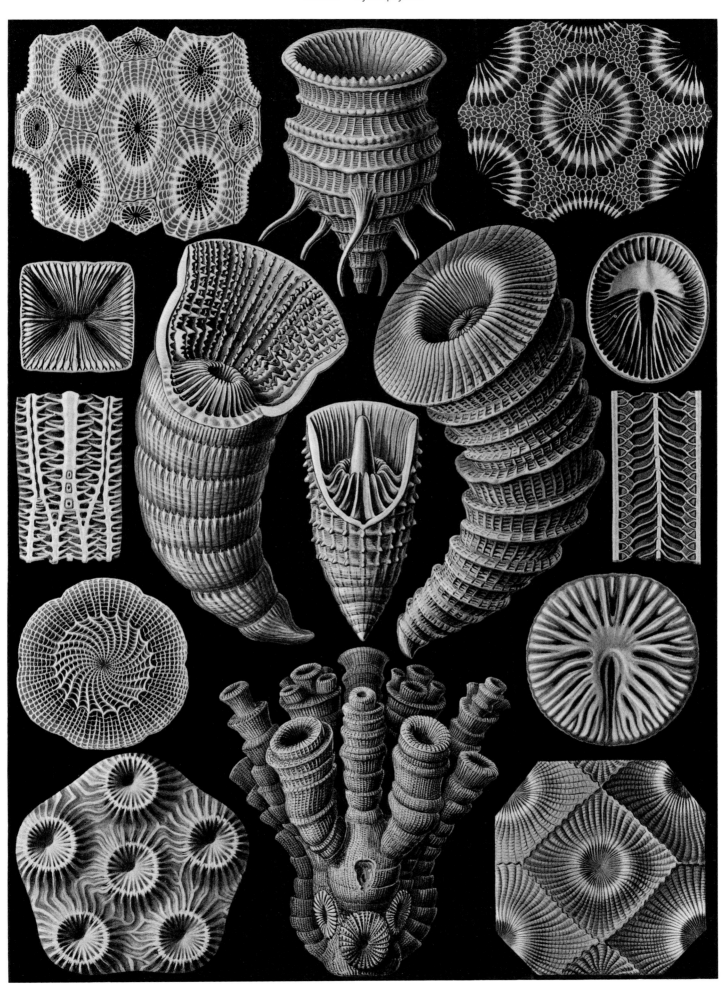

Tetracoralla. Vierstrahlige Sternkorallen.

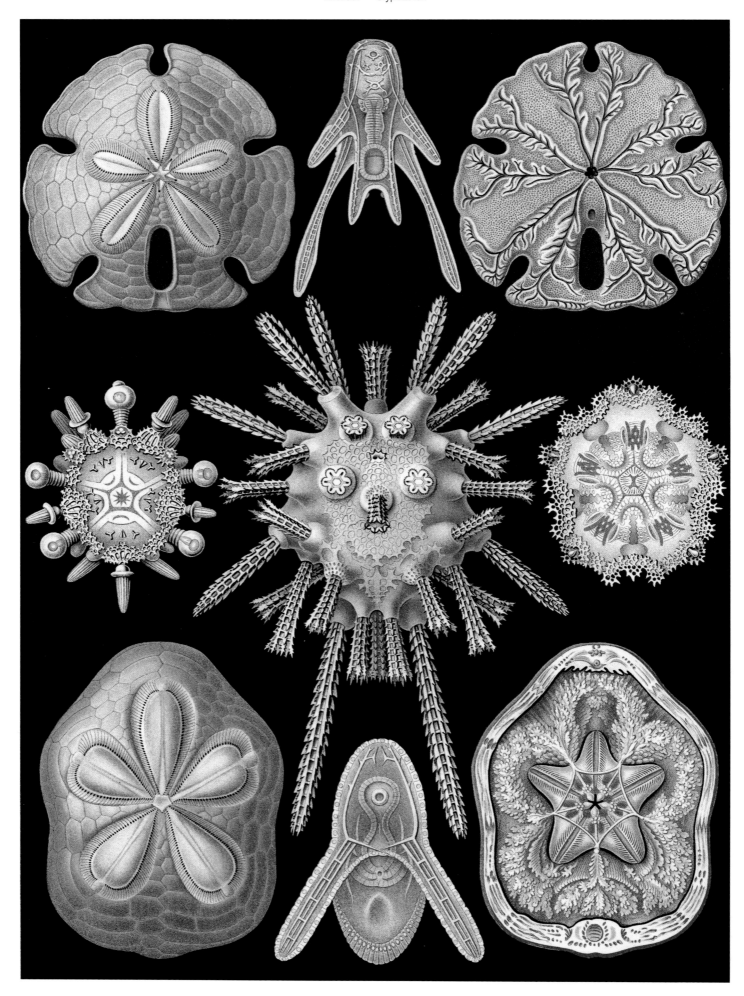

Echinidea. Igelsterne.

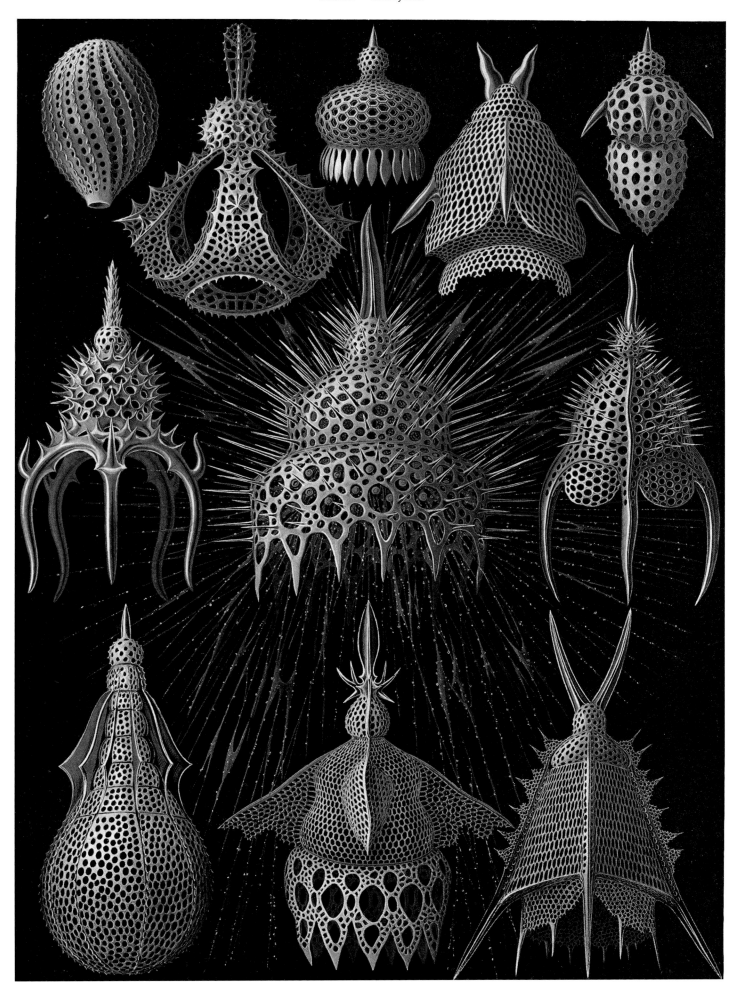

Cyrtoidea. Flaschenstrahlinge.

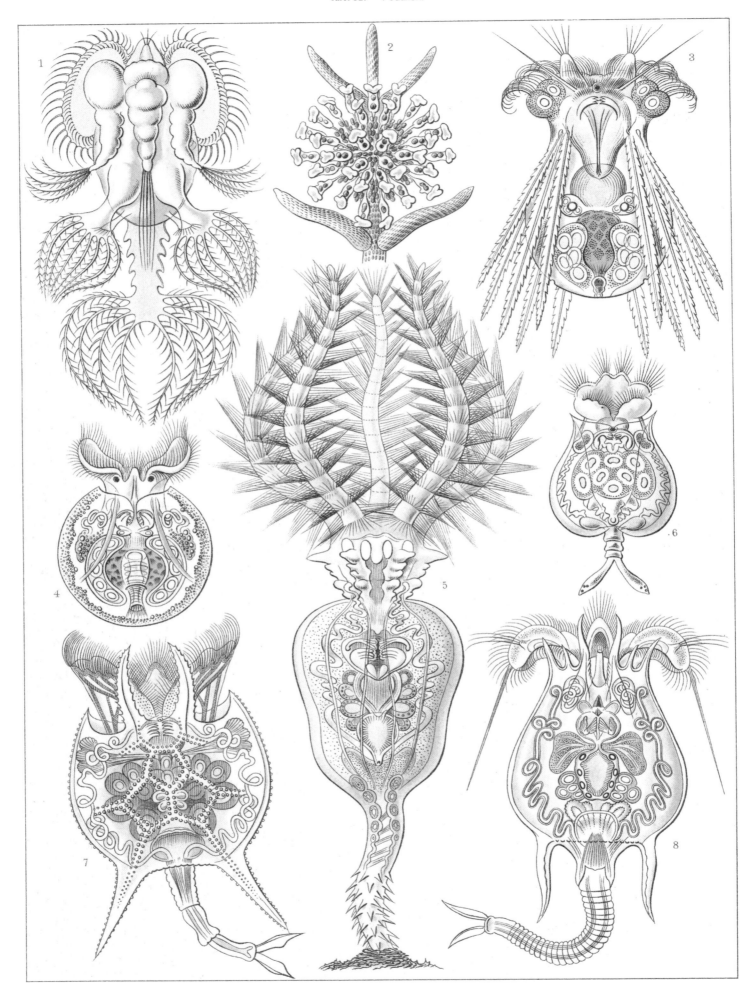

Rotatoria. Rädertiere.

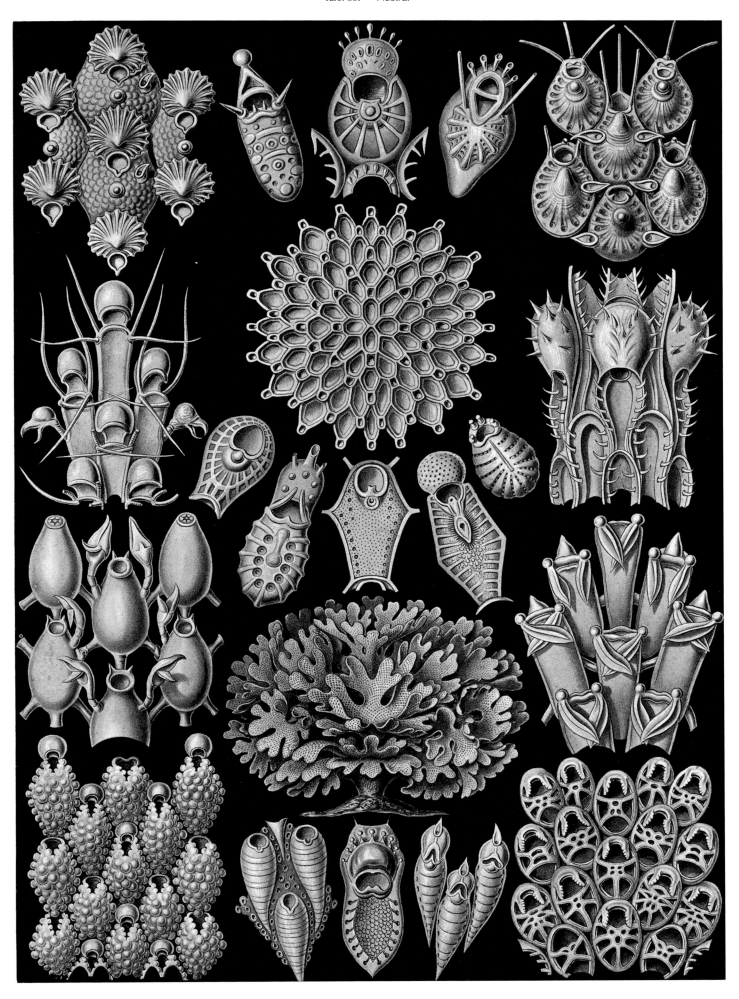

Bryozoa. Moostiere.

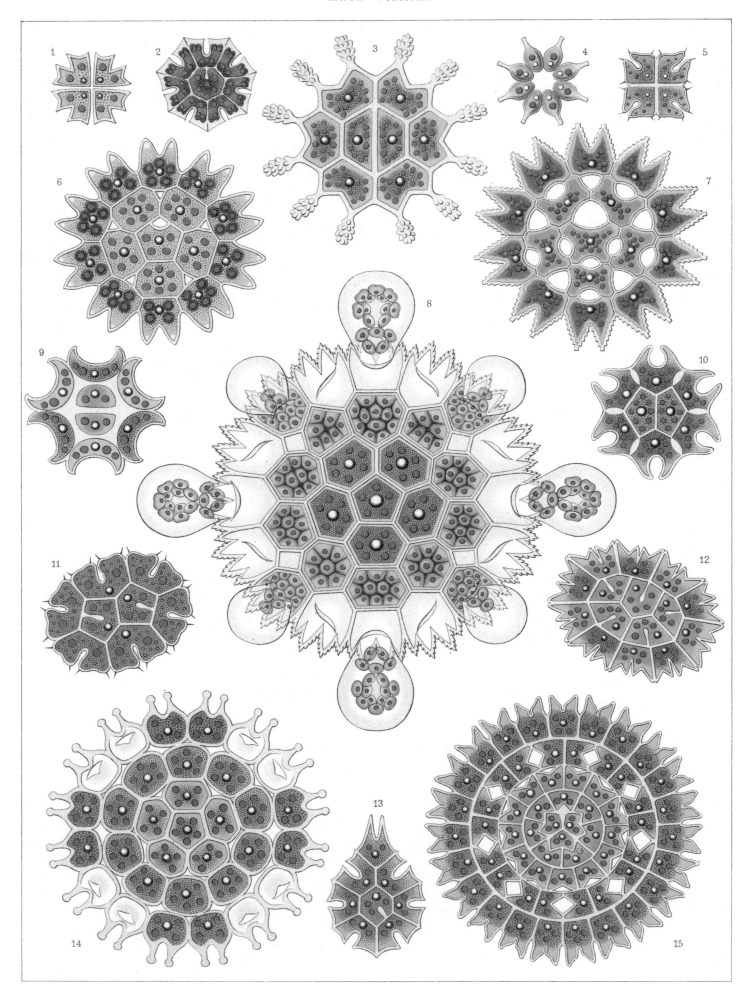

Melethallia. Gesellige Algetten.

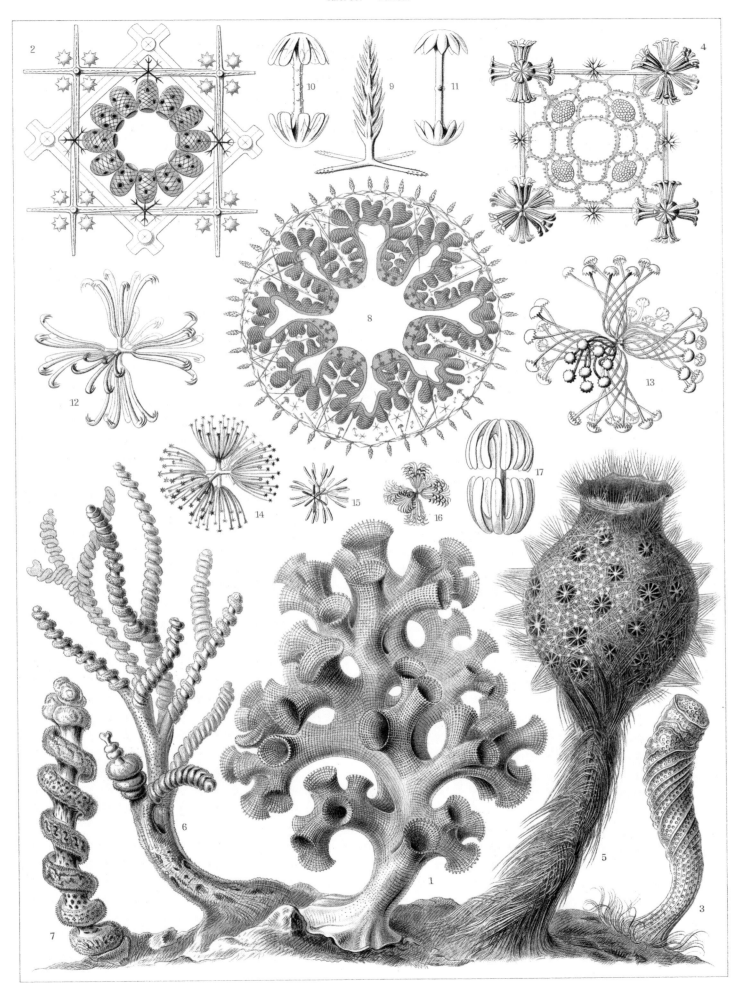

Hexactinellae. Glasschwämme.

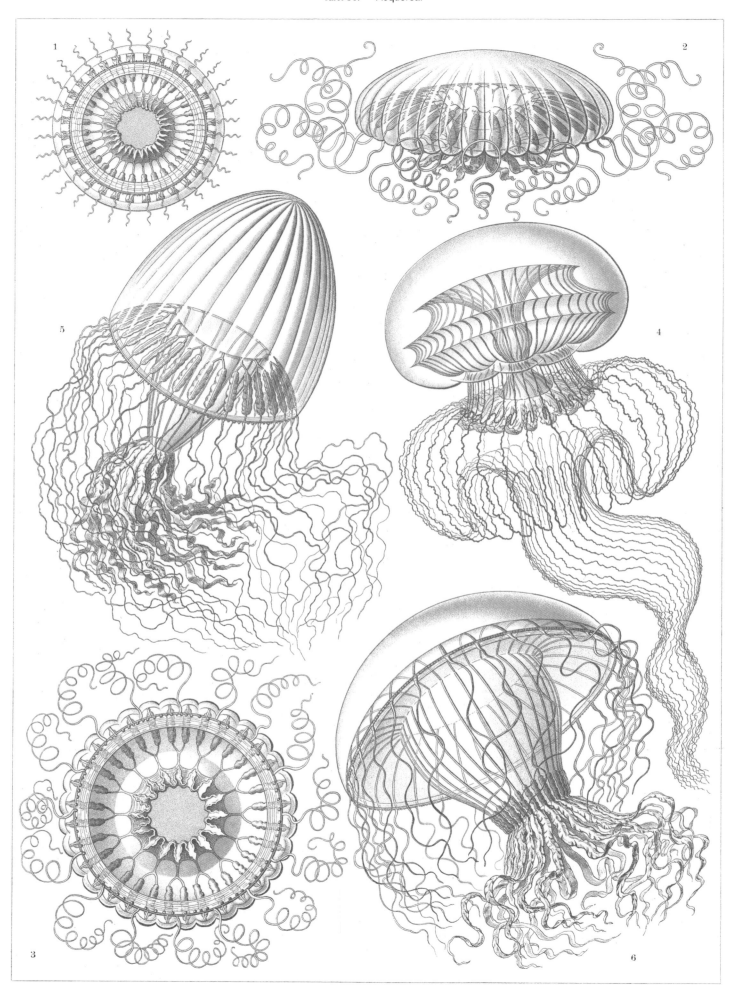

Leptomedusae. Faltenquallen.

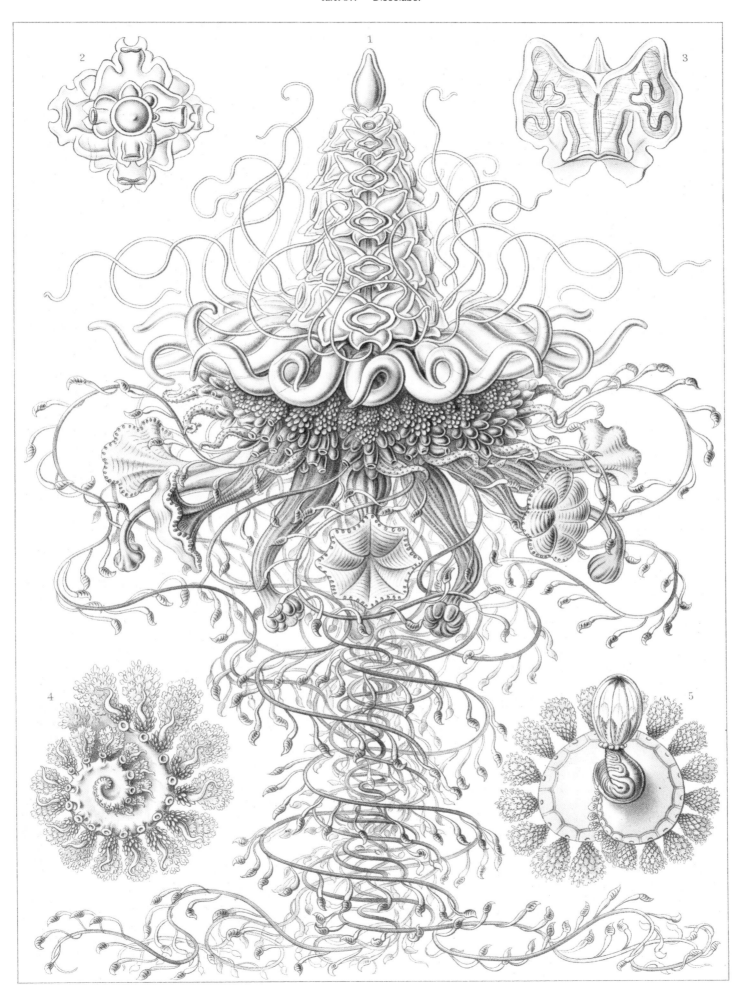

Siphonophorae. Staatsquallen.

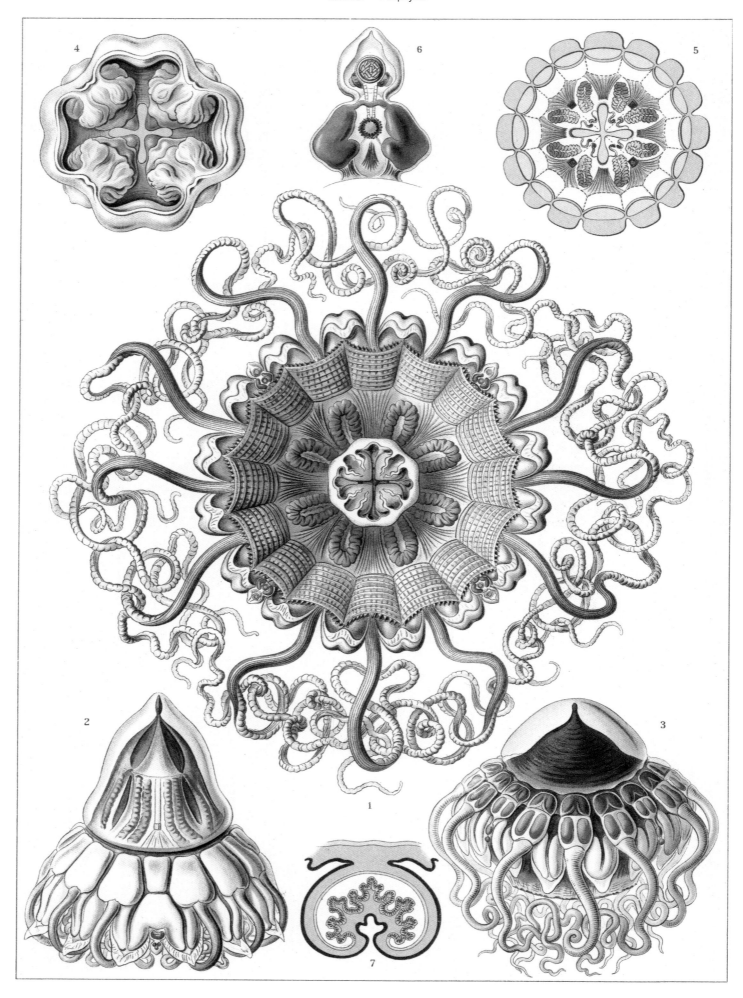

Peromedusae. Taschenquallen.

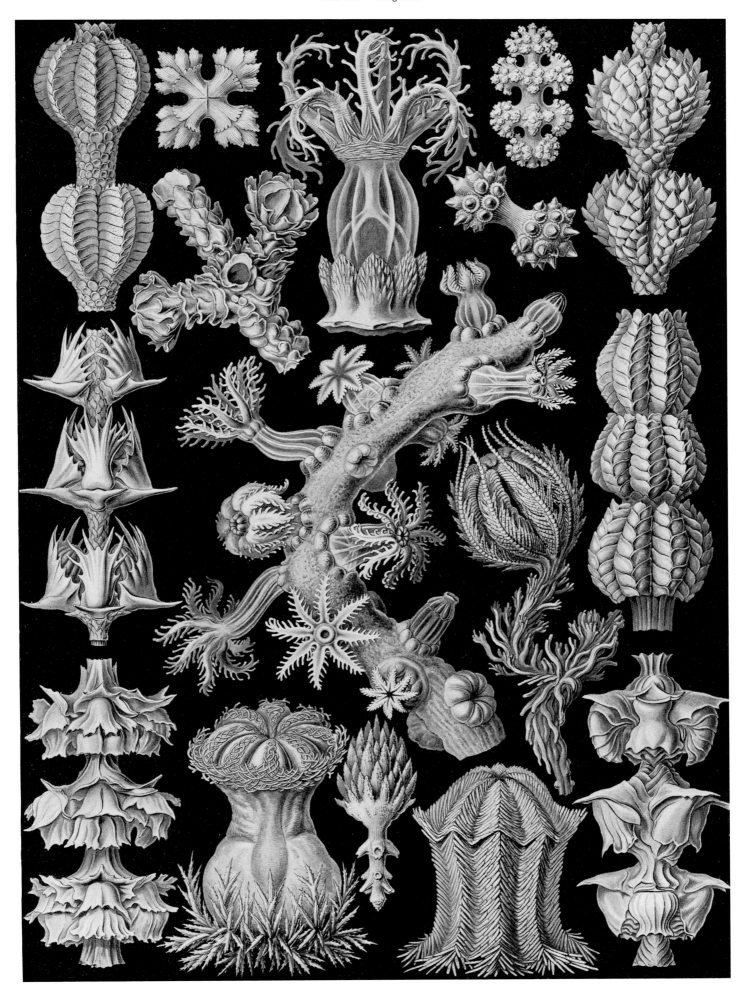

Gorgonida. Rindenkorallen.

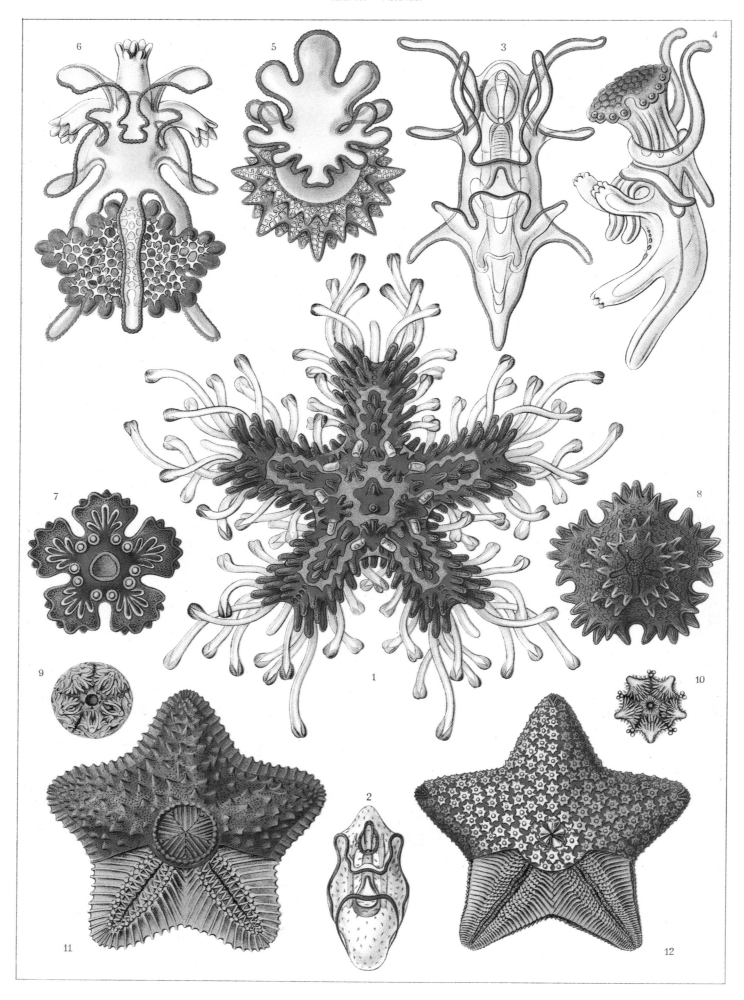

Asteridea. Seesterne.

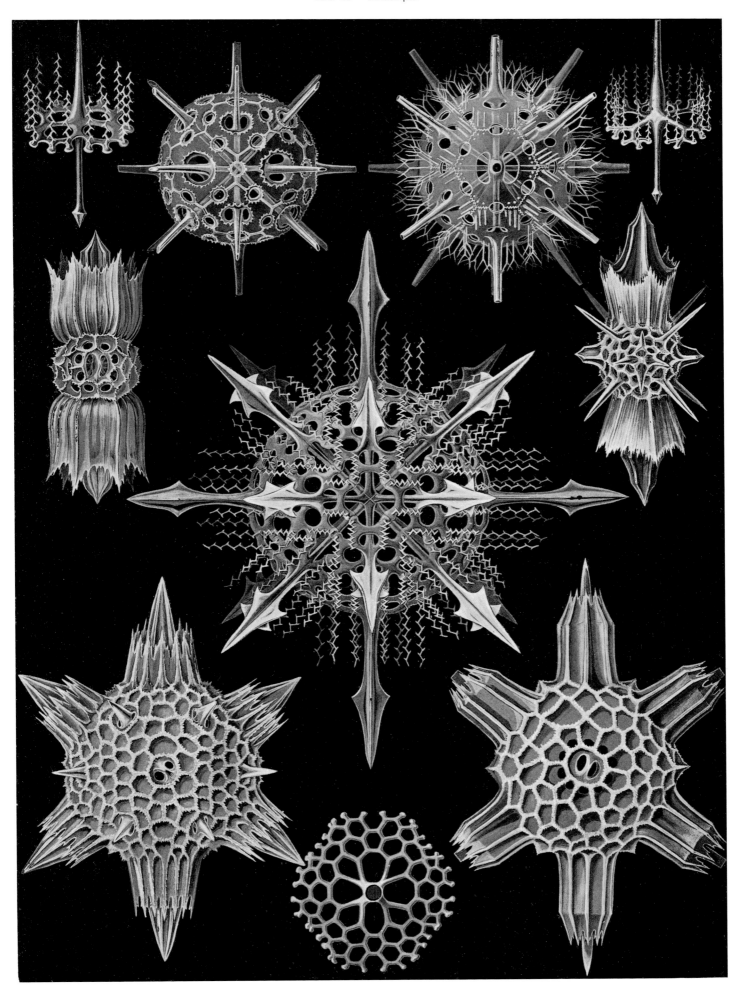

Acanthophracta. Wunderstrahlinge.

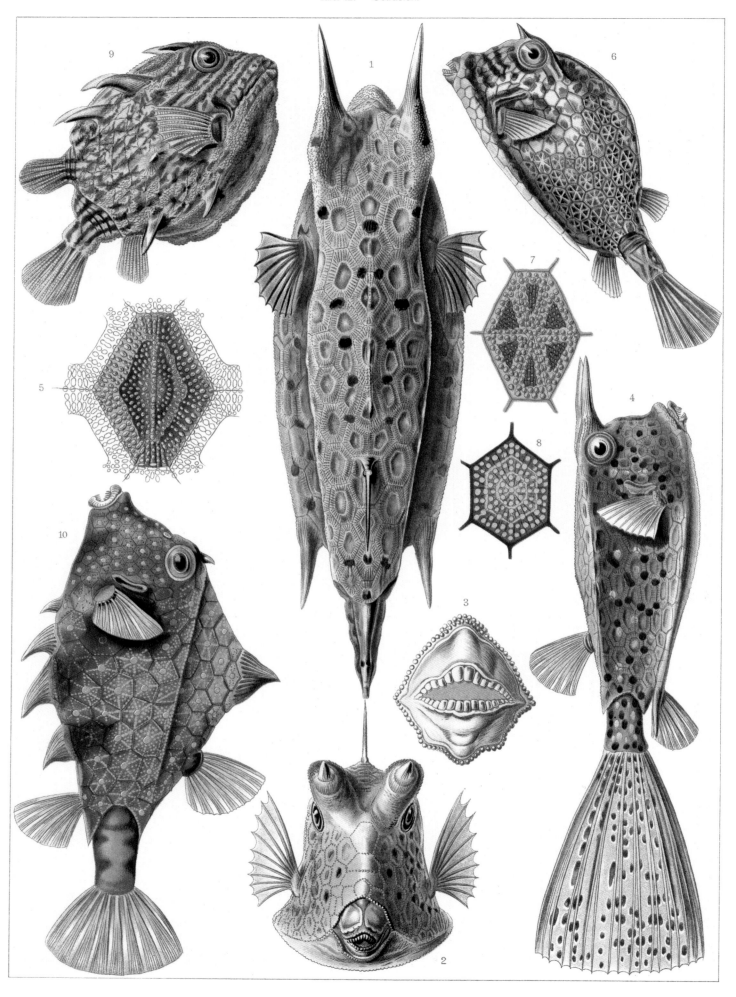

Ostraciontes. Kofferfische.

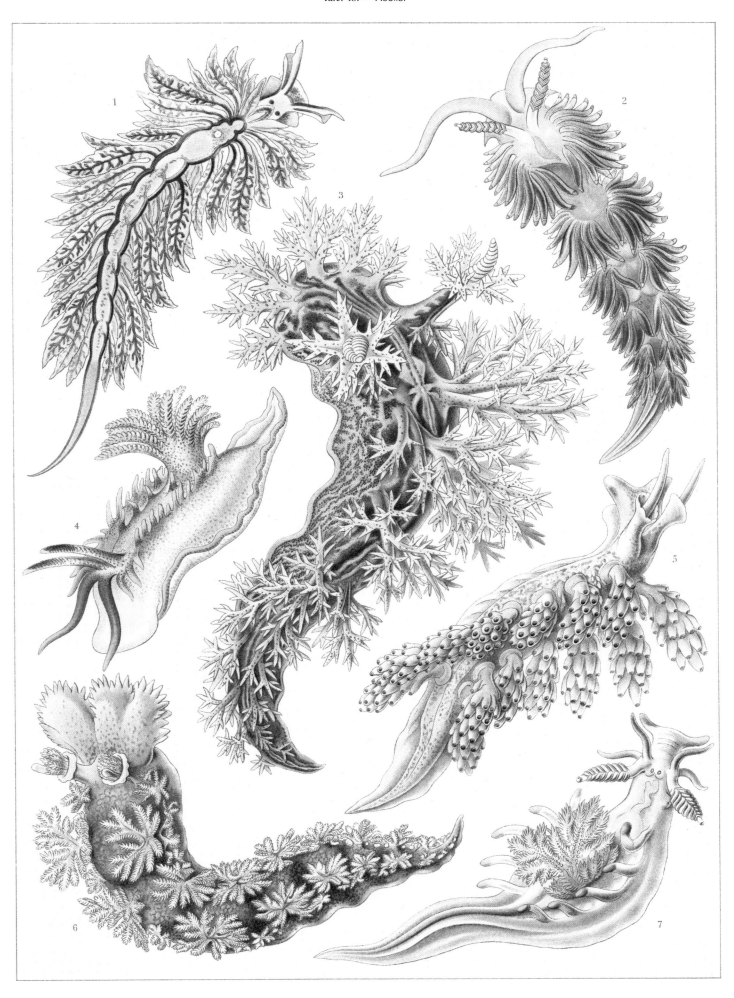

Nudibranchia. Nacktkiemen-Schnecken.

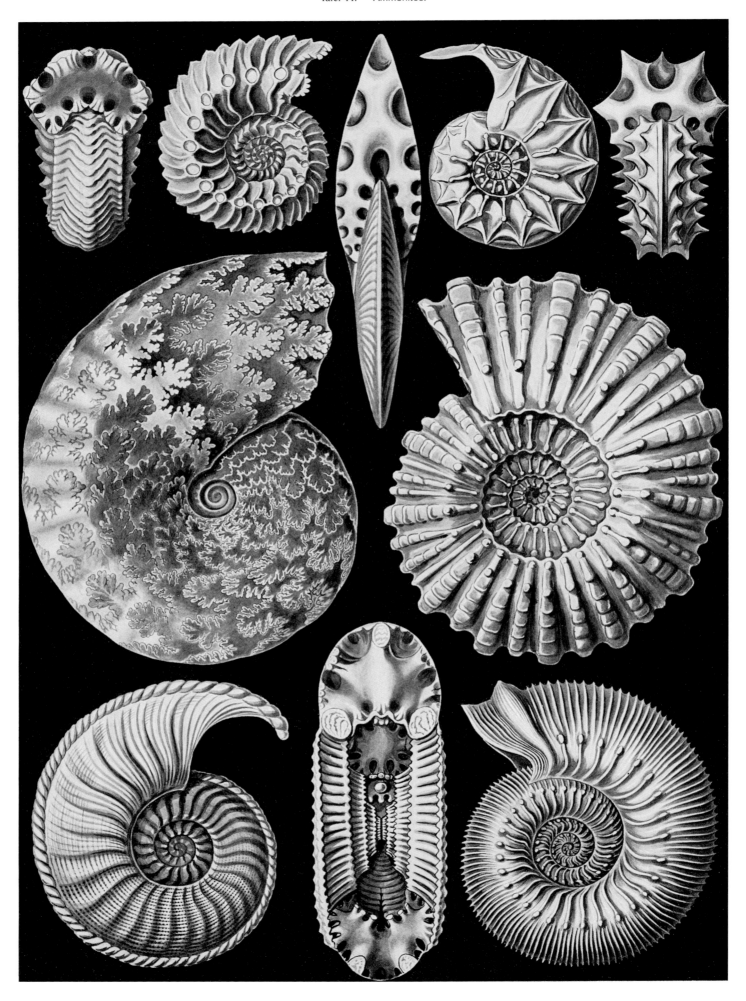

Ammonitida. Ammonshörner.

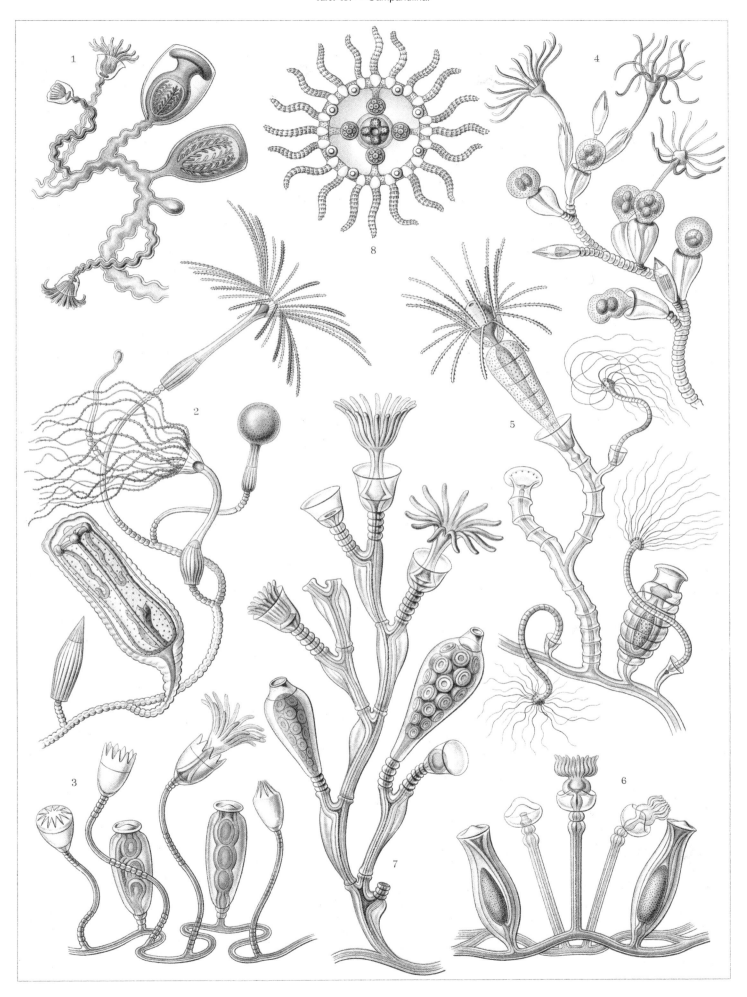

Campanariae. Glockenpolypen.

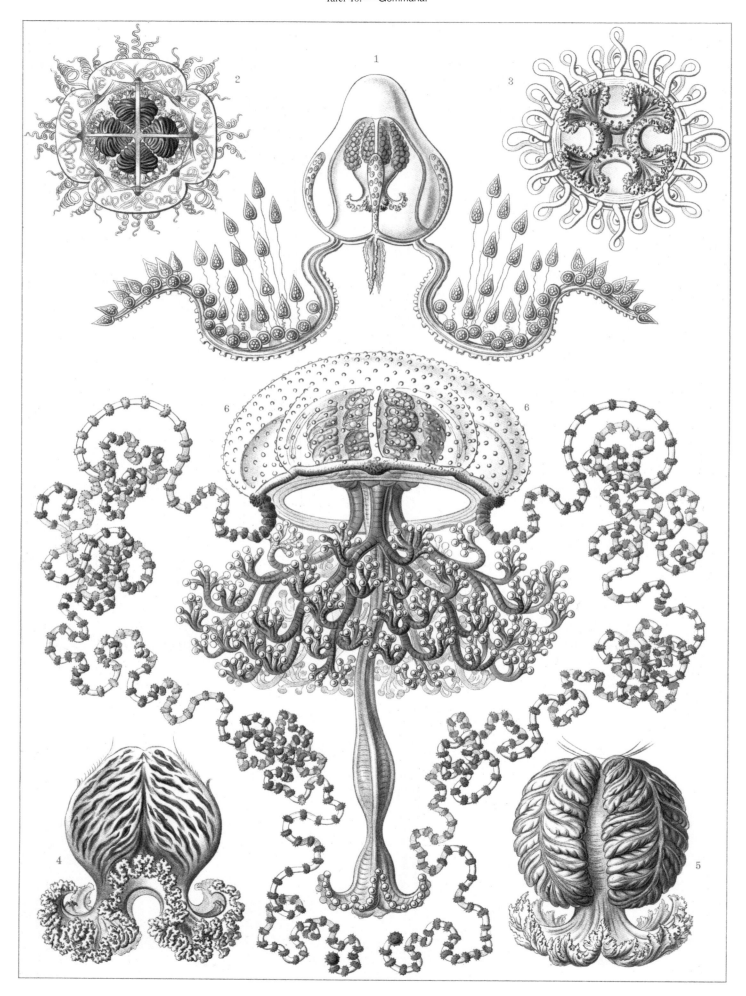

Anthomedusae. Blumenquallen.

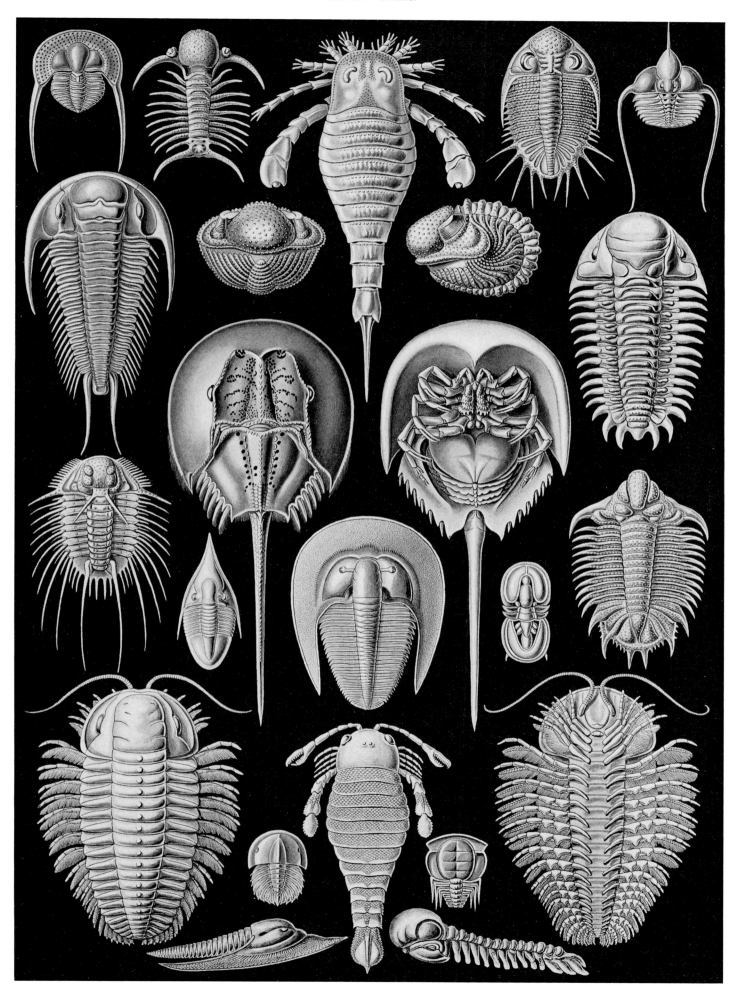

Aspidonia. Schildtiere.

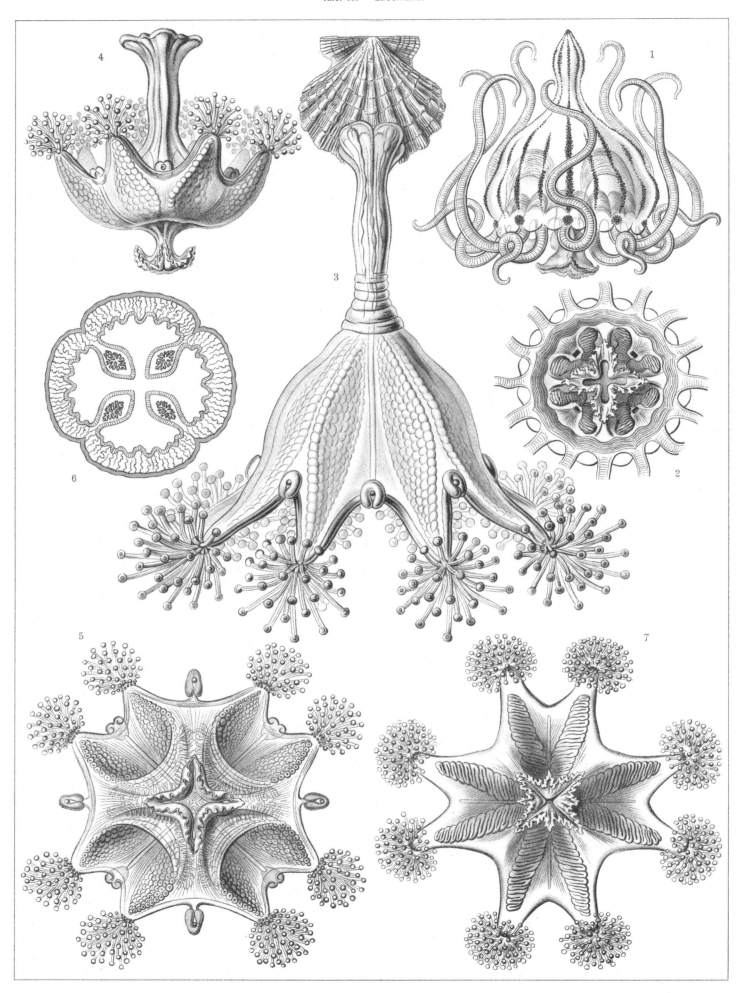

Stauromedusae. Becherquallen.

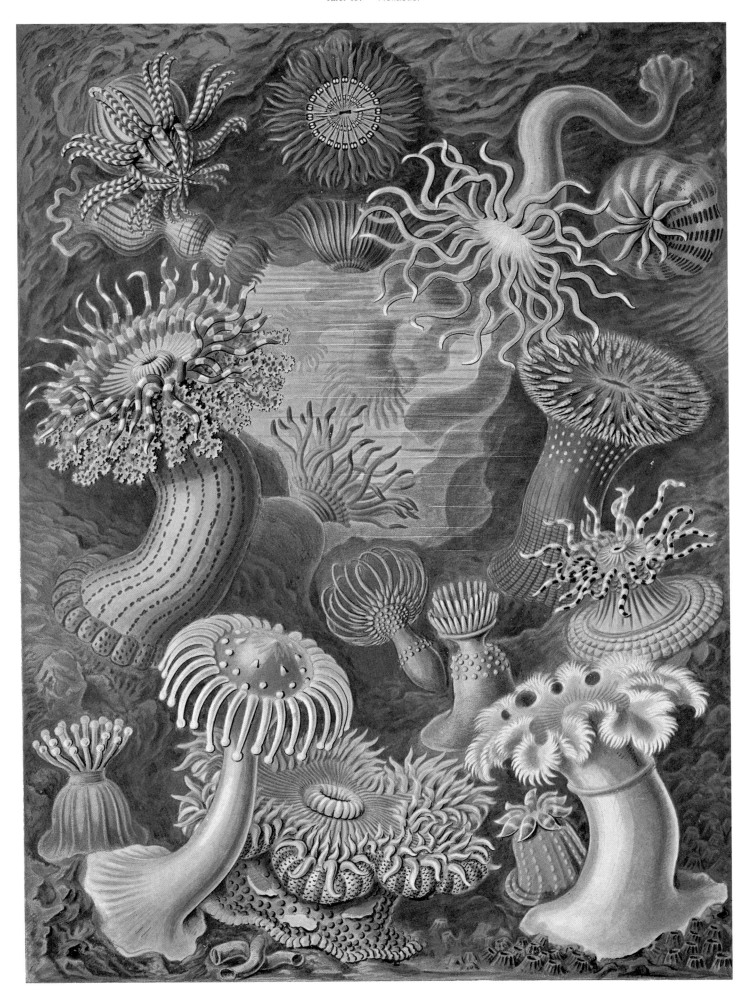

Actiniae. Seeanemonen.

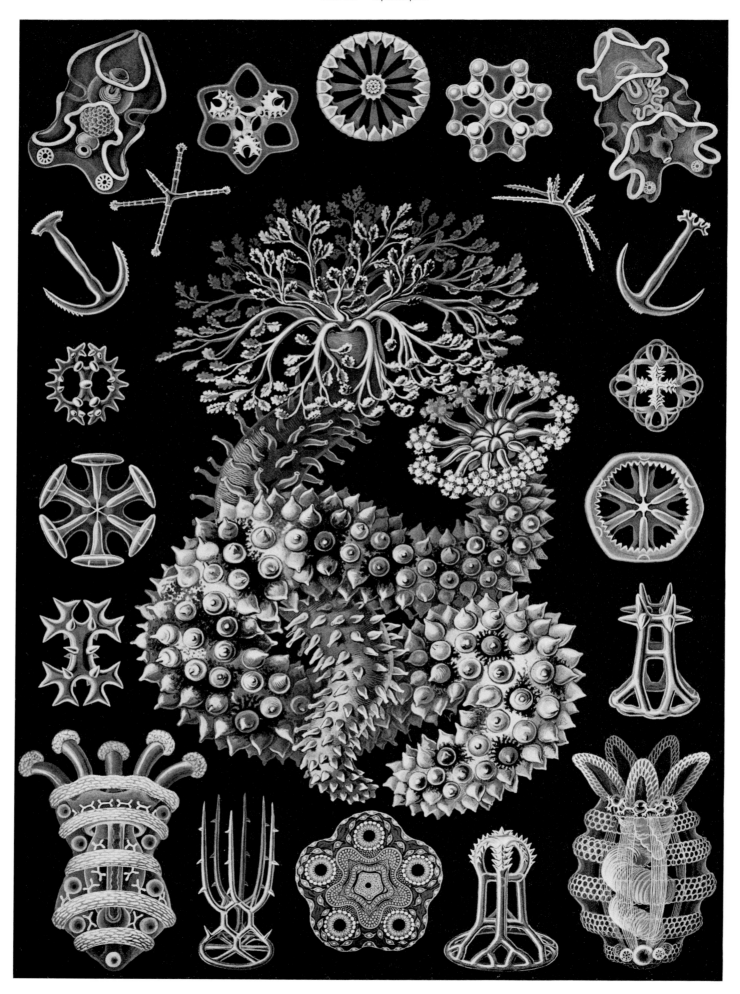

Thuroidea. Gurkensterne.

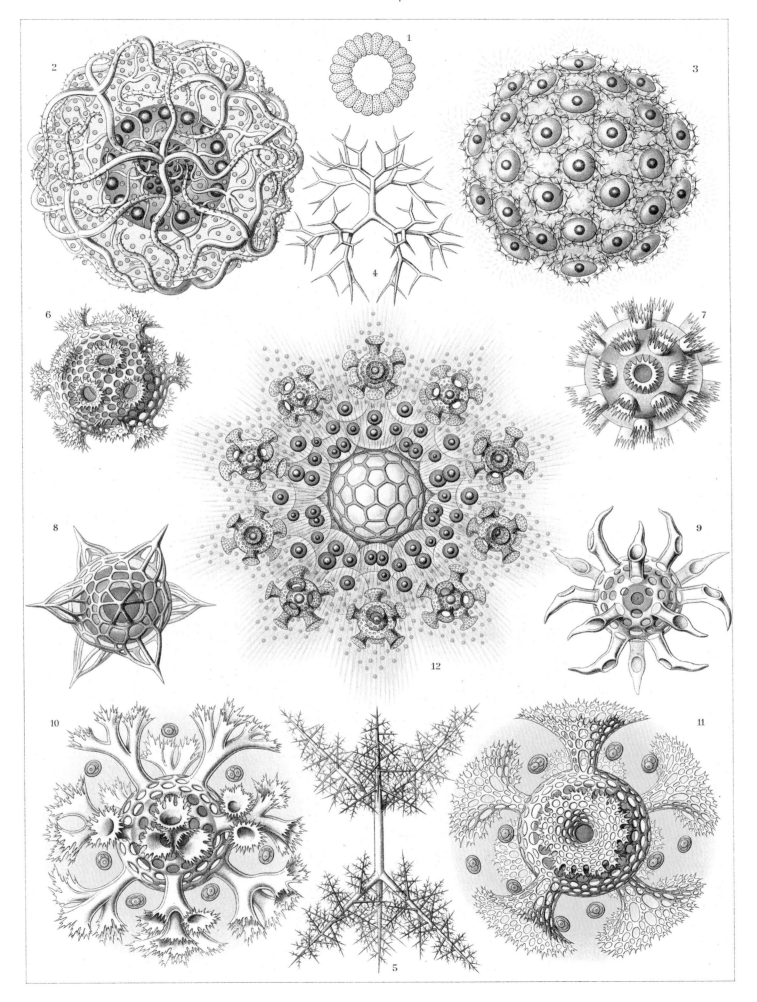

Polycyttaria. Vereins-Strahlinge.

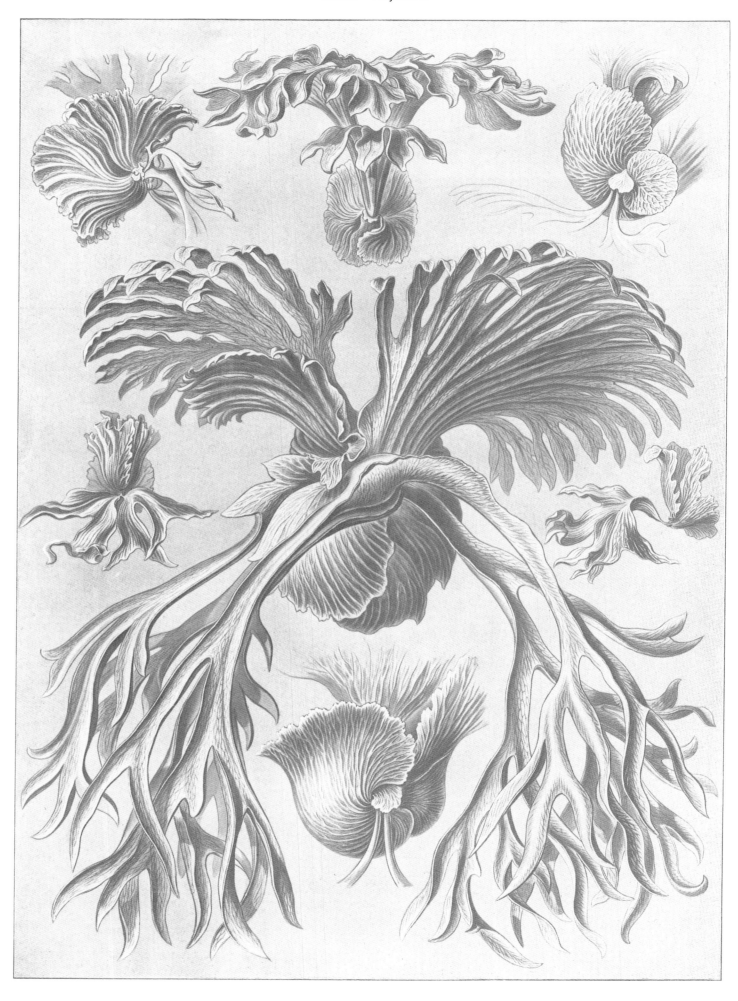

Filicinae. Laubfarne.

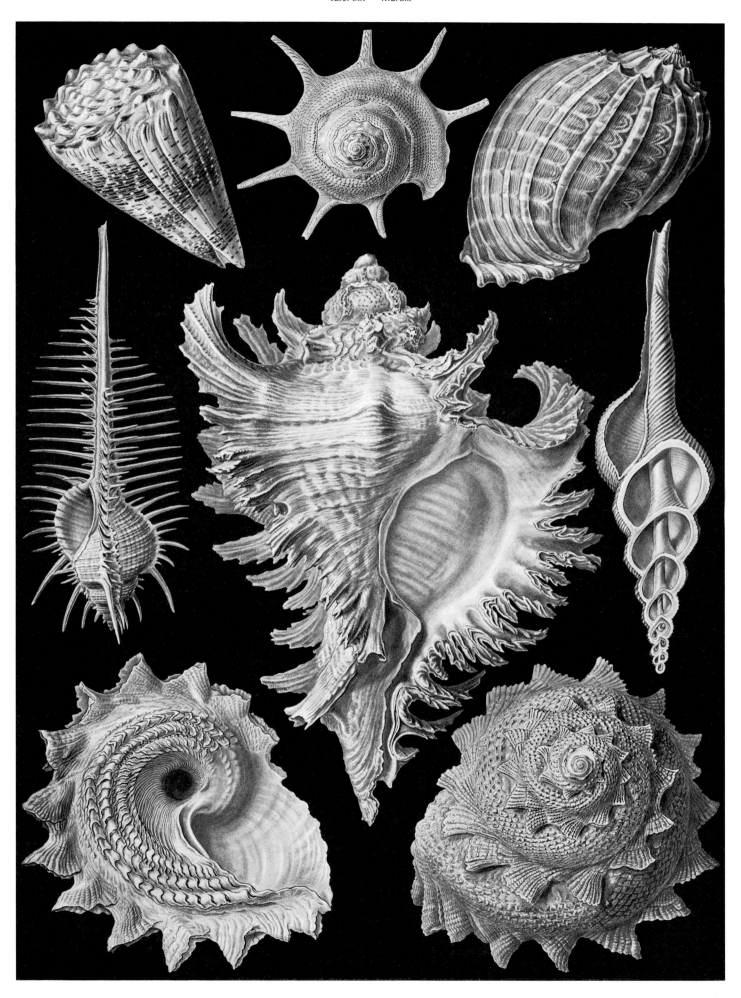

Prosobranchia. Vorderkiemen-Schnecken.

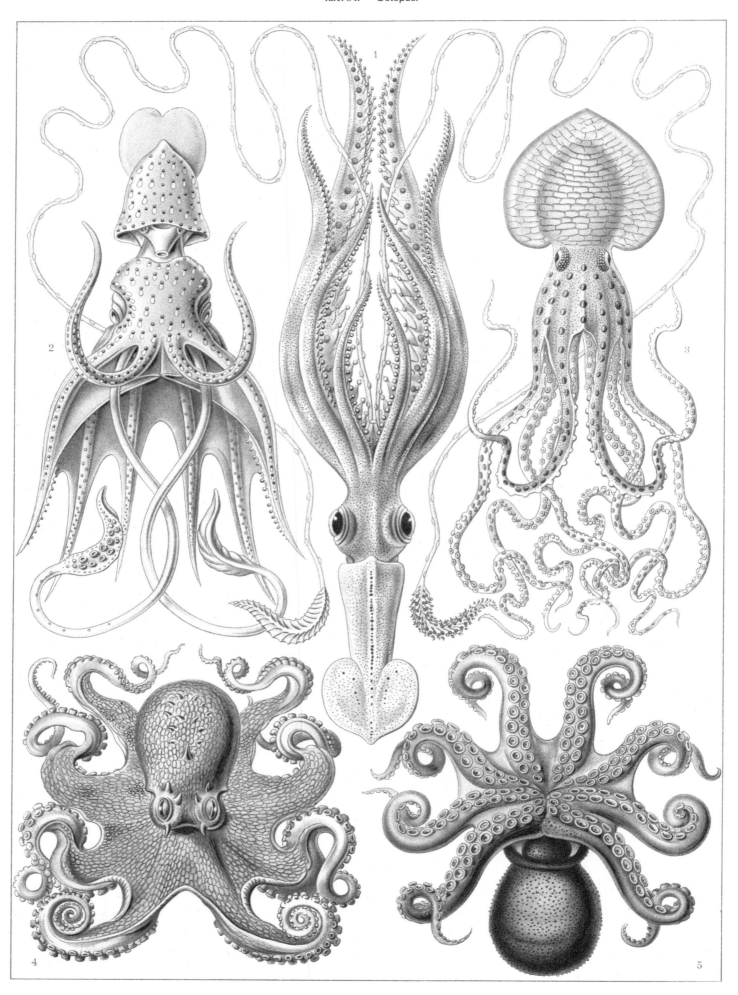

Gamochonia. Trichterkraken.

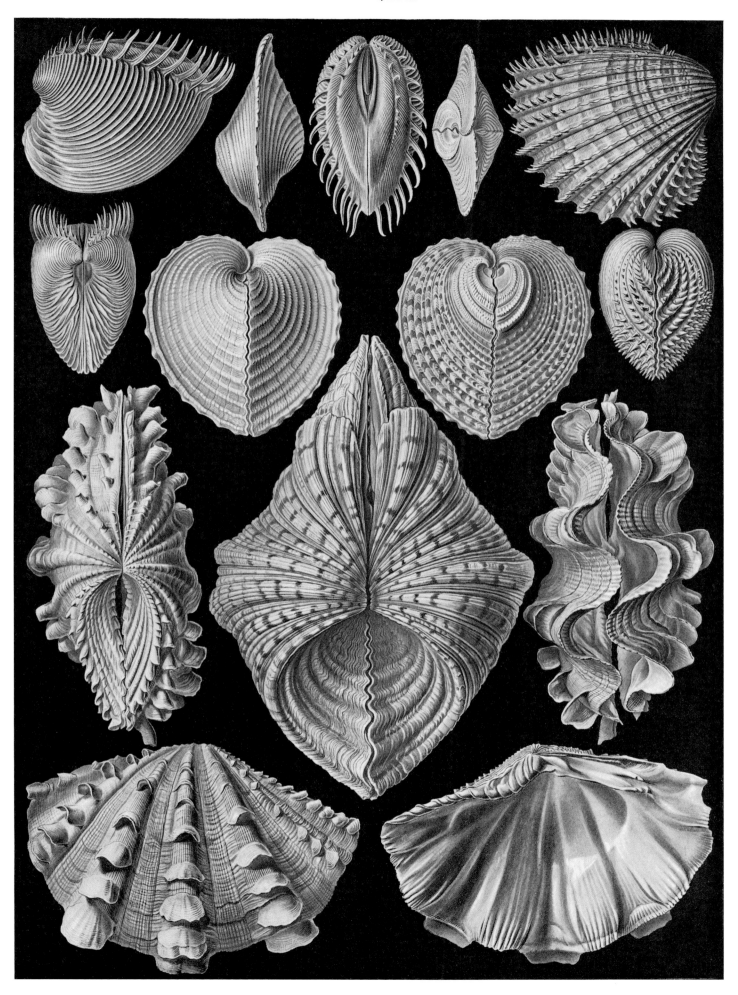

Acephala. Muscheln.

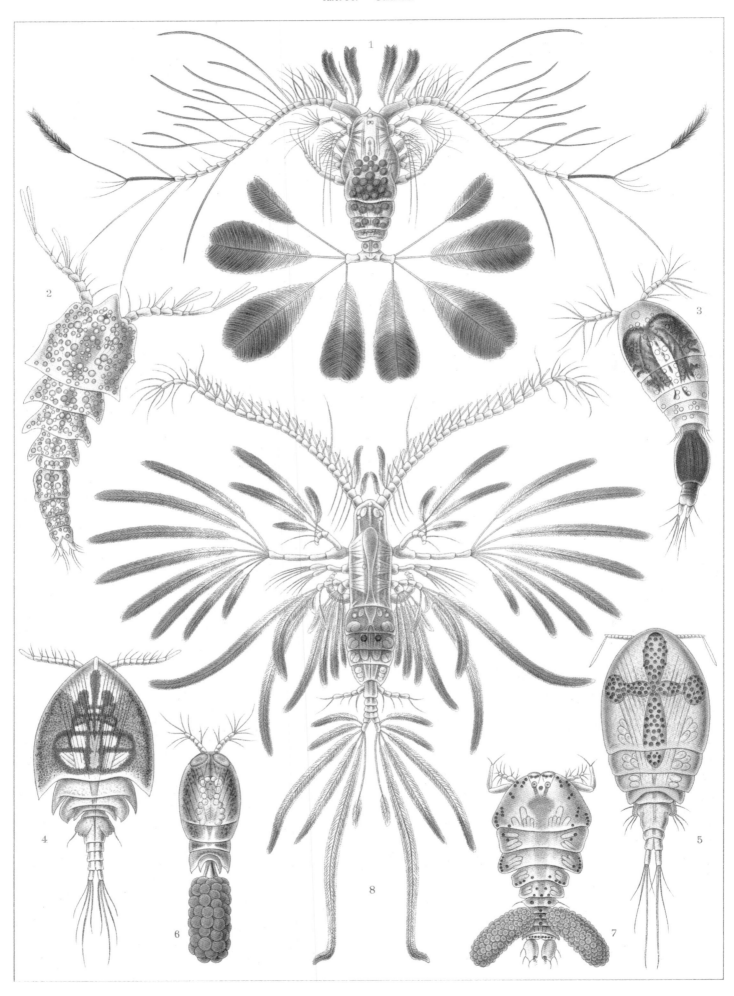

Copepoda. Ruderkrebse.

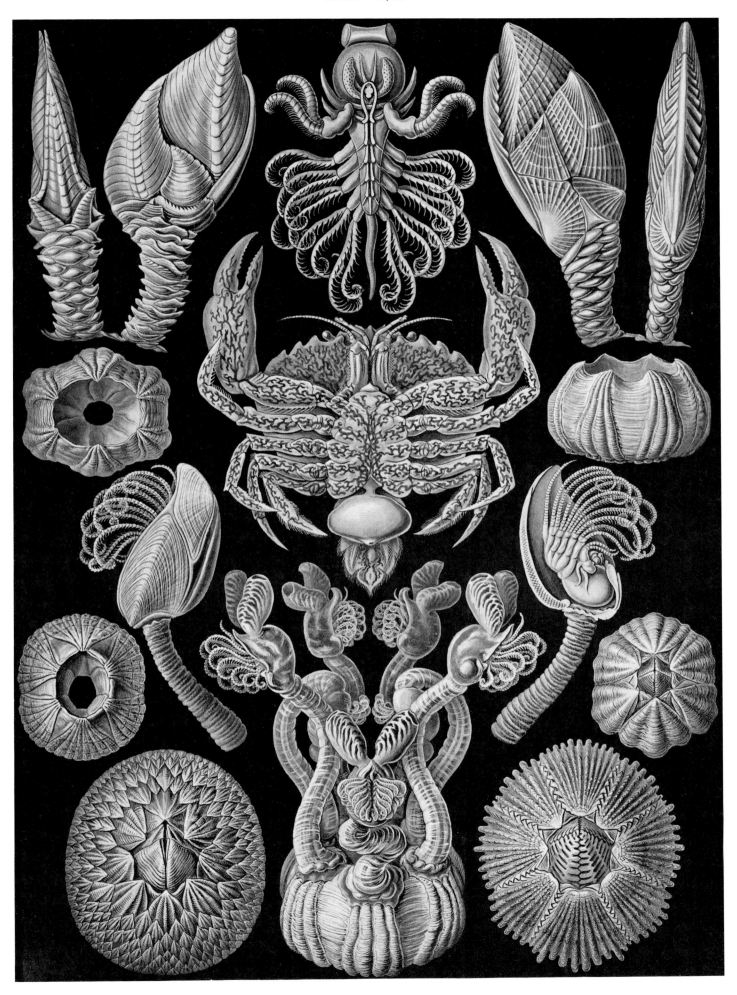

Cirripedia. Rankenkrebse.

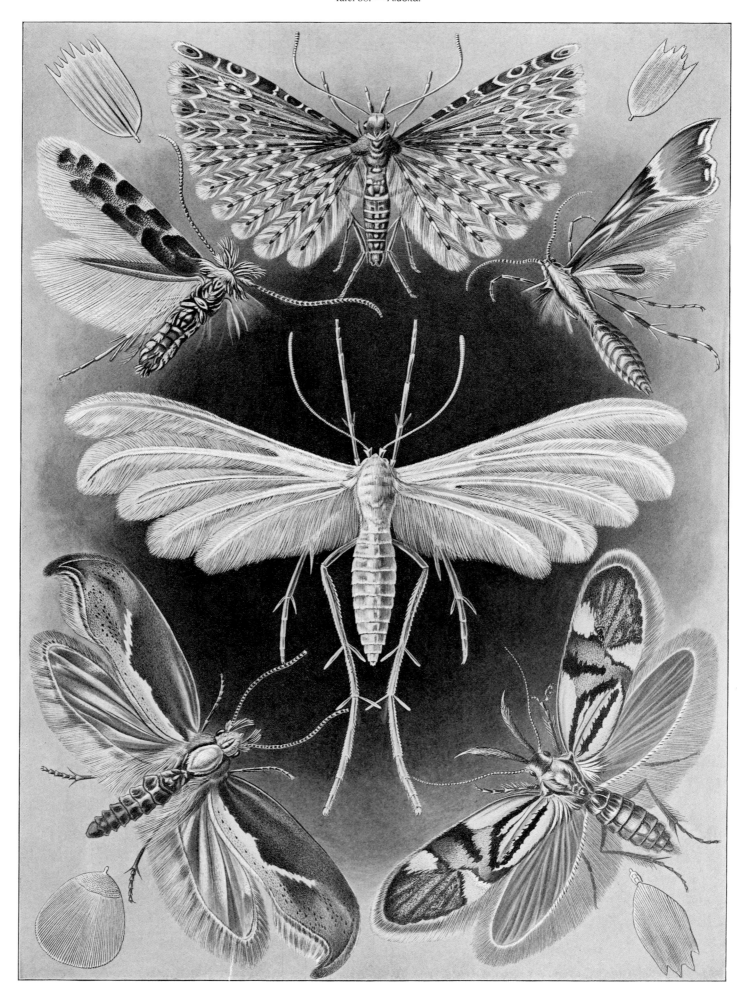

Tineida. Motten.

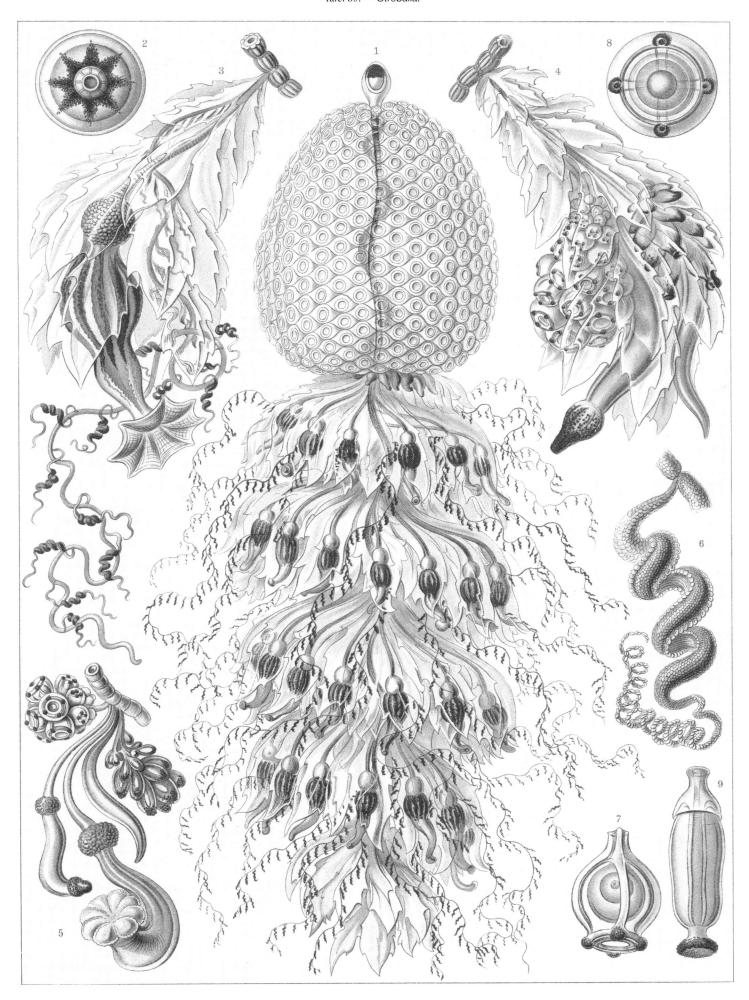

Siphonophorae. Staatsquallen.

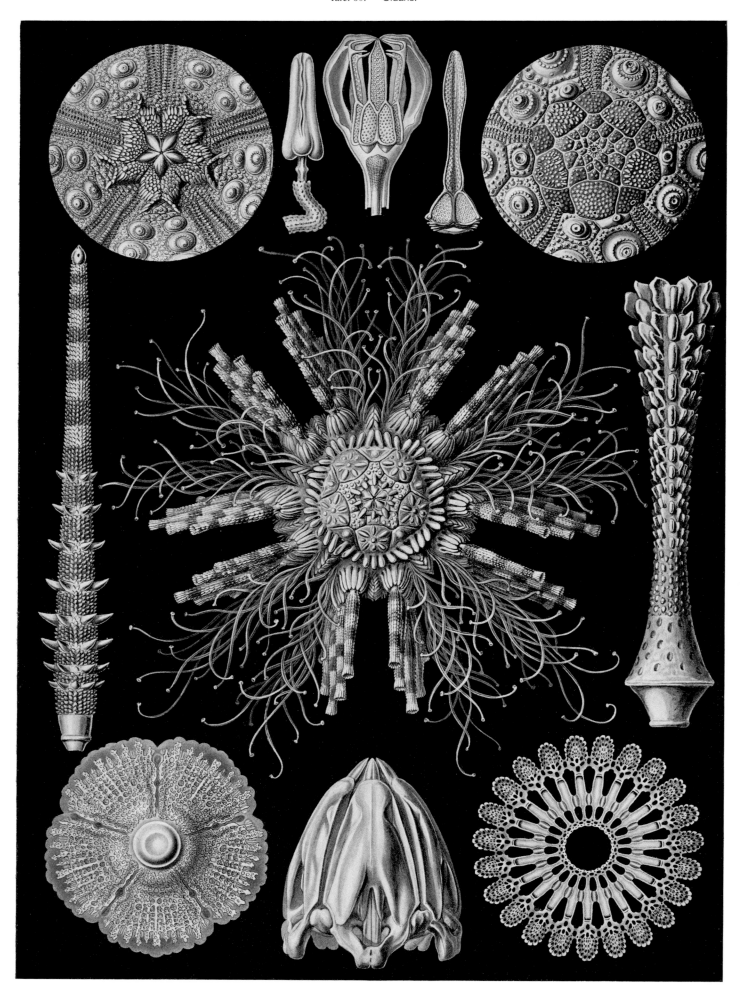

Echinidea. Igelsterne.

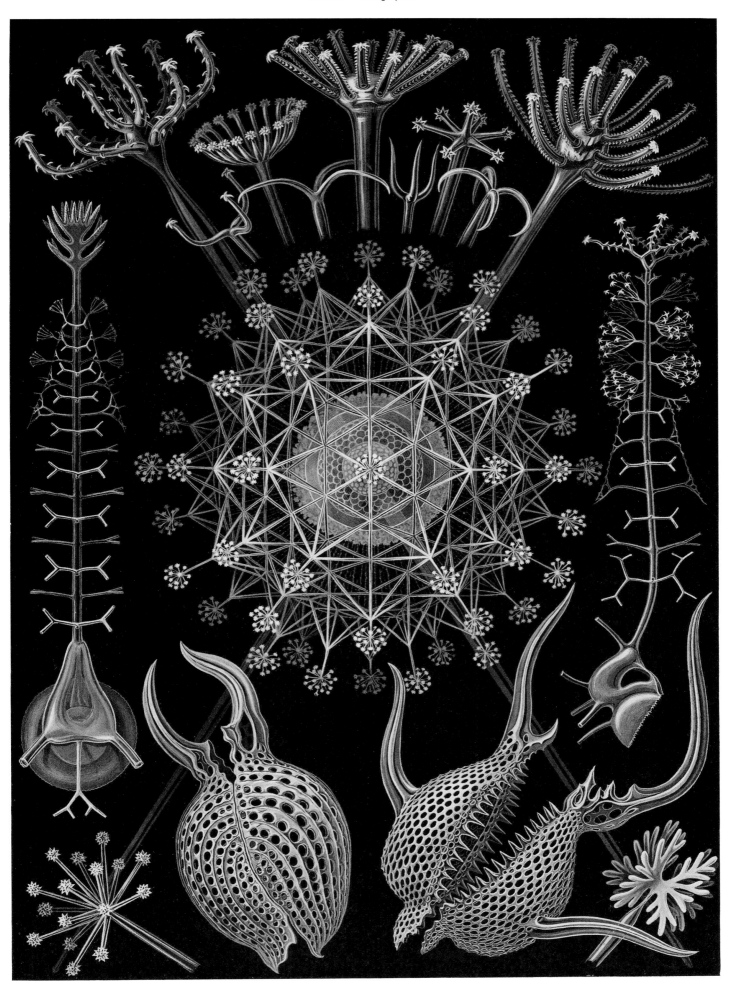

Phaeodaria. Rohrstrahlinge.

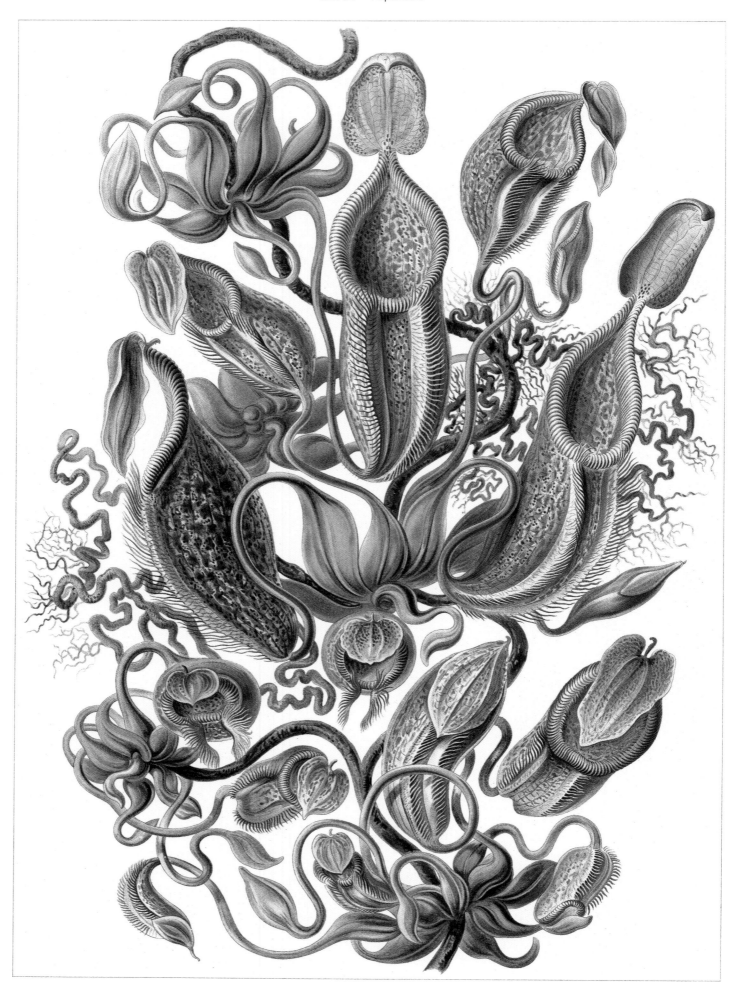

Nepenthaceae. Kannenpflanzen.

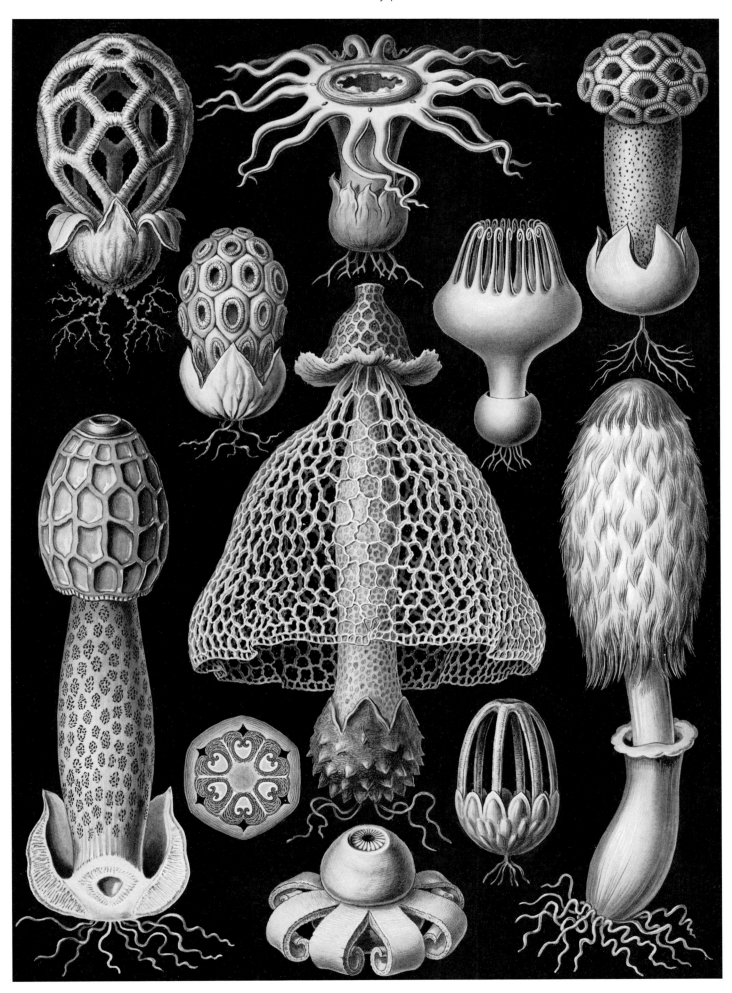

Basimycetes. Schwammpilze.

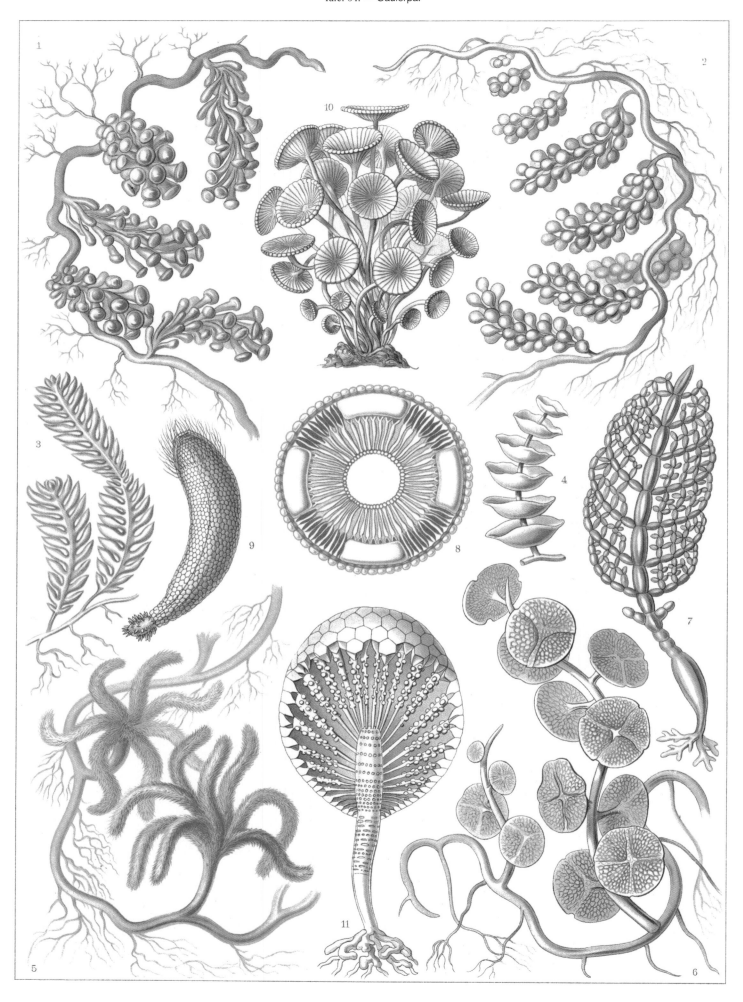

Siphoneae. Riesen-Algetten.

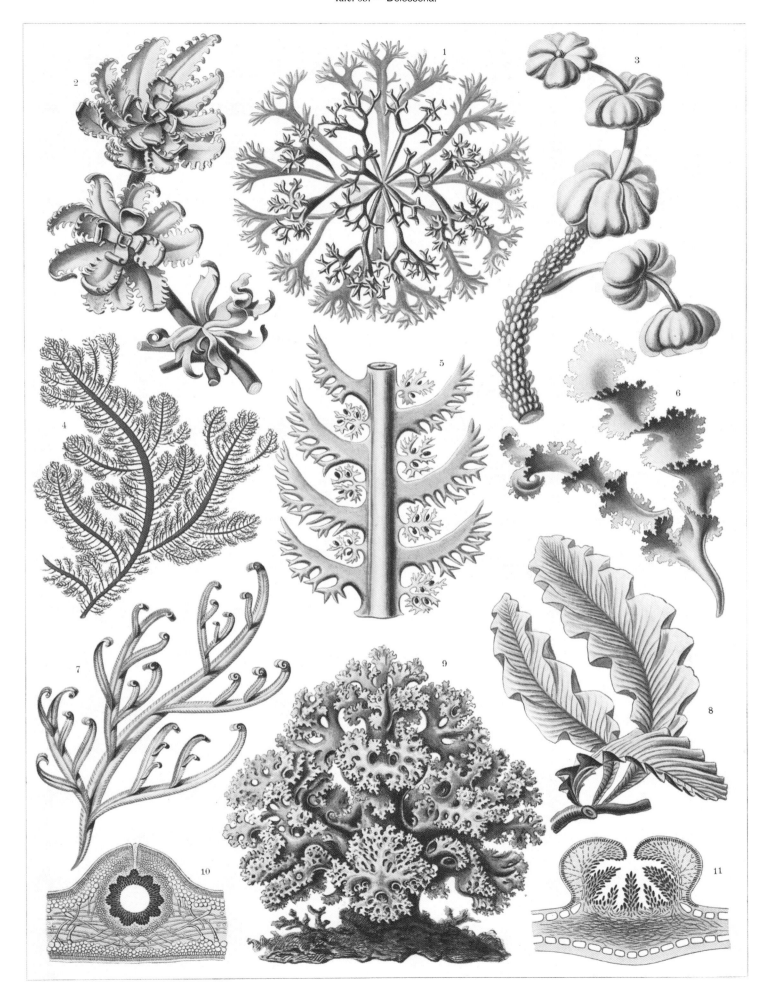

Florideae. Rotalgen.

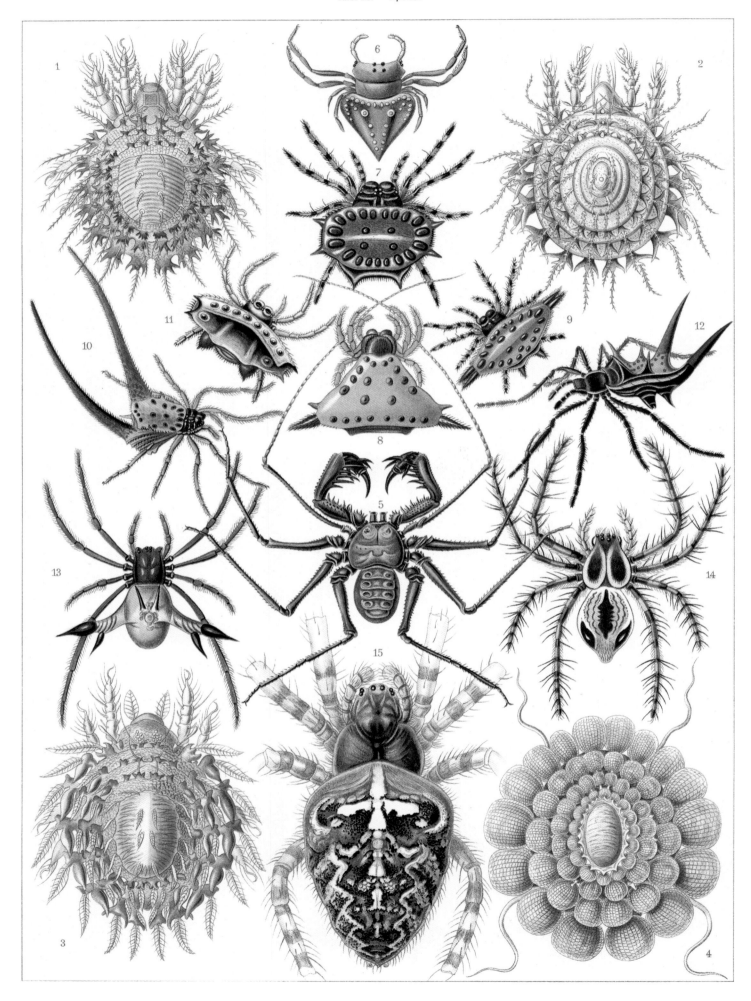

Arachnida. Spinnentiere.

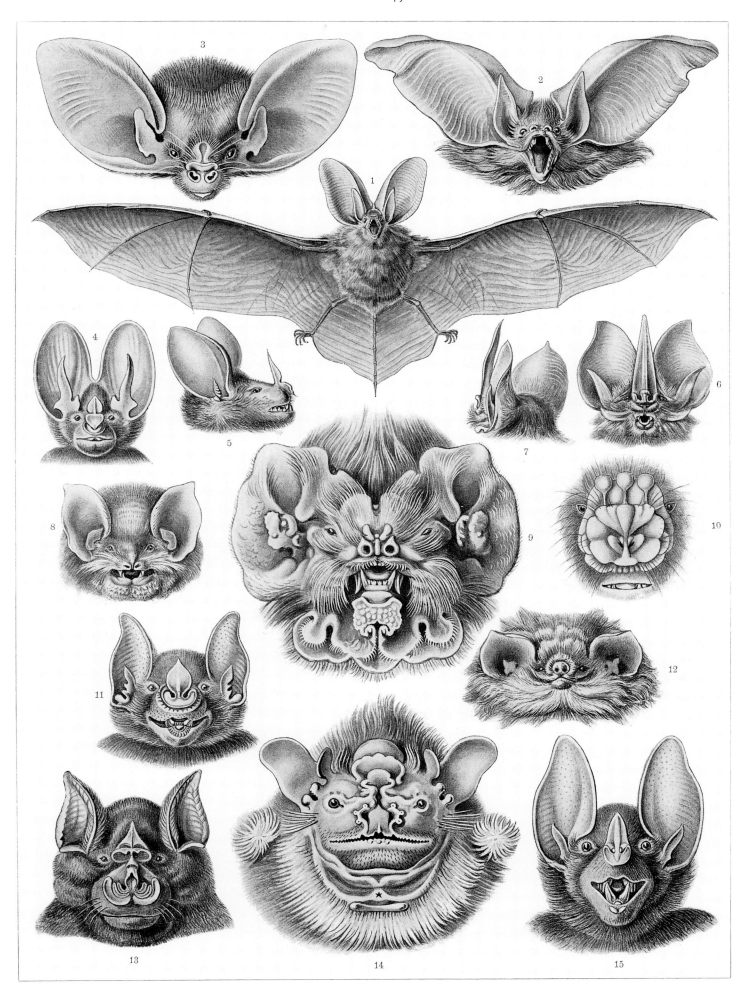

Chiroptera. Fledertiere.

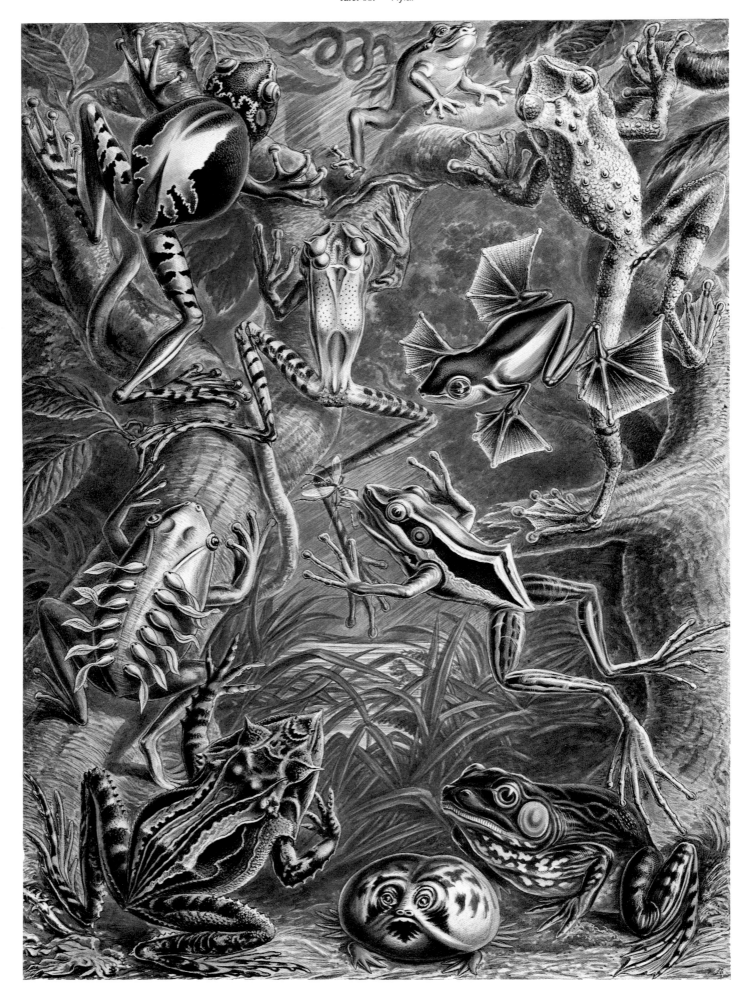

Batrachia. Frösche.

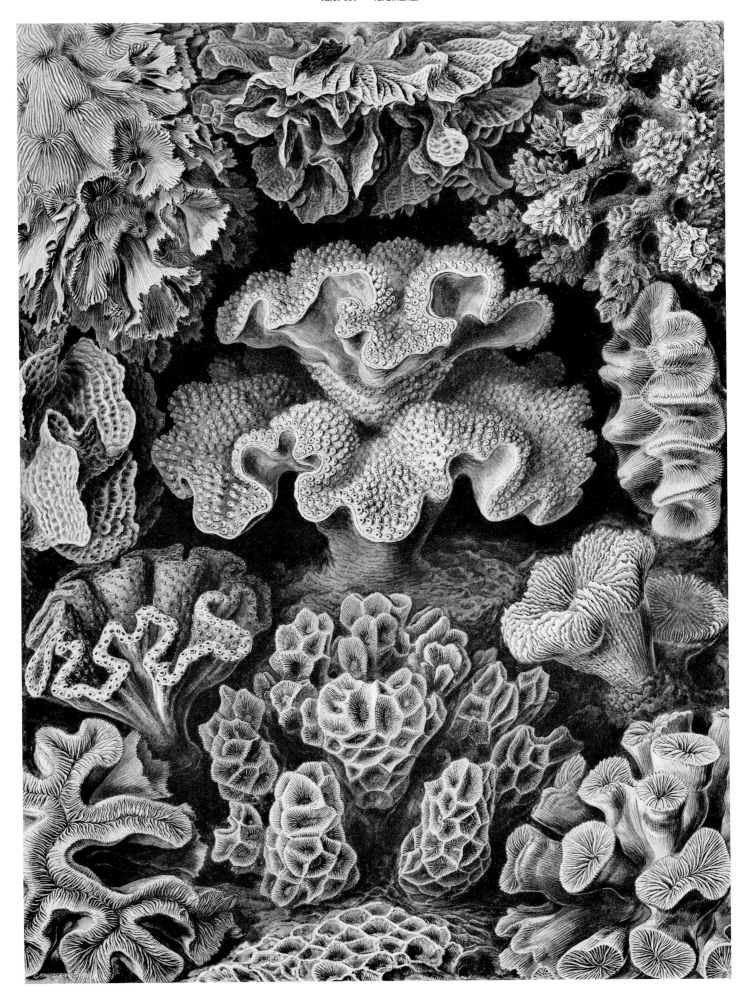

Hexacoralla. Sechsstrahlige Sternkorallen.

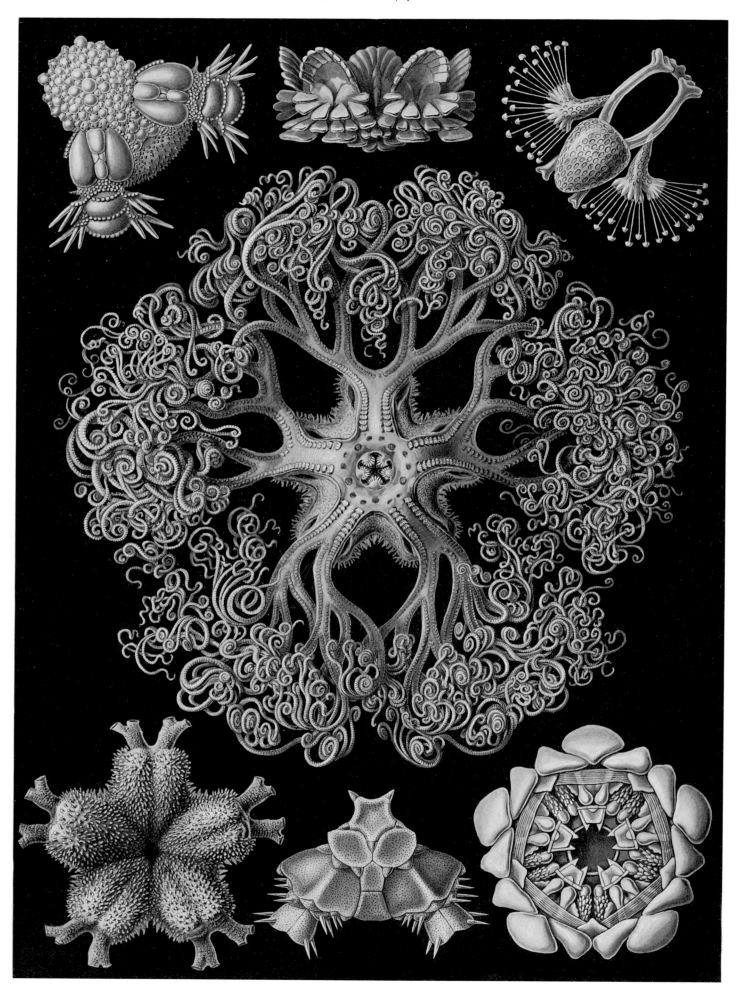

Ophiodea. Schlangensterne.

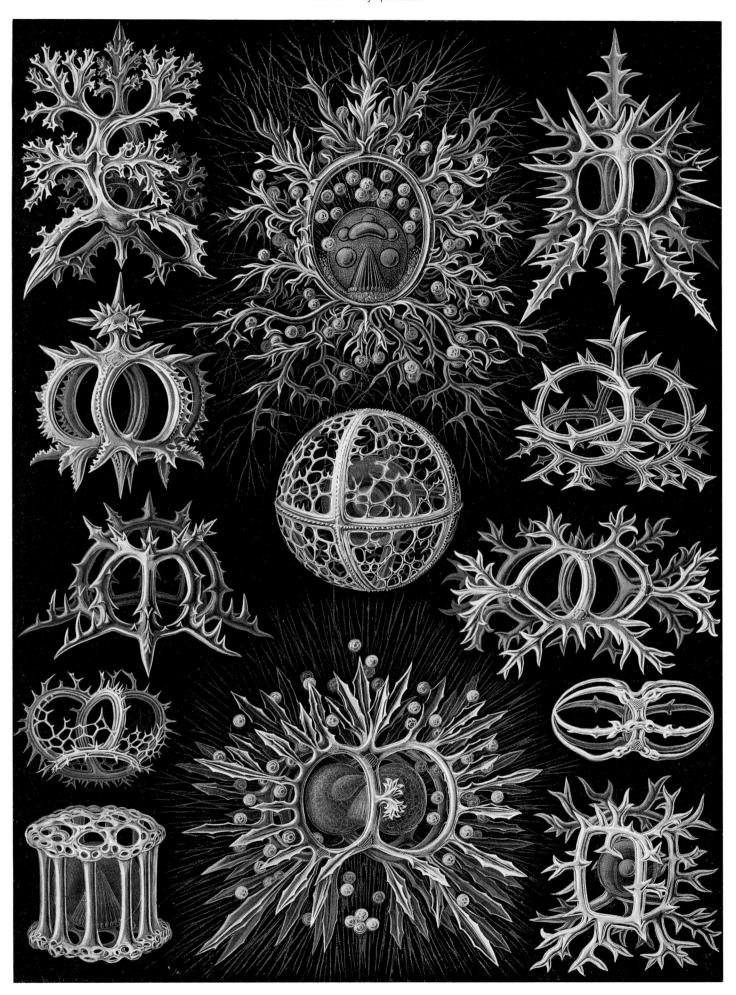

Stephoidea. Ringel-Strahlinge.

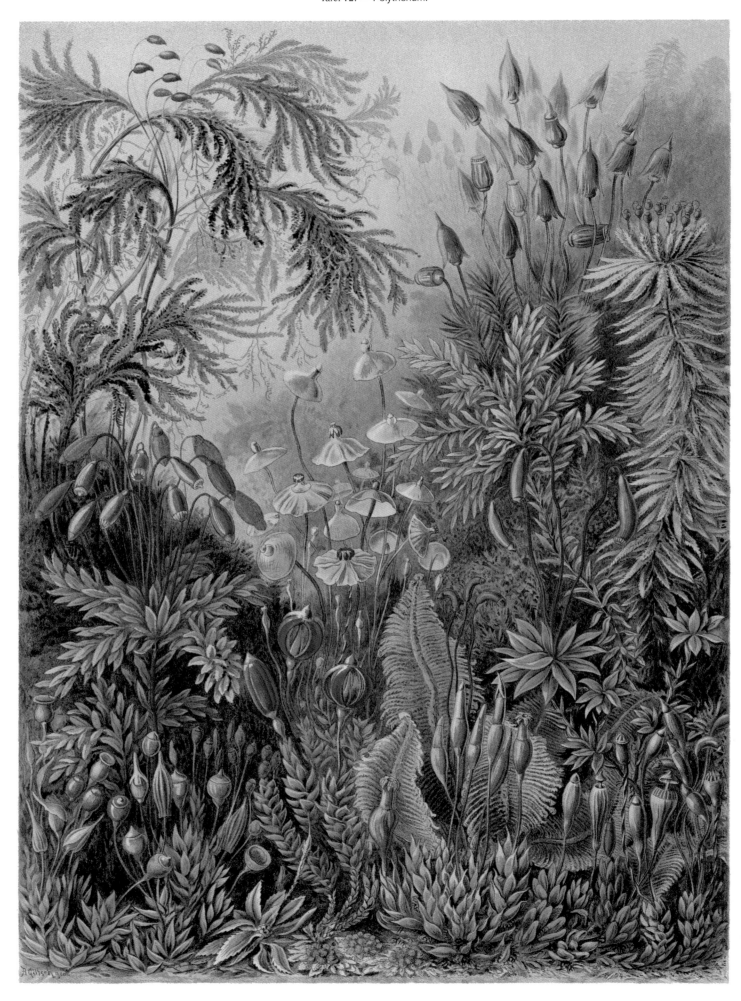

Muscinae. Laubmoose.

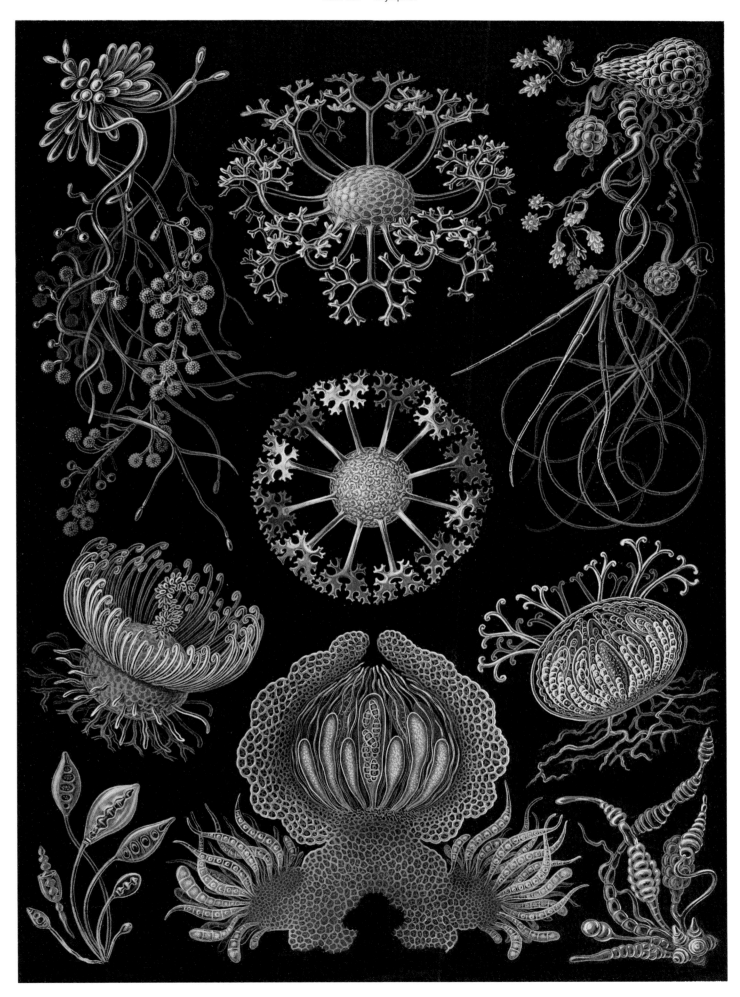

Ascomycetes. Schlauchpilze.

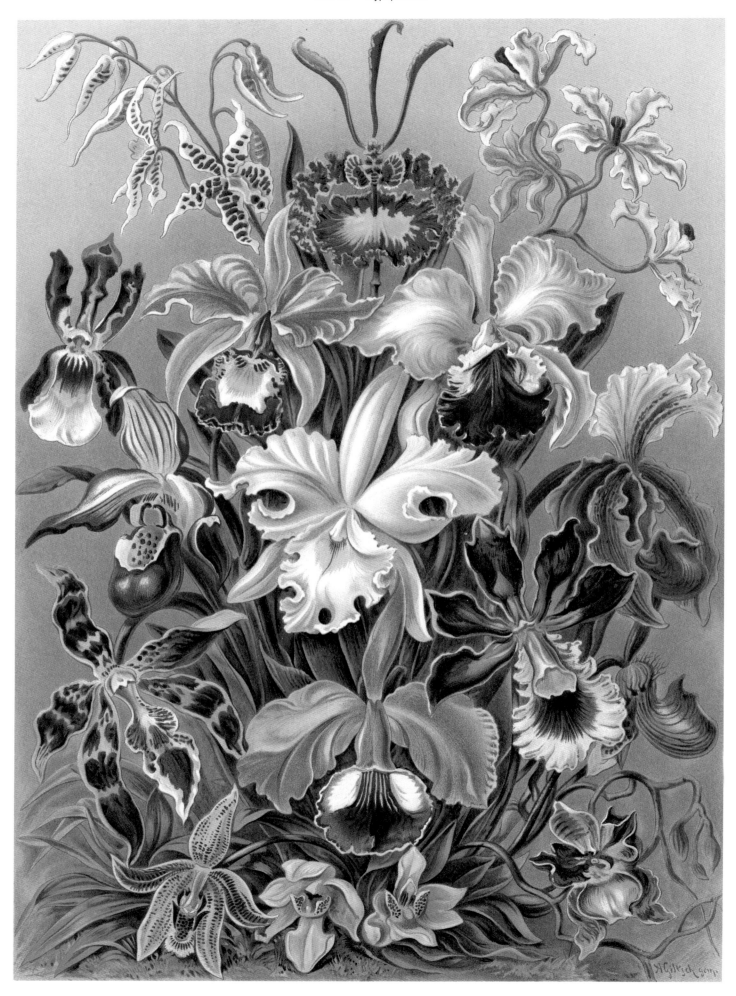

Orchideae. Venusblumen.

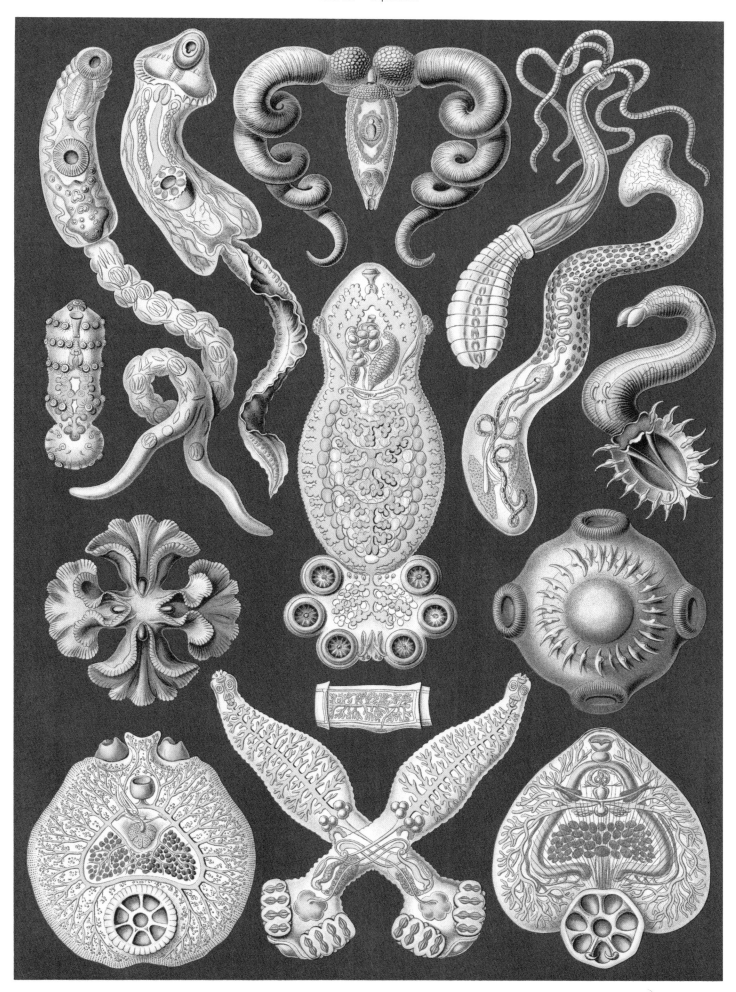

Platodes. Plattentiere.

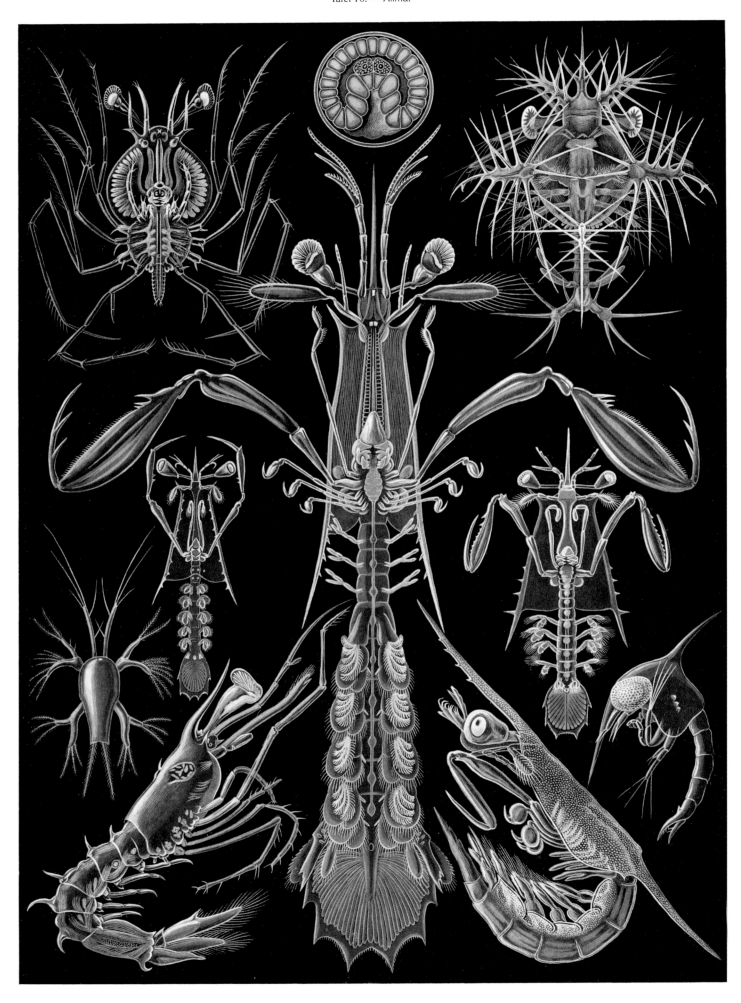

Thoracostraca. Panzerkrebse.

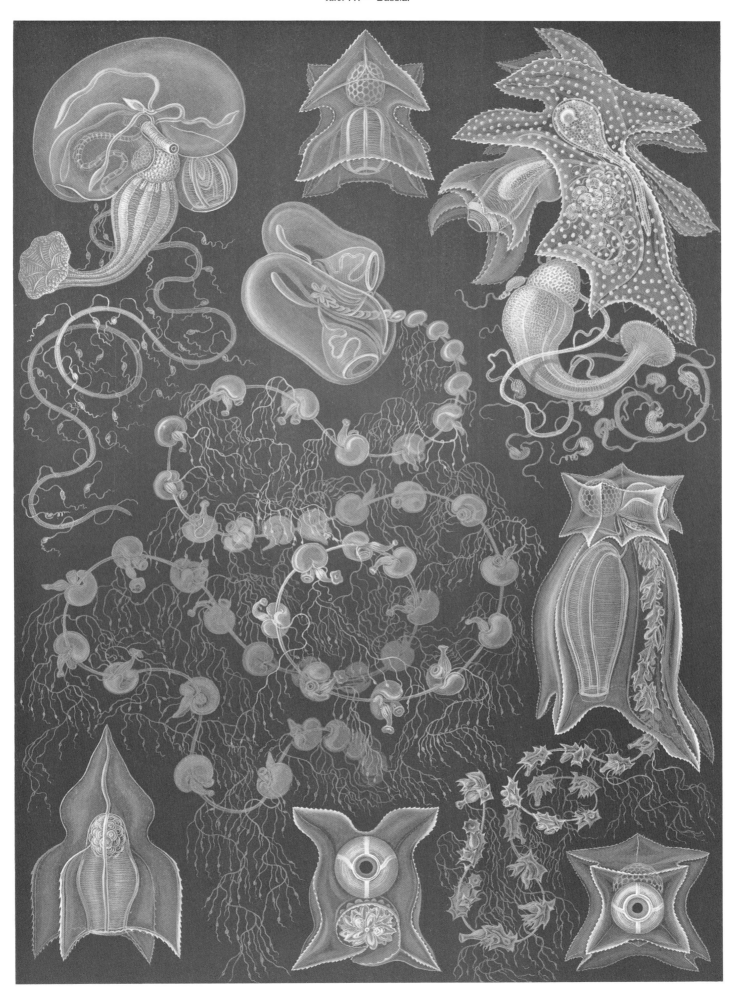

Siphonophorae. Staatsquallen.

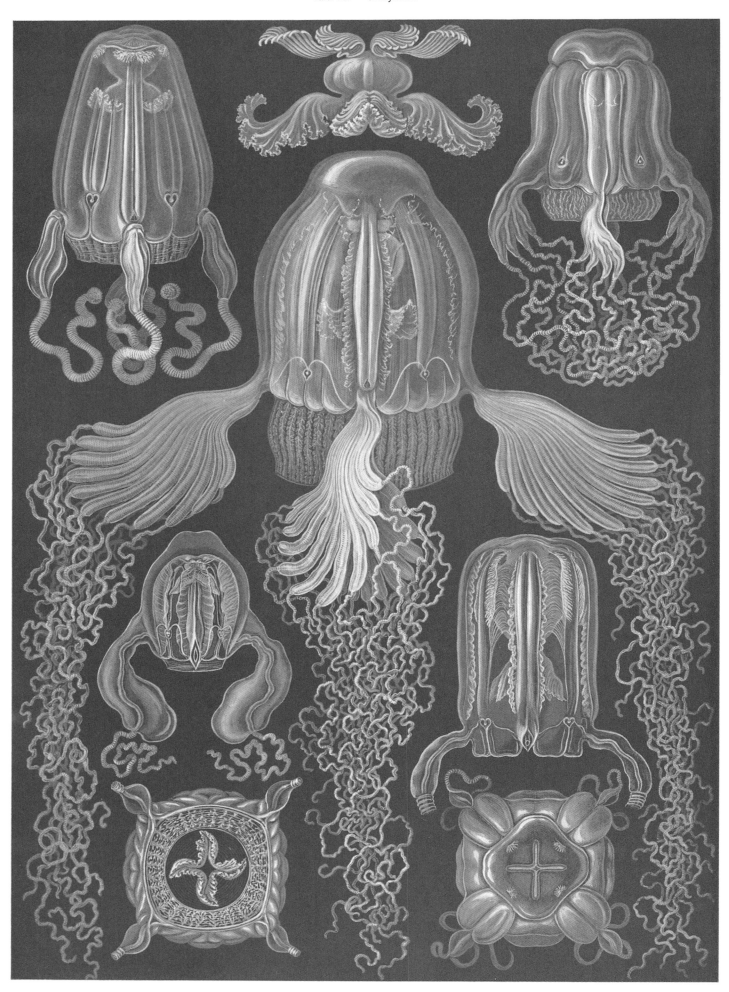

Cubomedusae. Würfelquallen.

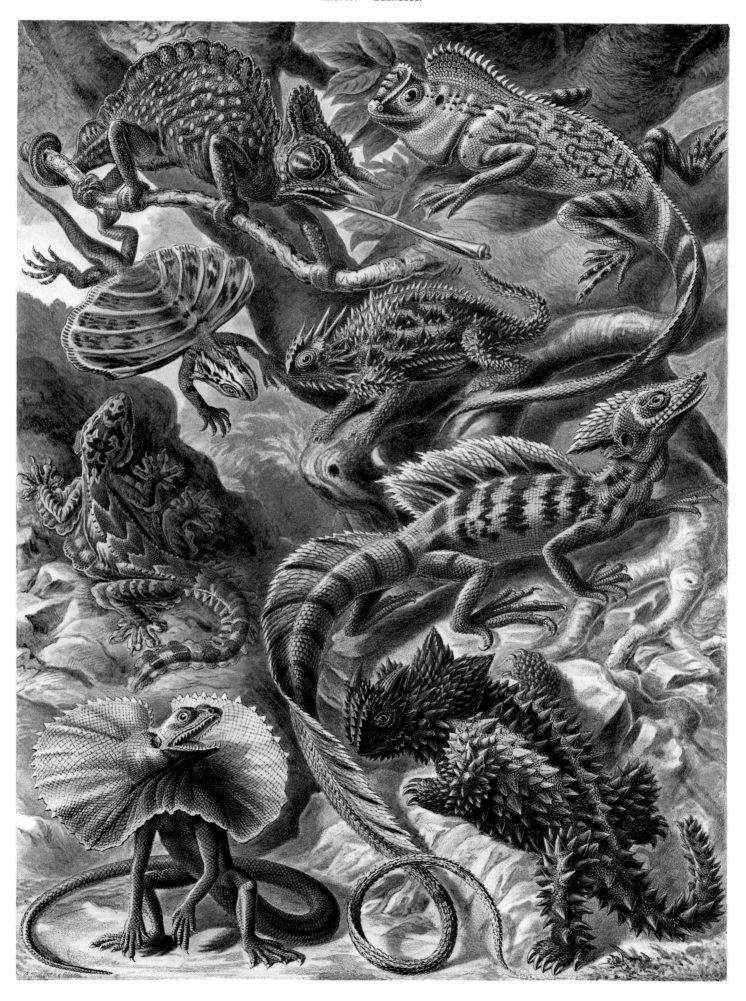

Lacertilia. Eidechsen.

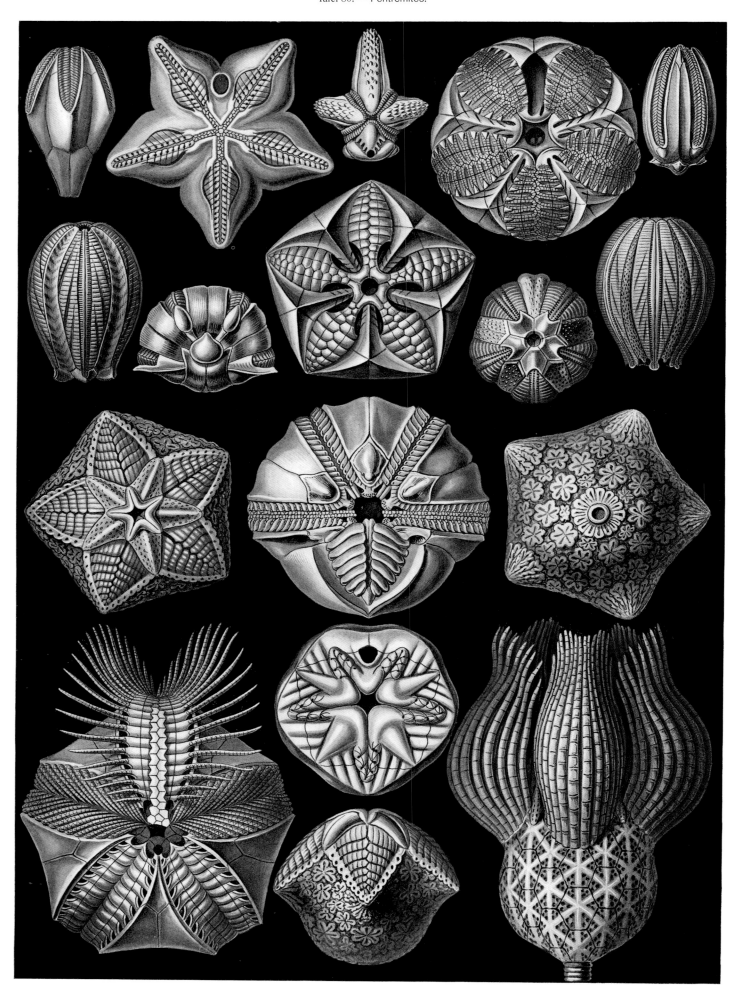

Blastoidea. Knospensterne.

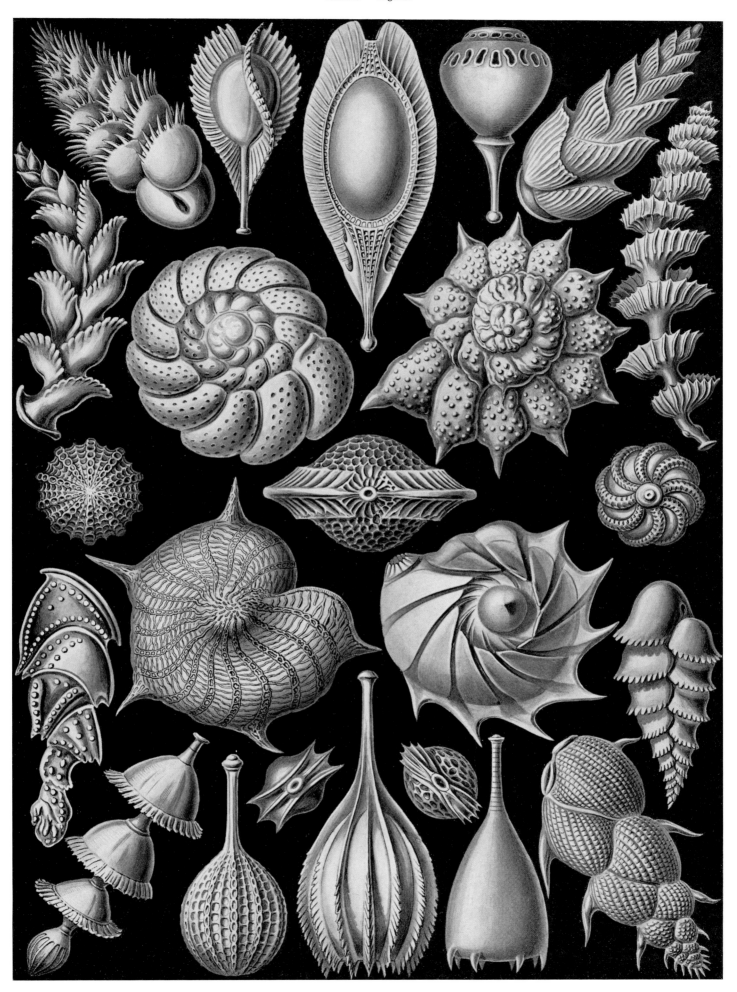

Thalamophora. Kammerlinge.

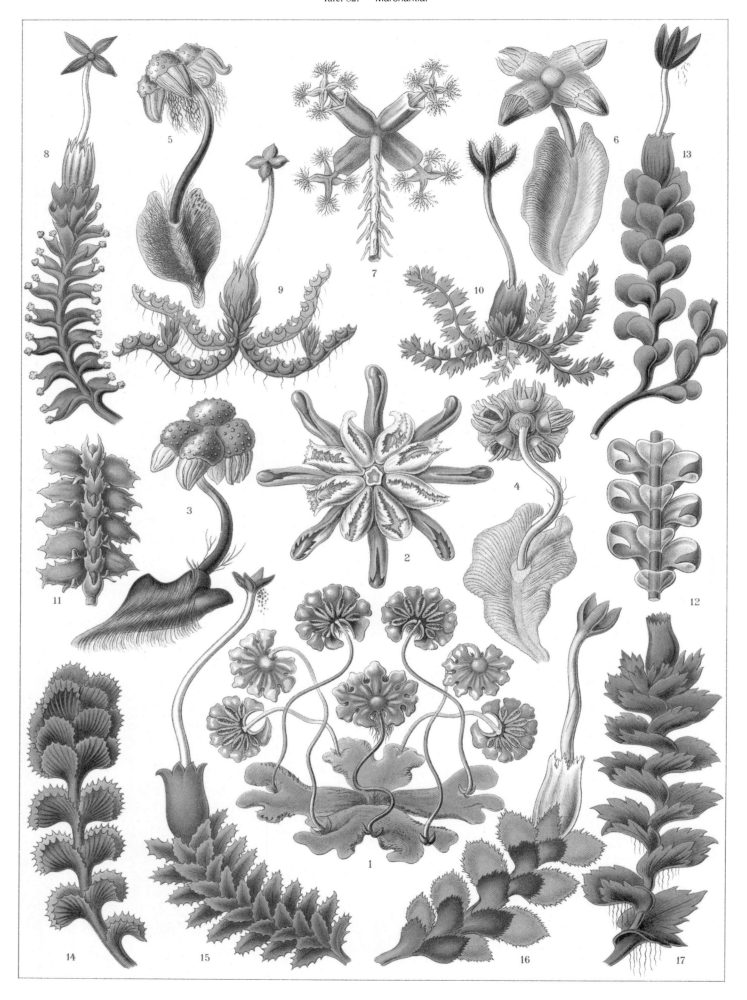

Hepaticae. Lebermoose.

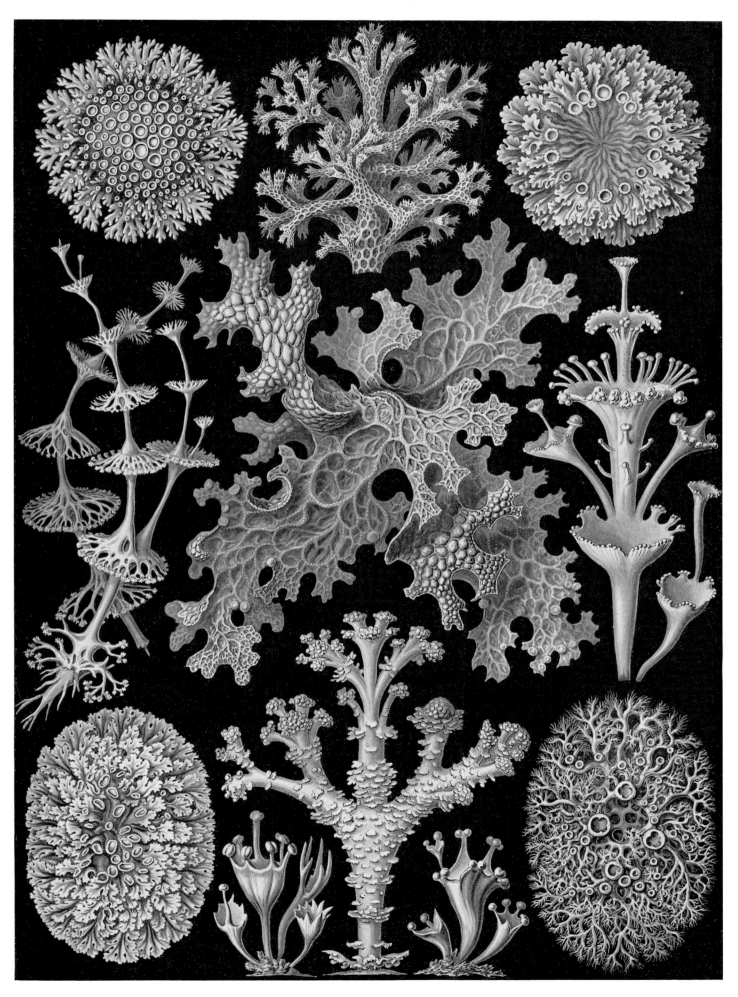

Lichenes. Flechten.

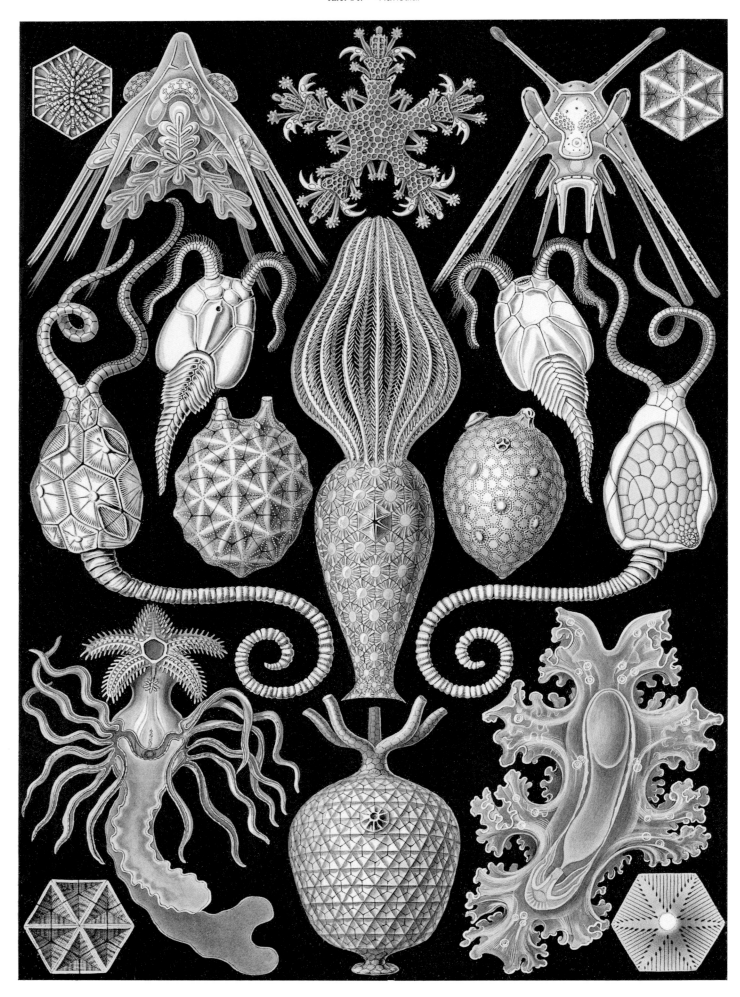

Diatomea. Schachtellinge.

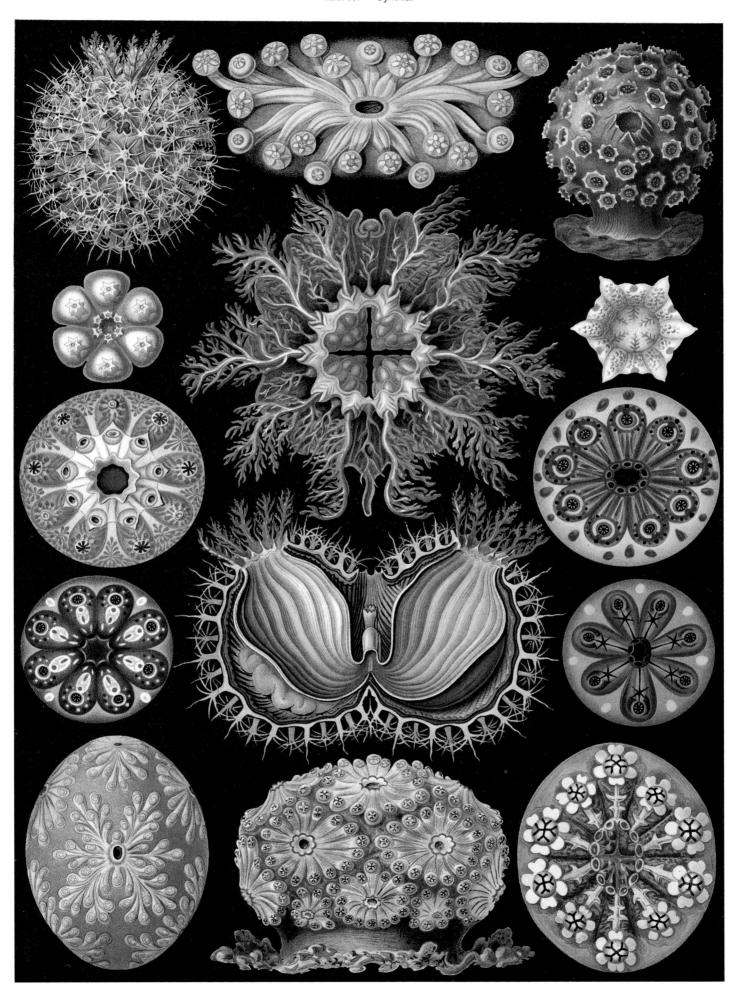

Ascidiae. Seescheiden.

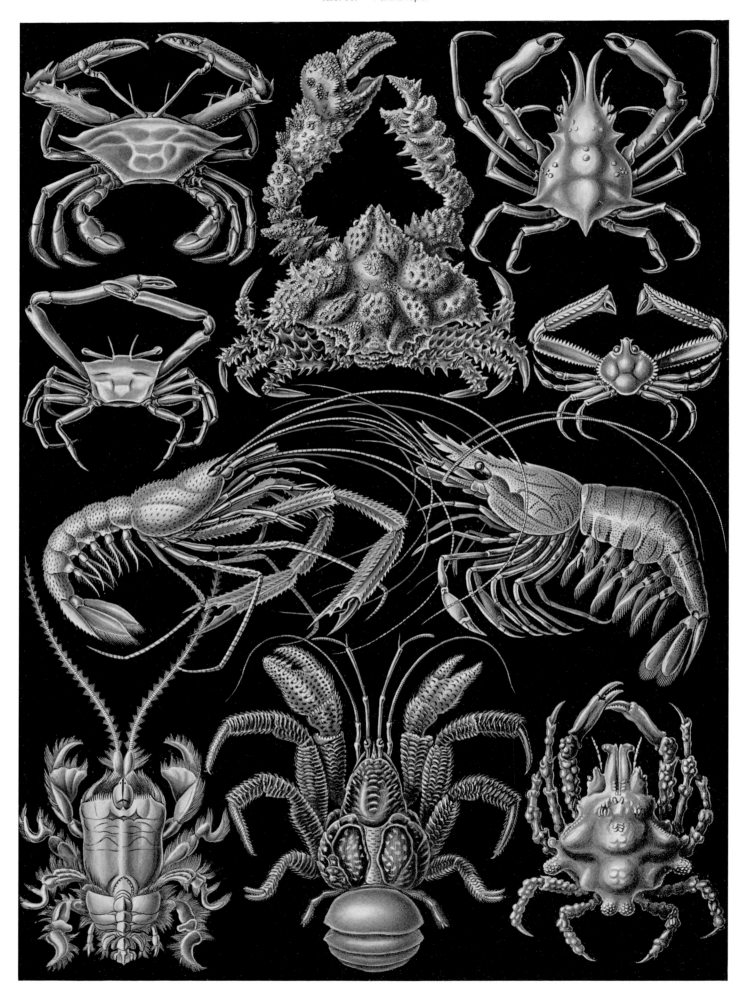

Decapoda. Zehnfußkrebse.

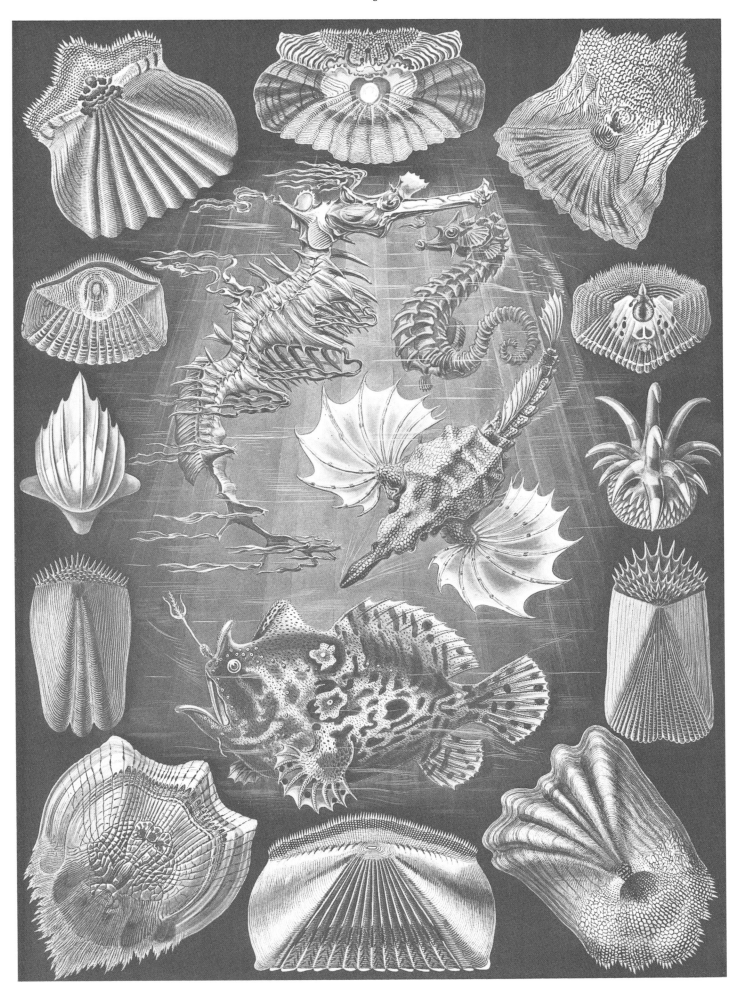

Teleostei. Knochenfische.

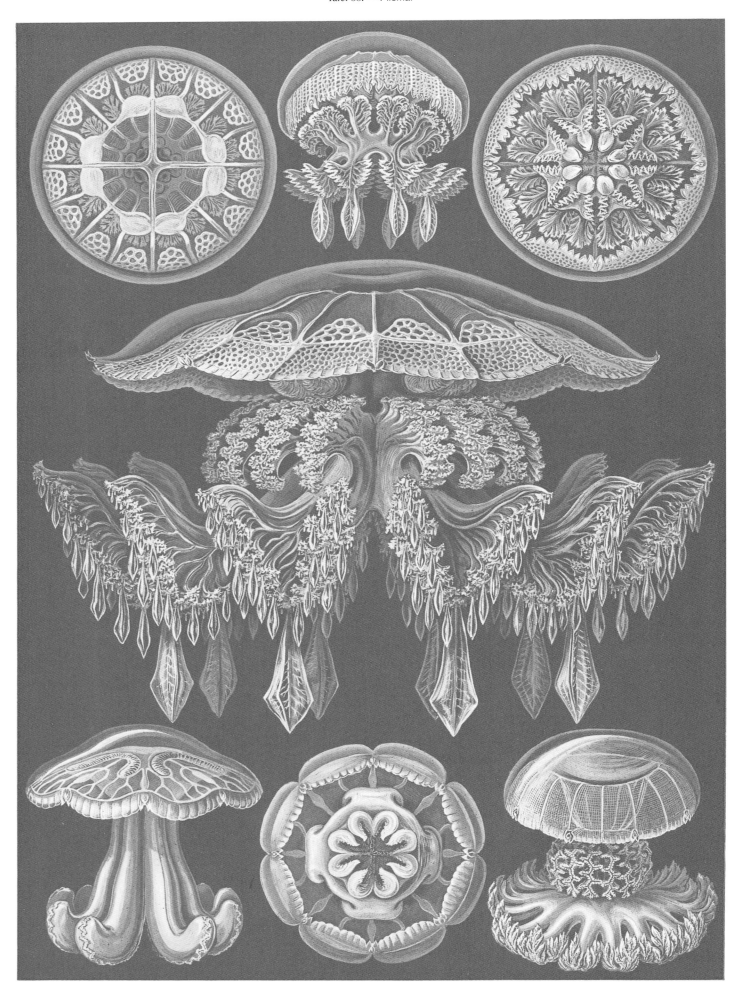

Discomedusae. Scheibenquallen.

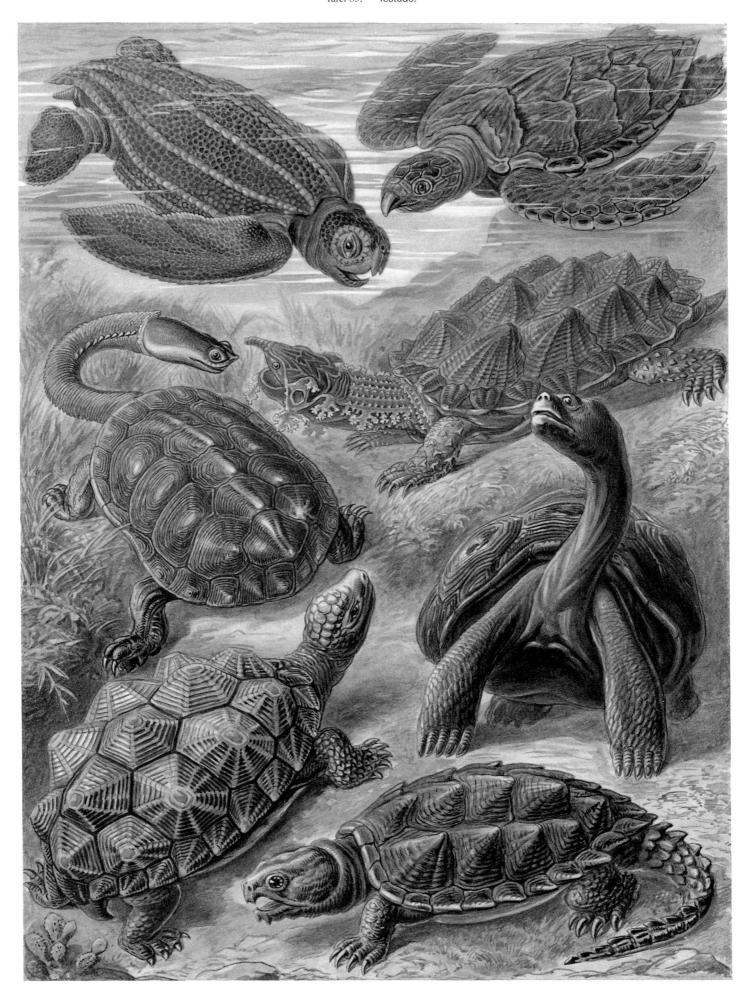

Chelonia. Schildkröten.

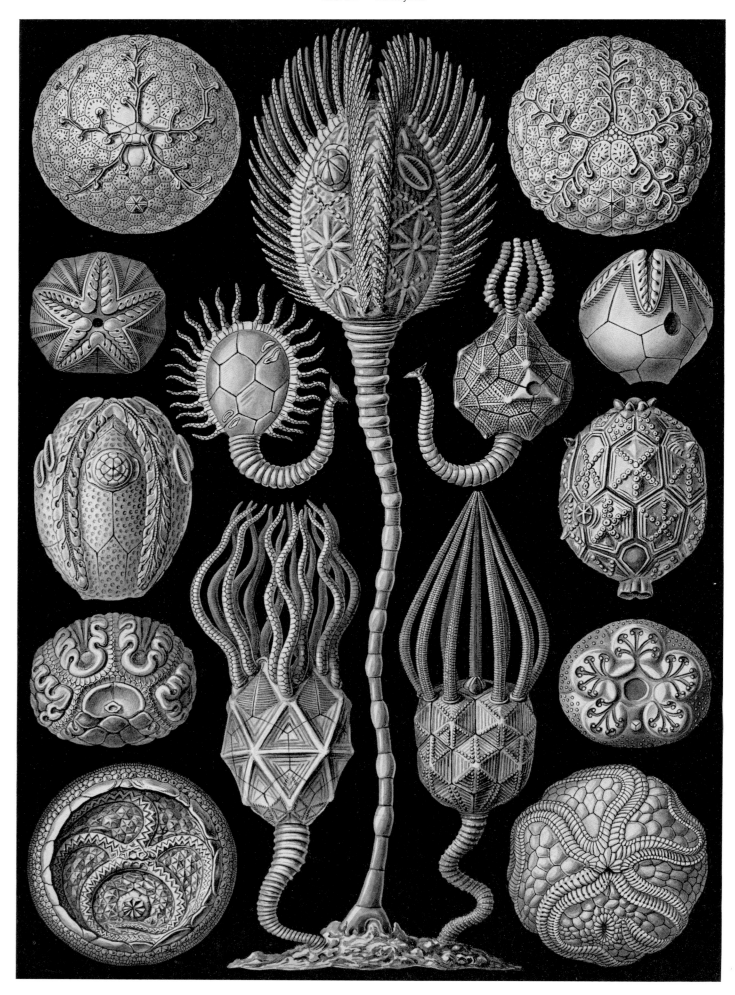

Cystoidea. Beutelsterne.

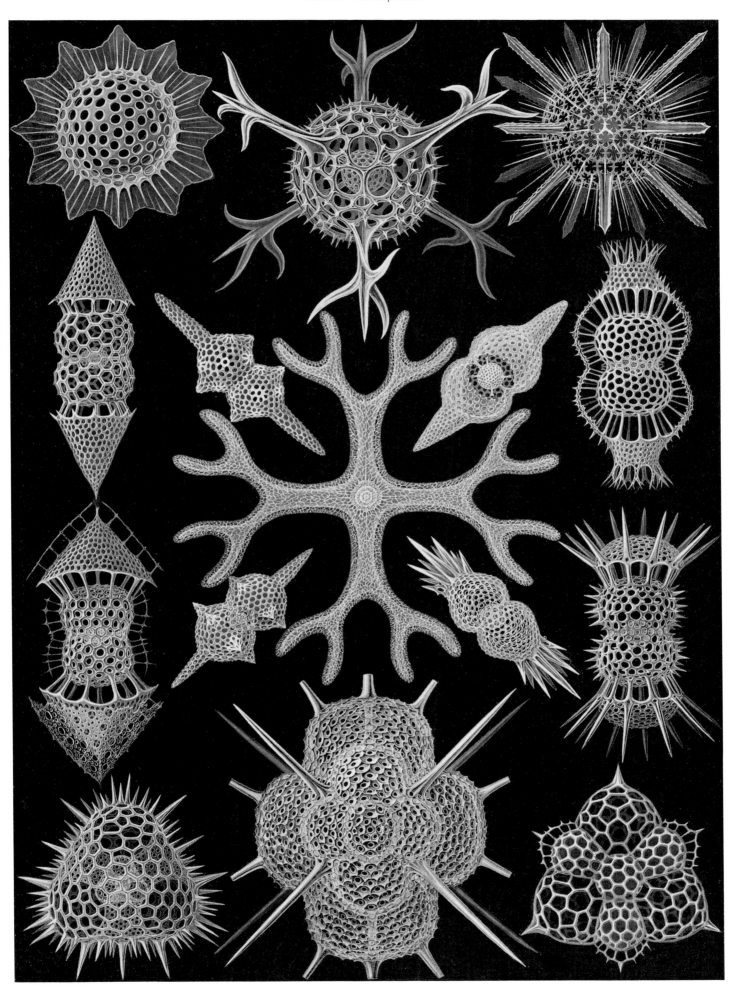

Spumellaria. Schaumstrahlinge.

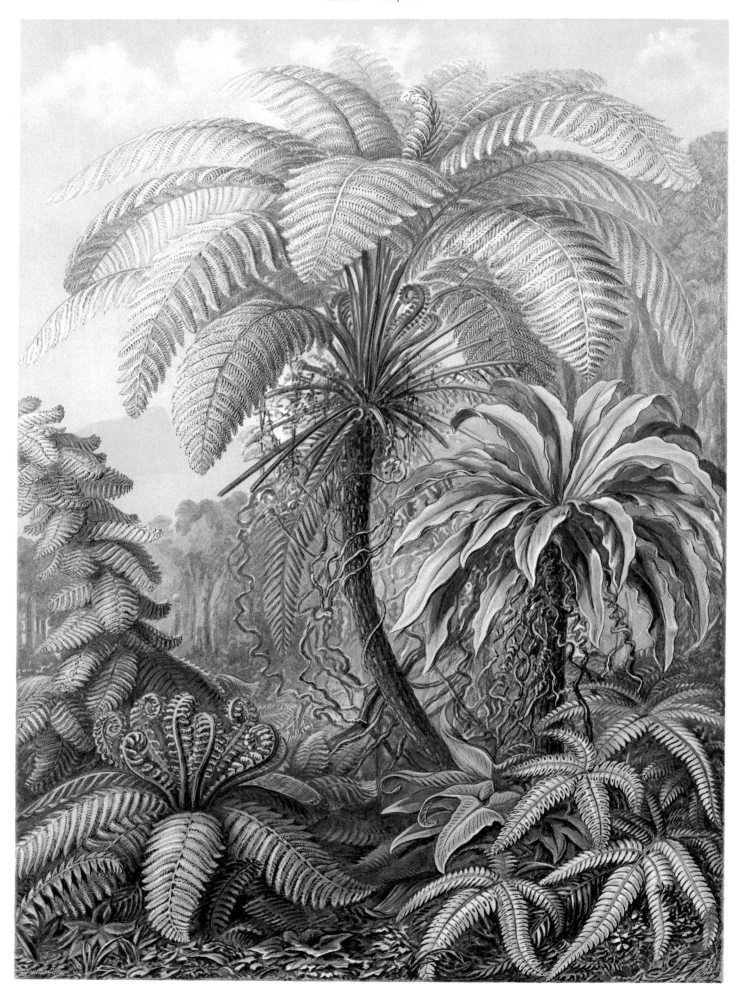

Filicinae. Laubfarne.

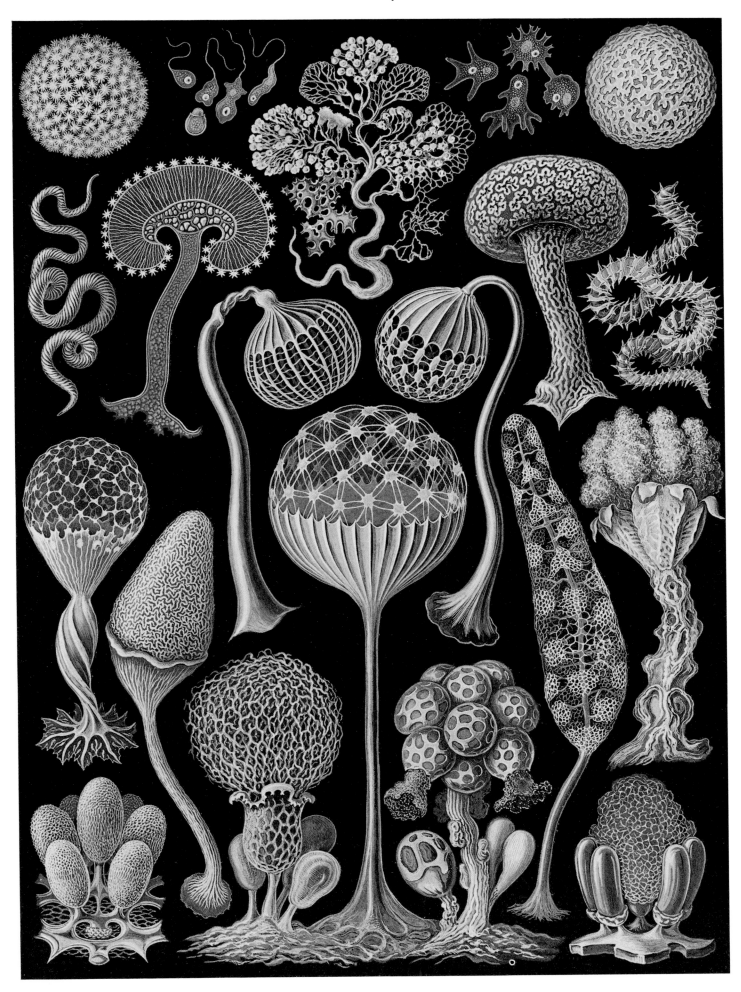

Mycetozoa. Pilztiere.

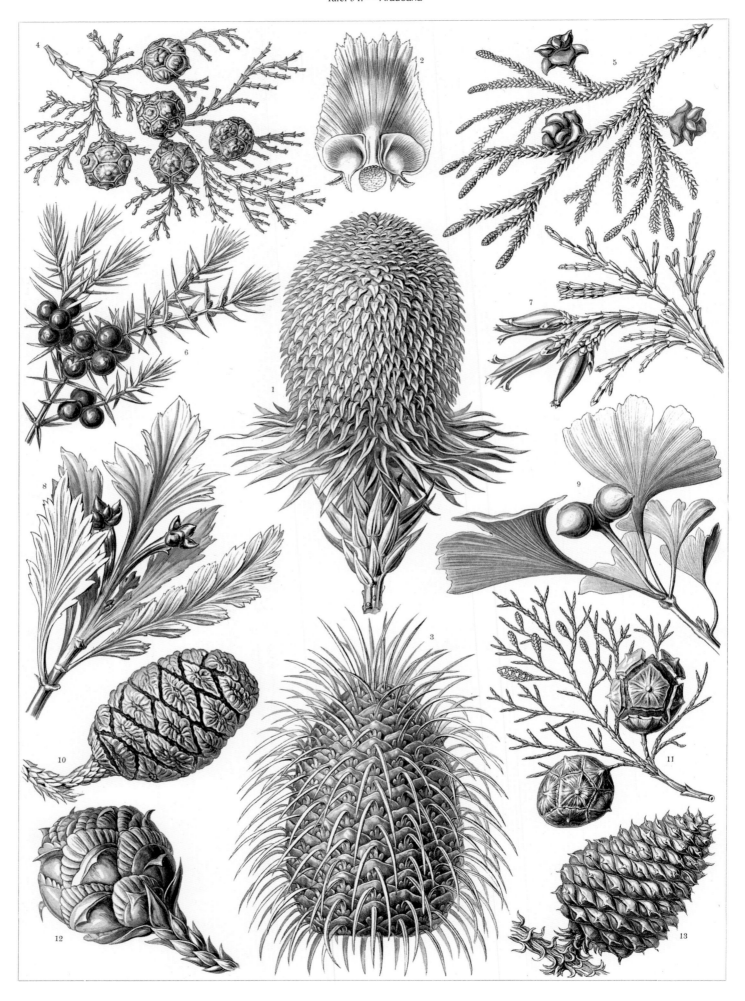

Coniferae. Zapfenbäume.

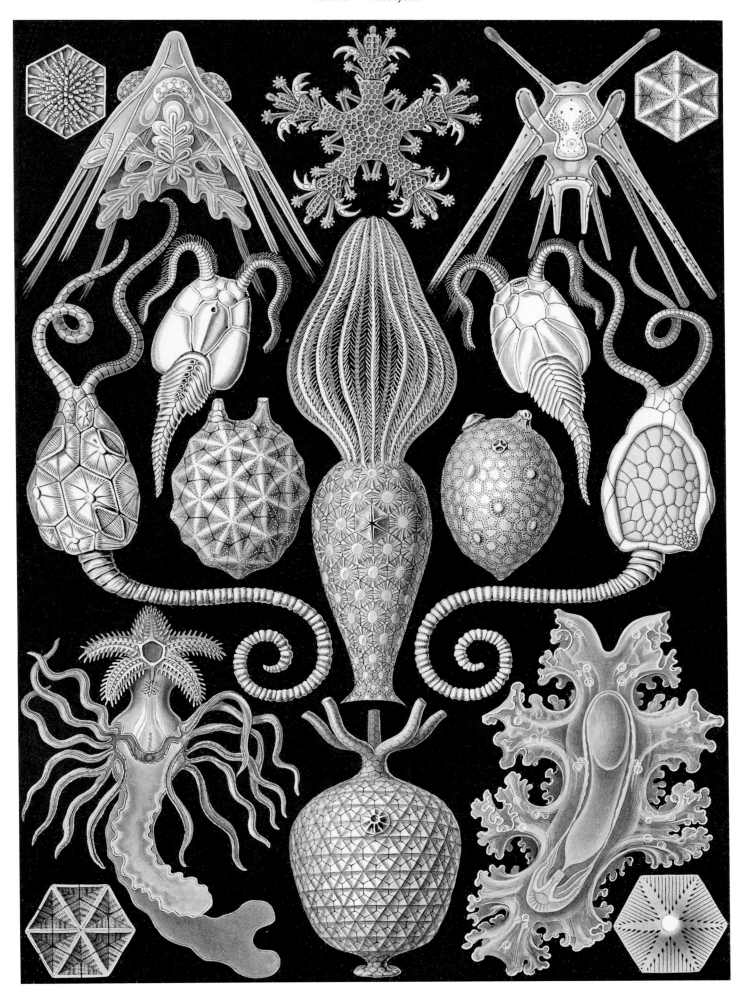

Amphoridea. Urnensterne.

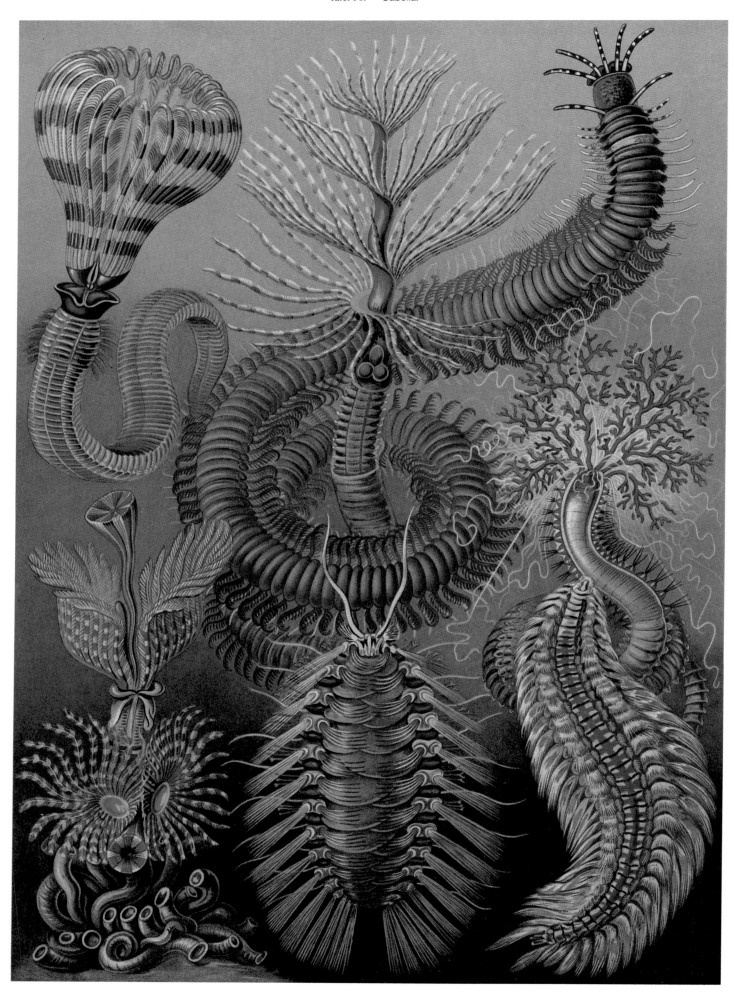

Chaetopoda. Borstenwürmer.

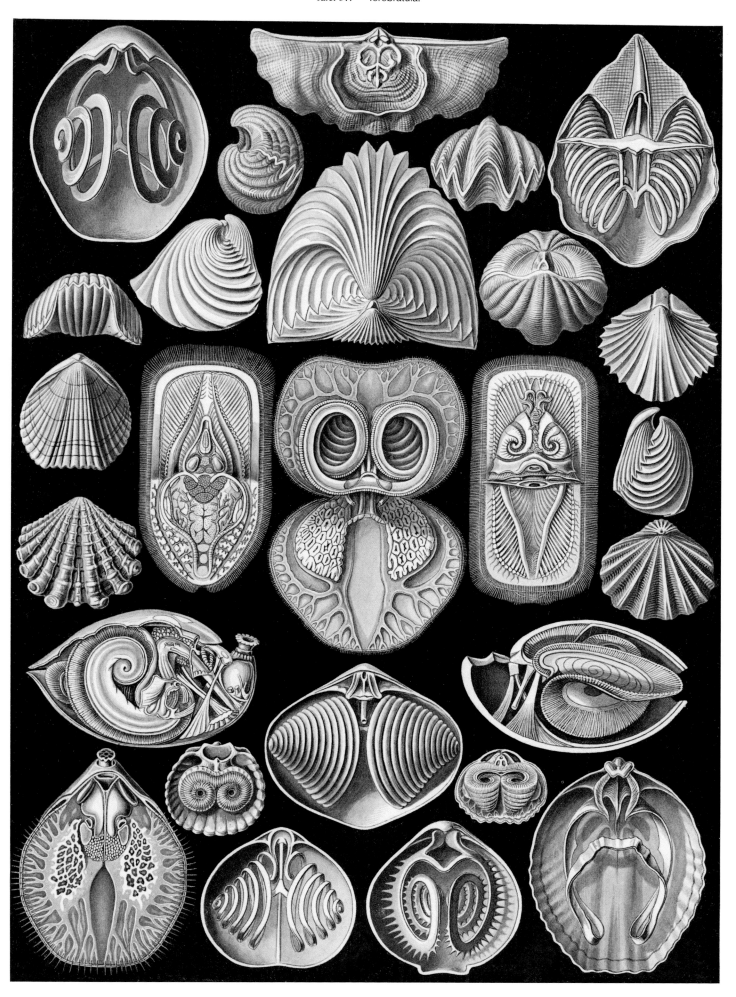

Spirobranchia. Spiralkiemer.

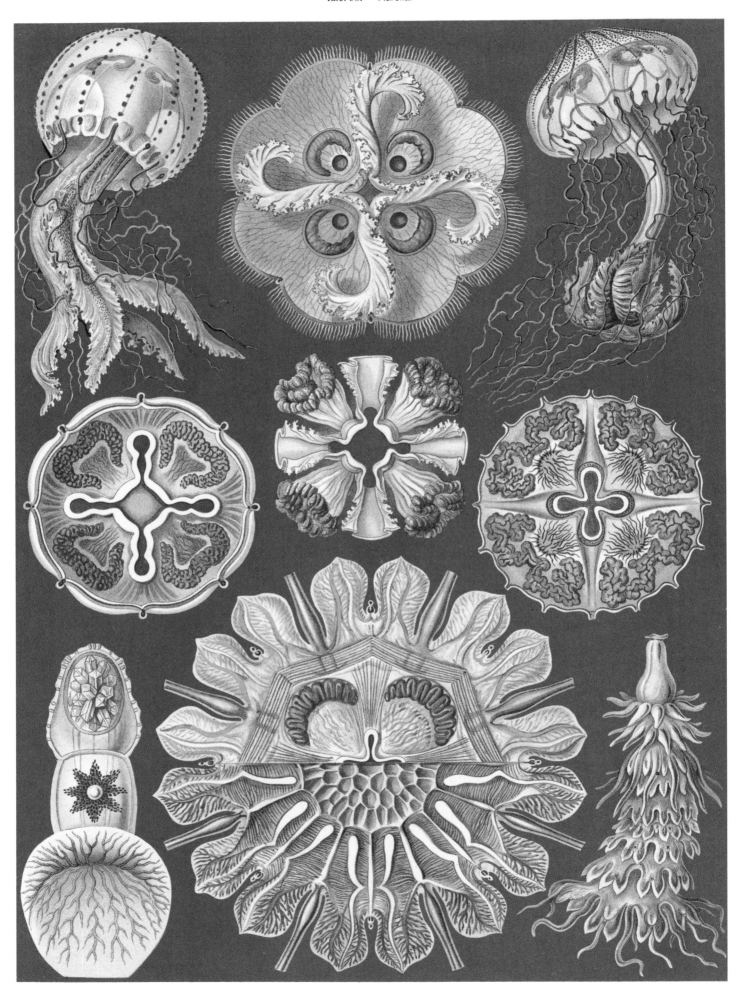

Discomedusae. Scheibenquallen.

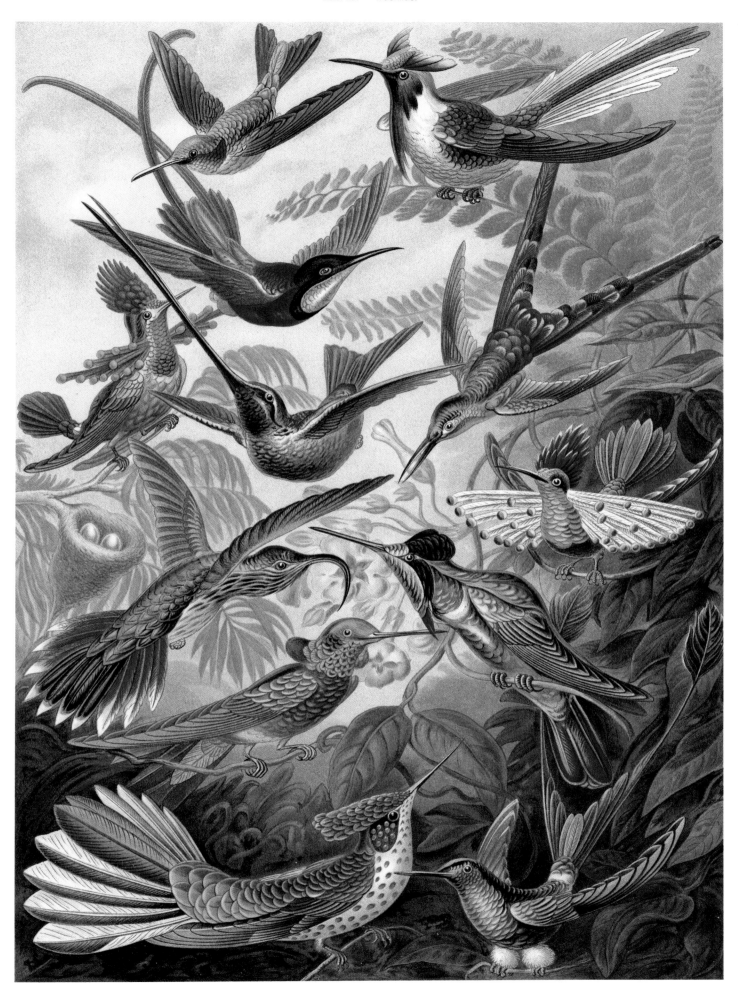

Trochilidae. Kolibris.

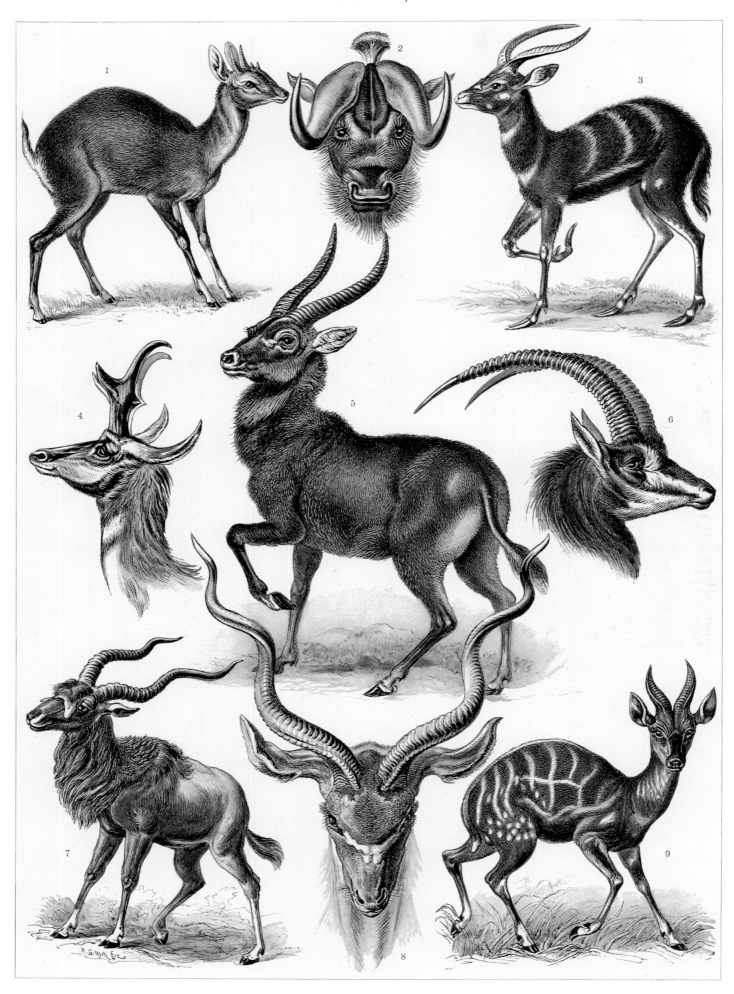

Antilopina. Antilopen.

Biographical Notes

Ernst Haeckel with his assistant Nikolaus Miclucho-Maclay on Lanzarote (1866)

practice as a general practitioner, a surgeon's assistant and an obstetrician. Opens his own practice.
On September 14, becomes engaged to his cousin, Anna Sethe.

1859–1860 After tentatively agreeing to take a teaching position in Jena, he embarks on a research trip to Italy; in Messina, he carries out research that forms the groundwork for his *Monographie über Radiolarien* (*Monograph on Radiolarians*), published in 1862. Haeckel vacillates between becoming a landscape painter or a scientist. On January 20, 1860, he writes to his friend Hermann Allmers: "I must have been completely blind back then [the previous year] when I painted water-colors with a positive passion; now that your spirit of criticism seems to have come over me, I have to laugh at myself." Shortly thereafter, at the beginning of 1860, he opts for zoology: "Despite this uninterrupted uniformity, life is anything but tedious owing to nature's inexhaustible richness which, time and again, produces ever-new, beautiful and fascinating forms that provide new material to speculate and ponder over, to draw and describe. Indeed, this is just the right sort of work for me because, in addition to the scientific element, it involves artistic matters to a large degree.

1834 Ernst Haeckel is born on February 16 in Potsdam, Prussia (today Germany).

1835 Family moves to Merseburg, Prussia (today Germany).

1852 After graduating from high school in Merseburg, begins to study medicine in Berlin and, from the second semester onwards, in Würzburg. Takes classes taught by Albert von Koelliker, Franz Leydig and Rudolf Virchow.

1854 Continues his studies in Berlin, where he is taught by the renowned physiologist Johannes Müller, who introduces him to marine biology while on an expedition on the island of Helgoland in the North Sea, where he writes his

first monograph, printed in 1855, entitled *Über die Eier der Scomberesoces* (*On the Eggs of the Scombresocidae*), a family of osseous fish.

1855 Returns to Würzburg.

1856 Acts as assistant to the leading pathologist of the day Rudolf Virchow; in the fall travels to Nice, France, to study marine life there with Albert von Koelliker.

1857 Earns his doctorate with a dissertation on the tissue of river crabs. During the summer semester he studies in Vienna.

1858 Takes state medical examinations at the University of Berlin; is licensed to

Phylogenetic Classification of Vertebrates. Palaeontologically based, designed and drawn by Ernst Haeckel, Jena 1866, for *The General Morphology of Organisms*.

Sycaltis conifera and Sycaltis glacialis. Drawing for Plate 45 in monograph *Calcareous Sponges*, vol. 3, 1872

At the same time, I have once again completely reconciled myself to my dear science in loyalty, which shall, throughout my entire life, take the highest priority and which I had seriously begun to doubt owing to your artistic-aesthetic influences." Haeckel reads with enthusiasm the first German translation of Darwin's *On the Origin of Species by Means of Natural Selection.*

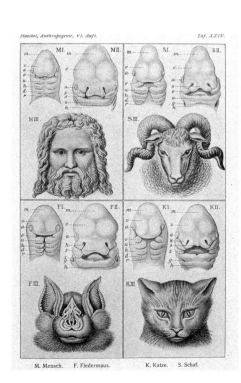

Haeckel, Anthropogenie, VI. Aufl. Taf. XXIV.

M. Mensch. F. Fledermaus. K. Katze. S. Schaf.

Germinal development of four types of mammal (human, sheep, bat, and cat). Plate XXIV in *The Anthropogeny or Developmental History of Man*, Ernst Haeckel, 6th edition, 1910

1861 With his *Habilitation*, qualifies as a lecturer in comparative anatomy at the School of Medicine, University of Jena.

1862 Is appointed associate professor of zoology at the University of Jena. Marries Anna Sethe on August 18.

1863 Holds a lecture entitled "Über die Entwicklungstheorie Darwins" (On Darwin's Theory of Evolution) at the 38th Assembly of German Natural Scientists and Physicians in Szczecin, Prussia (today Poland), in which he takes a firm stand in favor of Darwin's theory of evolution.

Fig. 1.

Letter decorated with Arabian corals, Ernst Haeckel, 1876

1864 Death of his wife, Anna.

1865 Is appointed full professor of zoology at the University of Jena.

1866 *Generelle Morphologie der Organismen* (*General Morphology of Organisms*) is published—an attempt at what Haeckel referred to as an "organic crystallography"—which contains the first detailed genealogical tree relating all the various orders of organisms.

1866– Scientific expedition to the Canary
1867 Islands.

1867 Marries Agnes Huschke.

1868 Birth of his son, Walter.

1869 Travels to Norway.

1871 Birth of his daughter, Elisabeth. Sojourns in Dalmatia between March and April; turns down a position in Vienna.

1872 Important monograph on calcareous sponges of the Red Sea in which

Phylogenetic Classification of Mankind. Design for Plate XII in *The Anthropogeny or Developmental History of Man*, 1874

Haeckel coins the phrase "fundamental biogenetic law."

1873 Takes first trip to the Orient. Studies coral reefs at the Red Sea. Birth of his daughter, Emma.

1874 *Anthropogenie oder Entwicklungs-geschichte des Menschen* (*The Anthropogeny or Developmental History of Man*) and *Die Gastrea-Theorie, die phylogenetische Classification des Thierreichs und die Homologie der Keimblätter* (*The Gastrea Theory: The Phylogenetic Classification of the Animal Kingdom and the Homology of Germ Layers*) are published.

1875 Carries out research on Corsica.

Elaborate presentation used by Haeckel in his lecture on "The Human Problem and Linné's Master Animals," Jena, 1907

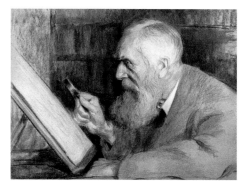

Ernst Haeckel – Portait by Fritz Reusing 1917

1876 Becomes vice president of the
 University of Jena.
1877 Does research on the Greek island
 of Corfu.

Poster advertising one of Haeckel's lectures in
Berlin, 1905

1878 Carries out research in marine
 biology in Brittany, France.
1881– Scientific expedition to India and
1882 Ceylon.
1882– Initiates the building of a zoological
1883 institute at the University of Jena.
 Has his house, the "Villa Medusa,"
 built.
1884 Named honorary doctor of the
 University of Edinburgh.
 Re-elected vice president of the
 University of Jena.
1887 Travels to Palestine, Syria and Asia
 Minor.
1889 Concludes work on animal groups
 collected on the English deep-sea
 Challenger Expedition (1872–76).
 Travels to Algeria.
1892 Holds lecture entitled "Der Monis-
 mus als Band zwischen Religion und
 Wissenschaft" (Monism as the Link
 between Religion and Science).
1894– *Systematische Phylogenie*
1896 (*Systematic Phylogeny*) is published.
 Scientific expedition to Finland and
 Russia.

1898 Named honorary doctor of the
 University of Cambridge.
1899 *Die Welträthsel (Riddle of the
 Universe)*, an outline of Haeckel's
 monistic *weltanschauung*, is pub-
 lished and proves to be immensely
 popular: over 400,000 copies are
 printed, and it is translated into
 more than 30 languages.
1899– *Kunstformen der Natur (Art
1904 Forms in Nature)* is published in a
 series of 10 installments, each with
 10 illustrations.
1900– Scientific expedition to the tropics
1901 of Ceylon, Singapore, Java and
 Sumatra.
1904 Die *Lebenswunder (The Miracle of
 Life)* appears as a supplementary
 edition to Haeckel's *Riddle of the
 Universe*.
 In September, at the International
 Free Thinkers' Congress in Rome,
 Haeckel is solemnly proclaimed
 "anti-pope" during breakfast in the
 ruins of the Imperial Palaces, with
 over 2,000 participants.
 Haeckel's landscape studies (sketches
 in watercolor and oil), executed on
 his travels, are issued as high-quality
 printed plates. Unlike *Art Forms in
 Nature*, this edition is not a success,
 possibly owing to the rather conven-
 tional style of the paintings. However,
 aside from representing numerous
 printed accounts of his journeys
 illustrated with his own paintings,
 they document Haeckel's pretensions:
 he regarded his reproductions of
 nature as being part of nature.
 At the Sing Academy in Berlin,
 Haeckel holds three exceptionally
 well-received lectures in which he
 employs the most modern media

Phyletic Museum, Jena, founded by E. Haeckel
in 1907

 available at the time: "Struggles over
 the Concept of Evolution: The Theory
 of Evolution and Religion; Kinship
 with Apes and the Origins of Verte-
 brates; Immortality and the Concep-
 tion of God."
1906 Founds the "German Monist League"
 at the Zoological Institute, University
 of Jena.
1907 Nominated honorary doctor of the
 University of Upsala, Sweden.
 On August 28, lays the foundation
 stone for the building that will house
 the first museum dedicated to the
 theory of evolution (Phyletic Museum),
 in Jena; its construction is financed
 by Haeckel exclusively with donated
 funds; he donates the royalties re-
 ceived on his *Riddle of the Universe*
 and makes available funds from the
 Ernst-Hackel-Stiftung.
1908 Inauguration of the Phyletic Museum,
 Jena, and—on the occasion of the
 350th anniversary of the university—
 the building is donated to the
 University of Jena.
1909 Haeckel resigns from teaching.
 Named honorary doctor of the
 University of Geneva.
1910 Haeckel secedes from the Protestant
 Church.
1915 Death of his wife, Agnes.
1917 *Kristallseelen (Crystal Souls)* is pub-
 lished in which a series of topics on
 the then current debate on "artificial
 life" is included.
1919 Haeckel dies on August 9 in the
 "Villa Medusa."
 A comprehensive bibliography of
 Ernst Haeckel's writings is cited in:
 Krumbach, T., "Die Schriften Ernst
 Haeckels" in: Heberer, G., ed. *Der
 gerechtfertigte Haeckel*. Stuttgart,
 1968, pp. 15–22.

Ernst Haeckel's study in his house, the
"Villa Medusa"

SWINDON COLLEGE

LEARNING RESOURCE CENTRE

List of Plates

This list shows the modern taxonomical terms used in English (E), French (F), and German (D) for the taxa employed by Haeckel (TH). TZ refers to the zoological term, TB the botanical: taxa zoologica resp. botanica. The bibliographical references include the taxonomical lexica.

Abbreviations: gr = Greek, m = masculine, f = feminine, Radiol. = radiolarian, syn = synonym, U.-A. = sub-classification, Ord. = order, U.-Ord. = suborder, U.-Klasse = sub-class, Fam. = family, U.G. = sub-genus, US = American term, * = arch. term

Plate 1
TH: **Phaeodaria**
Rohrstrahlinge; Phaeodarien, Cannopyleen, Tripyleen; (U.-Ord. der osculosen Radiolarien); Phaeodarina (Haeckel) (gr. dämmrig, grau; danach Phaeodarium: ein schwärzlicher Körper) (→ Radiol.) eine Unterordnung der → Osculosa, mit doppelwandiger Zentralkapsel und sehr kompliziertem, hohem, daher fossil selten erhaltenem Skelett. Fossil unbedeutend.
TZ: Tripylina (syn: Phaeodorina)
E: Phaeodarea
F: Phaeodarea
D: Rohrstrahlinge

Plate 2
TH: **Thalamophora**
Kammerlinge, Thalamophoren (R. Hertwig 1876); Foraminiferen (d'Orbigny 1826), Testaceen (M. Schultze 1854), Kammerlinge; marine Rhizopodien
TZ: Foraminifera (syn: Thalamophora; Polythalamia)
E: Foraminifers; Foraminiferans; Porebearers; (US) Forams
F: Foraminifères
D: Kammerlinge; Porentierchen; Lochträger; Siebtierchen; Vielkammerige Porenträger; Vielkammerige Schalenwurzelfüßer; Schalenwurzelfüßer; Kreidetierchen; Schnörkelschnecken

Plate 3
TH: **Ciliata**
Wimperlinge; Ciliaten (Perty 1852, Infusorien im engeren Sinne, Aufgußtierchen, Wimperinfusorien; Protozoen mit zahlreichen kurzen Wimpern
TZ: Ciliata (syn: Empedotridia)
E: Ciliates
F: Infusoires Ciliés; Ciliés
D: Bewegliche Wimpertierchen; Wimpertierchen; Aufgußtierchen; Ziliaten

Plate 4
TH: **Diatomea**
Schachtellinge; Diatomeen; reichhaltige Klasse von einzelligen Algen; Kieselalgen (Diatomeae: Bacillariophyceaem, Stamm Chrysophyta), einzellige Algen ohne Flagella (Geißeln)
TZ: Bacillariophyceae (syn: Diatomeae)
E: Diatoms
F: Diatomées
D: Schachtellinge; Kieselalgen

Plate 5
TH: **Calcispongiae**
Kalkschwämme; Calcispongien (Blainville 1830), Calcarosen (Haeckel 1896) (Kalkschwämme); Klasse der Schwämme
TZ: Calcarea (syn: Calcispongia)
E: Calcareous sponges; Chalky/Limy sponges
F: Éponges Calcaires; Calcispongiares; Calcisponges
D: Kalkschwämme

Plate 6
TH: **Tubulariae**
Röhrenpolypen; Tubularien (Röhrenpolypen); Ord. der Hydropolypen
TZ: Tubulariidae
E: Tubularid Hydroids; Oat-en-pipes Hydroid
F: Tubulaires
D: Röhrenpolypen; Augenfleckenmedusen

Plate 7
TH: **Siphonophorae**
Staatsquallen; Siphonophoren (Schwimmpolypen, Röhrenquallen, Staatsquallen); Ord. der Nesseltiere
TZ: Siphonophora
E: Siphonophores
F: Siphonophores
D: Staatsquallen; Röhrenquallen; Schwimmpolypen

Plate 8
TH: **Discomedusae**
Scheibenquallen; Discomedusen (Discophoren, Scheibenquallen, Schirmquallen) Ord. der Scyphomedusen
TZ: Discomedusae (syn: Discophora)
E: Disk Jellies
F: Méduses à Bord Combrellaire Lobé; Discoméduses; Cyclomorphes
D: Schirmquallen; Scheibenquallen

Plate 9
TH: **Hexacoralla**
Sechsstrahlige Sternkorallen; Hexacorallien (Hexactinien); Ord. der Korallentiere
TZ: Hexacorallia (syn: Hexactinia; Polyactinia)
E: Hexacorallians
F: Hexacoralliaires
D: Sechsstrahlige Korallen; Seeanemonen und Steinkorallen; Sechsstrahlige Polypen; Sechsstrahlige Korallentiere; Sechsstrahlige Blumentiere; Mehrstrahlige Blumentiere

Plate 10
TH: **Ophiodea**
Schlangensterne; Ophiuroideen (Ophiodeen, Schlangensterne); Klasse der Echinodermen
TZ: Ophiuroidea
E: Brittle Stars; Serpent Stars; Ophiuroids; Ophiuroideans; Spinigrade Echinoderms
F: Ophiurides; Ophiures, (larva) Ophiopluteus
D: Schlangensterne; Schlangenschwanzsterne; Ophiuroiden

Plate 11
TH: **Discoidea**
Scheiben-Strahlige; Discananthen (Disconecten, Discoideen, Schildquallen); Gruppe der Röhrenquallen
TZ: Disconanthae (syn: Chondrophora; Disconectae)
E: Discoidea; Disconanthes
F: Discoïdes; Disconanthes
D: Knorpelquallen

Plate 12
TH: **Thalamophora**
Kammerlinge; Thalamophoren (R. Hertwig 1876); Foraminiferen (d'Orbigny 1826), Testaceen (M. Schultze 1854), Kammerlinge; marine Rhizopodien
TZ: Foraminifera (syn: Thalamophora; Polythalamia)
E: Foraminifers; Foraminiferans; Porebearers; (US) Forams
F: Foraminifères
D: Kammerlinge; Porentierchen; Lochträger; Siebtierchen; Vielkammerige Porenträger; Vielkammerige Schalenwurzelfüßer; Schalenwurzelfüßer; Kreidetierchen; Schnörkelschnecken

Plate 13
TH: **Flagellata**
Geißlinge; Flagellaten (Mastigophoren, Geißelinfusorien, Geißelträger); [Protozoen]
TZ: Zoomastigophora (syn: Flagellata; Zoomastigina; Mastigophora; Rhizoflagellata; Zooflagellata; Autoflagellata; Astomata)
E: Flagellates; Mastigophores
F: Flagellés; Zooflagellés; Rhizoflagellés; Protozoaires Flagellés
D: Geißeltierchen; Zooflagellaten; Nackte Geißelträger; Geißelträger

Plate 14
TH: **Peridinea**
Geißelhütchen; Dinoflagellaten; Unterabt. der Geißelinfusorien; (nach der Gattung Peridinium benannt) = Dinoflagellaten. … überwiegend marine, planktische Flagellaten (Stamm Pyrrhophyta, Rotalgen) … Als Dinoflagellaten faßt man Angehörige der Klassen Desmophyceae und Dinophyceae zusammen, letztere mit der fossil bedeutsamen Ordnung Peridiniales.
TZ: Peridiniales; Dinoflagellata
E: Dinoflagellates
F: Peridinidae
D: Wirbelflagellaten

Plate 15
TH: **Fucoideae**
Brauntange; an order of brown algae composing in the class Cyclosporeae
TB: Fucales (Fucacae)
E: (Fucacae)
F: (Fucacae)
D: Brauntange

Plate 16
TH: **Narcomedusae**
Spangenquallen; Narcomedusen (Spangenquallen); U.-Ord. der Kolbenquallen
TZ: Narcomedusae
E: Narcomedusae
F: Narcomeduses
D: Spangenquallen; Narcopolypen

Plate 17
TH: **Siphonophorae**
Staatsquallen; Siphonophoren (Schwimmpolypen, Röhrenquallen, Staatsquallen); Ord. der Nesseltiere
TZ: Siphonophora
E: Siphonophores
F: Siphonophores
D: Staatsquallen; Röhrenquallen; Schwimmpolypen

Plate 18
TH: **Discomedusae**
Scheibenquallen; Discomedusen (Discophoren, Scheibenquallen, Schirmquallen; Ord. der Scyphomedusen
TZ: Discomedusae (syn: Discophora)
E: Disk Jellies
F: Méduses à Bord Combrellaire Lobé; Discoméduses; Cyclomorphes
D: Schirmquallen; Scheibenquallen

Plate 19
TH: **Pennatulida**
Federkorallen; Pennatulaceen (Pennatuliden, Federkorallen, Seefedern); U.-Ord. der Federkorallen
TZ: Pennatulidae
E: Sea Pens
F: Plumes de Mer
D: Seefedern

Plate 20
TH: **Crinoidea**
Palmensterne; Crinoideen (Pelmatozoen, Haarsterne, Seelilien); Klasse der Stachelhäuter
TZ: Crinoidea (syn: Actinoidea)
E: Feather-stars; Sea Lilies; Sea Feathers; Stalked Crinoids; Crinoid Starfishes; Crinoids; Crinoideans; Pinnigrade Echinodermata
F: Crinoïdes; Lis de Mer
D: Haarsterne; Seelilien; Liliensterne; Crinoiden; Lilienstrahler; Stylastriten

Plate 21:
TH: **Acanthometra**
Stachelstrahlinge; U.-A. der Acantharien (Actiphyleen); an order of marine protozoans in the subclass Acantharia with 20 or less skeletal rods
TZ: Acanthometrida
E: Acanthometrides
F: Acanthometrides
D: Stachelstrahlinge

Plate 22:
TH: **Spyroidea**
Nüßchenstrahlinge
TZ: Spyroidea (U.G. Nasselaria)
E: Spyroidea
F: Spyroidea
D: Nüßchenstrahlinge

Plate 23
TH: **Bryozoa**
Moostiere; Bryozoen (Ehrenberg 1831), Polyzoen (Thompson 1830), Moostierchen; meist zu den Würmern gerechnete Klasse kolonienbildender, selten einzeln lebender (Loxosoma), kleiner Tiere mit wimperndem Tentakelkranz und hufeisenförmig gebogenem Darm. A major phylum of sessile aquatic invertebrates occuring in colonies with hardened exoskeleton
TZ: Bryozoa; (syn: Ectoprocta; Polyzoa; Bryocephala) Bryozoa
E: Bryozoans; (larva) Winter Bud); Moss Animals
F: Bryozoaires; Animaux-mousse; Ectoproctes; Bryozoaires; (larva) Bourgeon (m) D'Hiver; Hibernacule (m)
D: Moostierchen; Bryozoen; Ectoprocte; Moostiere; (larva) Winterknospe (f); (*Mooskorallen; Moospolypen; Doppelmündige; Korallentiere)

Plate 24
TH: **Desmidiea**
Zierdinge; A family of desmids, mostly unicellular algae in the order of Conjugales
TB: Desmidiaceae; Conjugatophyceae; Desmidiales
E: Desmidiaceae
F: Desmidiaceae
D: Jochalgen

Plate 25
TH: **Sertulariae**
Reihenpolypen; Sertularien (Reihenpolypen); Ord. der Hydrozoen
TZ: Sertulariidae
E: Sertularians; Sea Firs; Sea Moos; Squirrel's; Tails; Whiteweed
F: Mousses de Mer; Sertulaires
D: Becherpolypen; Wedelpolypen

Plate 26
TH: **Trachomedusae**
Kolbenquallen; Trachomedusen (Trachymedusen, Trachusen, Kolbenquallen); Ord. der trachylinen Hydromedusen
TZ: Trachymedusa
E: Trachymedusea
F: Trachyméduses
D: Trachymedusen; Trachusen

Plate 27
TH: **Ctenophorae**
Kammquallen; Ctenophoren (Rippenquallen); Klasse der Nesseltiere
TZ: Ctenophora
E: Comb-bearing Jellyfish; Comb Jellies; Comb Bearers; (larva) Cydippid; 2) Sea Walnuts; See Gooseberries; (US) Cat's Eyes
F: Cténophores; Cténaires
D: Rippenquallen; Ktenophoren; Kammquallen

Plate 28
TH: **Discomedusae**
Scheibenquallen; Discomedusen (Discophoren, Scheibenquallen, Schirmquallen); Ord. der Scyphomedusen
TZ: Discomedusae (syn: Discophora)
E: Disk Jellies
F: Méduses à Bord Combrellaire Lobé; Discoméduses; Cyclomorphes
D: Schirmquallen; Scheibenquallen

Plate 29
TH: **Tetracoralla**
Vierstrahlige Sternkorallen, Tetra-corallien (Rugosen, Runzelkorallen), fossile (paläozoisches Zeitalter) Ord. der Korallentiere; Tetracorallia (Haeckel 1866) = Rugosa. Rugosa (Edwards & Haime 1850) (lat. rugosus, runzelig). Syn. Pterocorallia, Tetracorallia; eine U.-Klasse der Klasse → Anthozoa. Auf das Paläozoikum (Ordovizium bis Perm) beschränkte Gruppe solitärer oder koloniebildender, bilateral-symmetrischer Korallen
TZ: Rugosa (syn: Tetracoralla)
E: Rugosa
F: Rugosa
D: Rugose Korallen

Plate 30
TH: **Echinidea**
Igelsterne; Echiniden; Fam. der regulären Seeigel
TZ: Echinidae
E: Sea Urchins; Urchins; Egg-urchins; Sea-eggs
F: Échinidés; Oursins de Mer; Oursins; Châtaignes de Mer
D: Echte Seeigel

Plate 31
TH: **Cyrtoidea**
Flaschenstrahlinge; Cyrtiden; Fam. der Strahltierchen
TZ: Cyrtoidae
E: Cyrtoidae
F: Cyrtoidae
D: Kegelstrahlinge; Kegelstrahlige

Plate 32
TH: **Rotatoria**
Rädertiere; Rotatorien (Rotiferen, Trochelminthen, Rädertierchen, Radwürmer); Klasse der Wurmtiere
TZ: Rotatoria (syn: Rotifera)
E: Wheel Animalcules; Rotifers
F: Rotiféres; Porte-roues
D: Rädertiere; Rädertierchen; Rotatorien; Rotiferen; Tümpelinfusorien

Plate 33
TH: **Bryozoa**
Moostiere; Bryozoen (Ehrenberg 1831), Polyzoen (Thompson 1830), Moostier-chen; meist zu den Würmern gerech-nete Klasse kolonienbildender, selten einzeln lebender (Loxosoma), kleiner Tiere mit wimperndem Tentakelkranz und hufeisenförmig gebogenem Darm. (A major phylum of sessile aquatic invertebrates occuring in colonies with hardened exoskeleton)
TZ: Bryozoa; (syn: Ectoprocta; Polyzoa; Bryocephala); Bryozoa
E: Bryozoans; (larva) Winter Bud); Moss Animals
F: Bryozoaires; Animaux-mousse; Ecto-proctes; Bryozoaires (larva) Bourgeon (m) D'Hiver; Hibernacule (m)
D: Moostierchen; Bryozoen; Ectoprocte Moostiere; (larva) Winterknospe (f) (* Mooskorallen; Moospolypen; Doppelmündige Korallentiere)

Plate 34
TH: **Melethallia**
Gesellige Algetten
TZ: Ord.: Chlorococcales; Fam.: Hydrodictyaceae
E: Hydrodictyaceae
F: Hydrodictyaceae
D: Kokkale Algen

Plate 35
TH: **Hexactinellea**
Glasschwämme; Hexactinelliden (Hexactinellen, Triaxonier, Hyalospongien, Glasschwämme); Gruppe der Kieselschwämme
TZ: Triaxonia (syn: Hexactinellida; Hyalospongiae; Silicospongia)
E: Glass Sponges; Hexactinellid Sponges
F: Triactines; Pharétones; Éponges Vitreuses; Hexactinellides
D: Glasschwämme; Dreistrahlige Kieselschwämme

Plate 36
TH: **Leptomedusae**
Faltenquallen; Leptomedusen (Haeckel 1866) (Leptusen, Faltenquallen); Ord. der leptolinen Hydromedusen
TZ: Thecophora (syn: Leptomedusae; Campanulariae)
E: Campanularian Hydroids; Thecate Hydroids; Sheathed Hydroids
F: Campanulariae
D: Faltenquallen; Randbläschenquallen; Leptusen

Plate 37
TH: **Siphonophorae**
Staatsquallen; Siphonophoren (Schwimmpolypen, Röhrenquallen, Staatsquallen), Ord. der Nesseltiere
TZ: Siphonophora
E: Siphonophores
F: Siphonophores
D: Staatsquallen; Röhrenquallen; Schwimmpolypen

Plate 38
TH: **Peromedusae**
Taschenquallen; Peromedusen (Haeckel 1877), Taschenquallen; Ord. der Scyphomedusen
TZ: Coronata (syn: Peromedusae)
E: Coronates; Coronate crowned Jelly-fishes
F: Coronates
D: Koronaten; Tiefseequallen; Kronenquallen

Plate 39
TH: **Gorgonida**
Rindenkorallen; Gorgoninen; Fam. der Rindenkorallen
TZ: Gorgonaria (syn: Gorgonacea)
E: Horny Corals; Gorgonians; Fan Corals
F: Gorgonaries; Gorgoniens; Gorgonides; Axiféres; Gorgones
D: Hornkorallen; Fächerkorallen; Rindenkorallen; Axenkorallen

Plate 40
TH: **Asteridea**
Seesterne; Asteroideen (Stelleriden, Seesterne); Klasse der Stachelhäuter
TZ: Asteroidea
E: Starfishes; Sea Stars; True Starfishes; Asteroideans
F: Etoilles de Mer; Astérroïdes; Astéries; Stellérides
D: Seesterne; Meersterne; Sternstrahler; Furchensterne; Asteroiden

Plate 41
TH: **Acanthophracta**
Wunderstrahlinge; U.-A. der Acantharien (Actiphyleen); an order of marine protozoans in the subclass Acantharia; skeleton includes a latticework shell and skeletal rods
TZ: Acanthophractida
E: Acantharia
F: Acantharia
D: Wunderstrahler

Plate 42
TH: **Ostraciontes**
Kofferfische; Ostracion quadricornis L. (Kofferfisch)
TZ: Ostraciontidae (syn: Ostraciidae)
E: Puffer-fishes; (US) Box-fishes; Trunkfishes
F: Coffers; Ostracions; Poissons-Coffres
D: Kofferfische

Plate 43
TH: **Nudibranchia**
Nacktkiemen-Schnecken; Nudibranchier (Nacktkiemer); U.-Ord. der Hinterkiemerschnecken
TZ: Nudibranchia (syn: Gymnobranchiata; Notobranchiata)
E: True Sea Slugs; Naked Sea Slugs; Sea Slugs; Naked-gilled Snails; Naked-gills; Nudibranchs; Nudibranchiates
F: Nudibranches
D: Nacktkiemer; Meeresnacktschnecken; Rückenkiemer; Nacktschnecken

Plate 44
TH: **Ammonitida**
Ammonshörner; Ammonoideen (Ammonitiden, Ammoniten, »Ammons-hörner«); fossile Gruppe der Cephalo-poden; allgemeine Bezeichnung für ausgestorbene Kopffüßler (Cephalo-poden), deren spiralig aufgerolltes Gehäuse z. T. einem Widerhorn ähnlich sehen. Im engeren, eigent-lichen Sinne versteht man unter »Ammoniten« die Neoammonoidea
TZ: Ammonitida (Ord. der Ammonoidea)
E: Ammonite
F: Ammonite
D: Ammonshorn

Plate 45
TH: **Campanaria**
Glockenpolypen; Campanarien (Glockenpolypen); Ord. der Hydropolypen
TZ: Campanulariidae (syn: Leptomedusae)
E: Bell-Polyps; Campanularian Hydroids; Bell-like Hydroids
F: Campanularians
D: Glockenpolypen

Plate 46
TH: **Anthomedusae**
Blumenquallen; Anthomedusen (Anthusen (Haeckel), Ocellaten, Blumenquallen); Ord. der leptolinen Hydromedusen
TZ: Athecata (syn: Anthomedusae; Tubularia)
E: Tubularian Hydroids; Athecate Hydroids; Naked Hydroids
F: Hydres-fleurs
D: Anthomedusen; Blumenkorallen; Augenfleckenmedusen

Plate 47
TH: **Aspidonia**
Schildtiere; Aspidonier (Palaeostraken, Schildtiere); Name, unter welchem Haeckel die fossilen Trilopiten und Gigantostraken mit den noch lebenden Xiphosuren als unterste Gruppe der Krebse (Crustaceen) zusammenfaßt
TZ: Chelicerata
E: Chelicerates
F: Chelicerates
D: Cheliceraten

Plate 48
TH: **Stauromedusae**
Becherquallen; Stauromedusen (Calycozoen, Cylicozoen, Königsquallen, Becherquallen); Ord. der Scyphomedusen (Acraspeden)
TZ: Stauromedusae (syn: Lucernariida; Calycozoa; Podactinaria; Cylicozoa)
E: Goblet Medusas; Stalked Medusae; Stalked Jelly-Fishes; Sedentary Jelly-fishes; Stauromedusas; Lucernids
F: Lucernaires
D: Becherquallen; Stielquallen; Kelchtiere

Plate 49
TH: **Actiniae**
Seeanemonen; Malacodermen (Actiniarien, Seerosen, Fleischkorallen, Actinien); U.-Ord. der Hexacorallien
TZ: Actinaria (syn: Actinaria; Malactinida; Holosarca; Zoantharia Malacodermata)
E: Sea Anemones; Piddifoggers; Suckers
F: Actiniares; Anémones de Mer; Actinies
D: Seerosen; Seeanemonen; Blumentiere; Aktinien; Fleischpolypen; Meernesseln; Fleischkorallen

Plate 50
TH: **Thuroidea**
Gurkensterne; Holothurien (Holothurioideen), (Thuroideen, Seewalzen, Seegurken, Gurkensterne); Klasse der Stachelhäuter
TZ: Holothurioidea (syn: Scytodermata)
E: Sea Cucumbers; Holothurians; Cirrho-vermigrade Echinoderms
F: Cornichons de Mer; Holothurides; Concumbres de Mer; Holothuries; Béches de Mer
D: Meerwalzen; Walzenstrahler; Wurmstrahler; Lederhäuter

Plate 51
TH: **Polycyttaria**
Vereins-Strahlinge; Peripyleen (Spumellarien, Polycyttarien); U.-Ord. der Strahltiere
TZ: Peripylea (syn: Spumellaria; Peripylaria; Pancollae)
E: Peripylea
F: Peripylea
D: Schaumstrahltiere; Gallertstrahltiere

Plate 52
TH: **Filicinae**
Laubfarne; Filices (Farne); Klasse der Pteridophyta
TB: Filicinae
E: Ferns
F: Fougeres
D: Farne

Plate 53
TH: **Ctenobranchia**
Kammkiemen-Schnecken; Azygobranchier; Gruppe der Vorderkiemenschnecken
TZ: Ctenobranchiata (syn: Pectinibranchiata; Chiastoneuro)
E: Ctenobranchs; Ctenobranchiates; Pectinibranchs; Chistaoneurans
F: Gastropodes Cténobranches; Gastropodes Pectinibranches
D: Kammkiemer; Ctenobranchiaten; Pectinibranchiaten; Chiastoneuren

Plate 54
TH: **Gamochonia**
Trichterkraken; Gammochonien; zweite U.-Klasse in Haeckels provisorischem System der Cephalopoden
TZ: Cephalapoda (syn: Cephalophora; Polypi)
E: Cuttle-fishes; Nautili; Squids and Octopuses; Cephalopods; Cuttles; Many-armed Mollusks
F: Céphalopodes; * (ova) Raisins de Mer
D: Kopffüßer; Kopffüßler; Tintenfische; Cephalopoden; * (ova) Eitrauben; (*Tintenschnecken; Armschnecken)

Plate 55
TH: **Acephala**
Muscheln; Lamellibranchier (Acephalen, Bivalven, Pelecypoden, Muscheln); Klasse der Weichtiere (Mollusken)
TZ: Lamellibranchia (syn: Bivalvia; Acephala; Pelecypoda)
E: Bivalved Mollusks; Bivalves; Clams; Mussels; Shellfish; Plate-gilled Bivalves; Lamellibranchs; Pelecypods
F: Bivalves; Lamellibranches; Acéphales; Coquilles; Pélécypodes
D: Muscheln; Muscheltiere; Blattkiemer; Keilfüßer; Blätterkiemer; Camellibranchien; Pelécypoden

Plate 56
TH: **Copepoda**
Ruderkrebse; Copepoden (Ruderfüßler)
TZ: Copepoda (syn: Cophyropoda)
E: Oar-footed Crustaceans; Copepods; Hair-footed Crustaceans
F: Copépodes
D: Ruderfüßer; Ruderfüßler; Hüpferlinge; Ruderfußkrebse; Krebsflühe; Ruderfußkrebschen; Büschelfüßer; Copepoden

Plate 57
TH: **Cirripedia**
Rankenkrebse; Cirripedien (Pectostraken, Rankenfüßler, Haftkrebse)
TZ: Cirripedia (syn: Testacostraca)
E: Curl-footed Crustaceans; Barnacles; Cirripeds; Barnacles and Acorn-shells; Tree Geese
F: Cirripèdes
D: Rankenfüßer; Rankenfüßler; Haftkrebse; Cirripeden; Rankenfußkrebse; Tierkrebse

Plate 58
TH: **Tineida**
Motten; Tineiden (Motten, Schaben); Fam. der Kleinschmetterlinge
TZ: Tineidae
E: Clothes Moths
F: Tinéides; Teignes; Teignes de Vétements; Teignes des Pelleteries
D: Echte Motten; Schaben

Plate 59
TH: **Siphonophorae**
Staatsquallen; Siphonophoren (Schwimmpolypen, Röhrenquallen, Staatsquallen); Ord. der Nesseltiere
TZ: Siphonophora
E: Siphonophores
F: Siphonophores
D: Staatsquallen; Röhrenquallen; Schwimmpolypen

Plate 60
TH: **Echinidea**
Igelsterne; Echiniden; Fam. der regulären Seeigel
TZ: Echinidae
E: Sea Urchins; Urchins; Egg-urchins; Sea-eggs
F: Échinidés; Oursins de Mer; Oursins; Châtaignes de Mer
D: Echte Seeigel

Plate 61
TH: **Phaeodaria**
Rohrstrahlinge; Phaeodarien; Cannopyleen, Tripyleen; U.-Ord. der osculosen Radiolarien; Phaeodarina (Haeckel) (gr. dämmrig, grau; danach Phaeodarium: ein schwärzlicher Körper) (→ Radiol.) eine Unterordnung der → Osculosa, mit doppelwandiger Zentralkapsel und sehr komplizierten, hohem, daher fossil sehr erhaltenem Skelett. Fossil unbedeutend
TB: Tripylina (syn: Phaeodorina)
E: Phaeodarea
F: Phaeodarea
D: Rohrstrahlinge

Plate 62
TH: **Nepenthaceae**
Kannenpflanzen. A family of dicotyledonous plants in the order Sarraceniales; includes many of the pitcher plants
TB: Epenthaceae (syn: Nepenthes L.)
E: Pitcher-plants
F: Népenthes
D: Kannenpflanzen

Plate 63
TH: **Basimycetes**
Schwammpilze
TB: Basidiomycetes
E: Basidiomycetes; Palisade Fungi
F: Basidiomycètes
D: Basidiomyceten; Ständerpilze

Plate 64
TH: **Siphoneae**
Riesen-Algetten; Siphonen (Freßpolypen, Nährpolypen); Siphonales; Ord. der Grünalgen mit vielen kalkabscheidenden Gattungen (→ Codiaceae)
TB: Siphonales
E: Siphonales
F: Siphonales
D: Siphonales

Plate 65
TH: **Florideae**
Rotalgen. A class of red algae, division Rhodophyta, having prominent pit conections between cells
TB: Florideophyceae
E: Red Algae
F: Algues
D: Rotalgen

Plate 66
TH: **Arachnida**
Spinnentiere, Arachnoideen (Arachniden, Spinnentiere); Klasse der luftatmenden Gliederfüßler
TZ: Arachnoidea (syn: Octopoda; Arachnida)
E: Spiders an Allies; Spiders; Scorpions; Mites and Ticks; Arachnoids; Octopodans; Octopods
F: Arachnides
D: Spinnentiere; Spinnenartige Tiere; Achtfüßler; Arachnoiden; Octopoden

Plate 67
TH: **Chiroptera**
Fledertiere, Chiropteren (Macrodactylen, Flattertiere, Fledermäuse); Ord. der Säugetiere; an order of mammals having the front limbs modified as wings
TZ: Cheiroptera; Chiroptera
E: Ch(e)iropterous Animals; Winghanded Animals; Chiropterans; Bats
F: Chiroptères; Chéiroptéres; Chauves-souris
D: Flattertiere; Fledermäuse; Fledertiere; Handflatterer; Handflügler

Plate 68
TH: **Batrachia**
Frösche, Anuchen (Batrachier, Ecaudaten, Froschlurche); Ord. der Froschlurche, deren jüngste Gruppe sie bilden (erst vom Tertiär an)
TZ: Amphidia (syn: Batrachia)
E: Amphibians; Amphibious Vertebrates; Amphibious Animals; Batrachians
F: Amphibians; Amphibies; Batraciens
D: Lurche; Amphibien

Plate 69
TH: **Hexacoralla**
Sechsstrahlige Sternkorallen, Hexacorallien (Hexactinien); Ord. der Korallentiere
TZ: Hexacorallia (syn: Hexactinia; Polyactinia)
E: Hexacorallians
F: Hexacoralliaires
D: Sechsstrahlige Korallen; Seeanemonen und Steinkorallen; Sechsstrahlige Polypen; Sechsstrahlige Korallentiere; Sechsstrahlige Blumentiere; Mehrstrahlige Blumentiere

Plate 70
TH: **Ophiodea**
Schlangensterne; Ophiuroideen (Ophiodeen, Schlangensterne); Klasse der Echinodermen
TZ: Ophiuroidea
E: Brittle Stars; Serpent Stars; Ophiuroids; Ophiuroideans; Spinigrade Echinoderms
F: Ophiuries; Ophiures (larva) Ophiopluteus
D: Schlangensterne; Schlangenschwanzsterne; Ophiuroiden

Plate 71
TH: **Stephoidea**
Ringel-Strahlinge; Stephoideen; Fam. der Strahltierchen
TZ: Stephoidea (U.G. der Nasselaria)
E: Stephoidea
F: Stephoidea
D: Stephoidea

Plate 72
TH: **Muscinae**
Laubmoose; Musci (Laubmoose); Klasse der Bryophyta
TB: Musci
E: Mosses
F: Mousses
D: Laubmoose

Plate 73
TH: **Ascomycetes**
Schlauchpilze; Ascomycetes (Schlauchpilze); Klasse der Pilze; a class of fungi in the subdivision Eumycetes, distinguished by the ascus
TB: Ascomycetes
E: Ascomycetes
F: Ascomycétes
D: Ascomyceten; Askomyzeten; Schlauchpilze

Plate 74
TH: **Orchideae**
Venusblumen
TB: Orchidales (Orchidaceae)
E: Orchids
F: Orchidées
D: Orchideen

Plate 75
TH: **Platodes**
Plattentiere; Platodes (Haeckel) (Plattentiere, Plattwürmer); Haeckel betrachtet die Platoden als einen Stamm und rechnet nur diejenigen Tiere dazu, welche außer den Merkmalen der Plathelminten auch durch das Fehlen des Afters und das Fehlen des Gefäßsystems charakterisiert sind
TZ: Platyhelminthes (syn: Plathelminthes; Platodes; Helmintha; Entozoa; Parenchymia)
E: Flatworms
F: Vers Plats; Vers Intestinaux Parenchymateux
D: Plattwürmer; Eingeweideinnenwürmer; Napfwürmer

Plate 76
TH: **Thoracostraca**
Panzerkrebse; Podophtalmen (Thoracostraken, Schalenkrebse, stieläugige oder Panzerkrebse); U.-A. der höheren Krebse
TZ: Thoracostraca (syn: Podophtalma)
E: Stalk-eyed Crustaceans; Thoracrustaceans
F: Thoracostracés; Podophthalmes
D: Schalenkrebse; Eigentliche Krebse; Panzerkrebse; Stieläugige

Plate 77
TH: **Siphonophorae**
Staatsquallen; Siphonophoren (Schwimmpolypen, Röhrenquallen, Staatsquallen); Ord. der Nesseltiere
TZ: Siphonophora
E: Siphonophores
F: Siphonophores
D: Staatsquallen; Röhrenquallen; Schwimmpolypen

Plate 78
TH: **Cubomedusae**
Würfelquallen; Cubomedusen (Würfelquallen); Ord. der Scyphomedusen (Acraspeden)
TZ: Cubomedusae (syn: Carybdeida; Charybdeida)
E: Cubical Medusas; Cuboidal Jellyfishes; Sea Wasps
F: Méduses de Forme Cubique; Cuboméduses; Charybdéides
D: Würfelquallen; Feuerquallen

Plate 79
TH: **Lacertilia**
Eidechsen; Lacertilien (Saurier, Eidechsen); Ord. der Schuppenechsen
TZ: Sauria (syn: Lacertilia; Autosauri)
E: Lizards; True Lizards; Saurians; Lacertilians
F: Lézards; Sauriens
D: Eidechsen; Echsen; Schuppenechsen; Saurier; Lacertilien

Plate 80
TH: **Blastoidea**
Knospensterne; Blastoideen (Seeknospen, Knospensterne); fossile (Silur bis Carbon) Echinodermen; (Say 1825) »Knospenstrahler« (Crinozoa). Ausgestorbene, meist gestielte Stachelhäuter
TZ: Blastoidea
E: Blastoids
F: Blastoides
D: Blastoiden

Plate 81
TH: **Thalamophora**
Kammerlinge; Thalamophoren (R. Hertwig 1876), Foraminiferen (d'Orbigny 1826), Testaceen (M. Schultze 1854), Kammerlinge; marine Rhizopodien
TZ: Foraminifera (syn: Thalamophora; Polythalamia)
E: Foraminifers; Foraminiferans; Porebearers; (US) Forams
F: Foraminifères
D: Kammerlinge; Porentierchen; Lochträger; Siebtierchen; Vielkammerige Porenträger; Vielkammerige Schalenwurzelfüßer; Schalenwurzelfüßer; Kreidetierchen; Schnörkelschnecken

Plate 82
TH: **Hepaticae**
Lebermoose; Hepaticae (Lebermoose); Klasse der Bryophyta
TB: Marchantiatae (syn: Hepaticae)
E: Liverworts
F: Hépatiques
D: Lebermoose

Plate 83
TH: **Lichenes**
Flechten; Lichenes (Flechten)
TB: Lichenes
E: Lichenes
F: Lichenes
D: Flechten

Plate 84
TH: **Diatomea**
Schachtellinge; Diatomeen; reichhaltige Klasse von einzelligen Algen; Kieselalgen (Diatomeae: Bacillariophyceaem, Stamm Chrysophyta), einzellige Algen ohne Flagella (Geißeln)
TZ: Bacillariophyceae (syn: Diatomeae)
E: Diatoms
F: Diatomées
D: Diatomeen

Plate 85
TH: **Ascidiae**
Seescheiden; Tethyodeen (Ascidiaeformen, Ascidien, Seescheiden); Ord. der Manteltiere
TZ: Tethyoidea (syn: Ascidiacea; Ascidiae)
E: Ascidians
F: Ascidies; Ascidiacés; Téthyes; Ascidies Fixées
D: Seescheiden; Seewalzen

Plate 86
TH: **Decapoda**
Zehnfußkrebse; Decapoden; U.-Ord. der Cephalopoden
TZ: Decabrachia (syn: Decapoda)
E: Decapod Cuttle-fishes; Decapods; Decapodous Cuttles; Chokkers;
F: Décapodes
D: Zehnarmige Kopffüßer; Zehnarmige; Zehnarmige Tintenfische; Zehnfüßige Tintenfische; Zehnfüßer; Tintenfische

Plate 87
TH: **Teleostei**
Knochenfische; Teleosteer (Knochenfische); Ord. der Fische
TZ: Teleostei (syn: Teleostomi)
E: True Fishes; Teleostean Fishes; Teleosteans; (US) Teleost Fishes
F: Téléostéens; Actinoptérygiens Modernes; Poissons Osseux
D: Echte Knochenfische; Neu-Knochen-Fische

Plate 88
TH: **Discomedusae**
Scheibenquallen; Discomedusen (Discophoren, Scheibenquallen, Schirmquallen); Ord. der Scyphomedusen
TZ: Discomedusae (syn: Discophora)
E: Disk Jellies
F: Méduses à Bord Combrellaire Lobé; Discoméduses; Cyclomorphes
D: Schirmquallen; Scheibenquallen

Plate 89
TH: **Chelonia**
Schildkröten; Cheloniden (Carettiden, See- oder Meeresschildkröten); Fam. der Schildkröten
TZ: Testudines (syn: Chelonia; Testudinata; Chelonii; Hydrosauria; Cataphracta)
E: Turtles and Tortoises; Bucklered Reptiles; Shield Reptiles; Chelonians
F: Tortues; Chéloniens
D: Schildkröten; Wassersaurier; Schildechsen; Bepanzerte Reptilien

Plate 90
TH: **Cystoidea**
Beutelsterne; Cystoiden (Beutelstrahler, Seeäpfel); fossile (paleozoische) Fam. der Stachelhäuter (Echinodermen); (von Buch 1844 = Hydrophoridea Zitt.), »Beutelstrahler«; eine im Altpaläozoikum weit verbreitete Klasse der Crinozoa. ... Die Cystoiden könnten die Stammgruppe der Blastoidea sein. Vorkommen (Kambrium) Ordovizium bis Oberdevon
TZ: Blastozoa
E: Blastozoa
F: Blastozoa
D: Blastozoa

Plate 91
TH: **Spumellaria**
Schaumstrahlinge; Spumellarien (Peripyleen); U.-A. der Radiolarien
TZ: Peripylea (syn: Spumellaria; Peripylaria; Pancollae)
E: Peripylea
F: Peripylea
D: Schaumstrahltiere; Gallertstrahltiere

Plate 92
TH: **Filicinae**
Laubfarne; Filices (Farne); Klasse der Pteridophyta
TZ: Filicinae
E: Ferns
F: Fougeres
D: Farne

Plate 93
TH: **Mycetozoa**
Pilztiere. A zoological designation for organisms that exhibit both plant and animal characters during their life history (Myxomycetes); equivalent to the botanical Myxomycophyta
TZ: Mycetozoa (syn: Myxomycophyta); Myxomycetes
E: Myxomycetes; Slime Moulds
F: Myxomycètes
D: Myxomyceten; Schleimpilze

Plate 94
TH: **Coniferae**
Zapfenbäume, Coniferae (Coniferopsida, Zapfenträger); Klasse der Nacktsamer
TB: Coniferae
E: Conifers
F: Conifères
D: Zapfenbäume; Nadelhölzer

Plate 95
TH: **Amphoridea**
Urnensterne, Amphorideen (See-urnen), Namen, unter denen Haeckel mehrere früher zu den Cystoiden gerechnete, fossile (Cambrium und Silur) Formen der Stachelhäuter (Echinodermen): die Pleurocystiden, Anomocystiden, Aristosystiden u. Palaeocystiden zusammenfaßt
TZ: Cystoidea
E: Cystoids
F: Cystoidea
D: Beutelstrahler

Plate 96
TH: **Chaetopoda**
Borstenwürmer, Chetopoden (Borstenwürmer), U.-Klasse der Ringelwürmer
TZ: Chaetopoda
E: Chaeopods
F: Chétopodes
D: Borstenwürmer; Borstenfüßer; Chaetopoden; Rotwürmer

Plate 97
TH: **Spirobranchia**
Spiralkiemer, Brachiopoden (Spirobranchier, Armfüßer, Spiralkiemer)
TZ: Anostraca (Branchiopoda; Euphyllopoda)
E: Gill-footed Crustaceans
F: Anostracés; Branchiopodes
D: Kiemenfußkrebse; Kiemenfüße; Kiemenfüßer; Schalenlose

Plate 98
TH: **Discomedusae**
Scheibenquallen; Discomedusen (Discophoren, Scheibenquallen, Schirmaquallen); Ord. der Scyphomedusen
TZ: Discomedusae (syn: Discophora)
E: Disk Jellies
F: Méduses à Bord Combrellaire Lobé; Discoméduses; Cyclomorphes
D: Schirmquallen; Scheibenquallen

Plate 99
TH: **Trochilidae**
Kolibris; Trochilidien (Kolibris, Schwirrvögel); Fam. der mauerschwalbenähnlichen Vögel; a tropical New World family of the suborder Trochili
TZ: Trochilidae
E: Hummingbirds
F: Coloibris; Oiseau-mouches
D: Kolibris

Plate 100
TH: **Antilopina**
Antilopen; Antilopinen (Antilopen); U.-Fam. der Horntiere
TZ: Antilopinae
E: Antelopes
F: Antilopes
D: Antilopen

Bibliography

Gozmány, Laszlo; Henrik Steinmann, Ernó Szily: *Vocabuilarium Nominum Animalium Europae Septem Linguis Redactum*, Akadémiai Kladó, Budapest 1979

Berger, Karl (Ed.): *Mycological Lexicon*. 32,000 references in 8 languages, Jena 1980

Grassé, Pierre P. (Ed.): *Traité de Zoologie, Anatomie, Systématique, Biologie*. Vols. I–XVI, Paris 1952

Meglitsch, Paul A.; Frederick R. Schram: *Invertebrate Zoology*, New York / Oxford 1991

Botanical Dictionary: Russian–English–German–French, Moscow 1962